T0318490

Dramaturgy of Form

"Kasia Lech has written a subtle, substantial, alert analysis of the practice and power of verse in Contemporary Theatre. Her deep, wide, impressive scope of reference displays her command of relevant methodology, underlining the centrality of poetry in much of the most innovative drama now being created on world stages. Lech is most skilled and sensitive in deciphering linguistic games and guile stretching the art of playwriting to its furthest, breathtaking extremes. Her book is the work of an outstanding critic".

– Frank McGuinness, Professor Emeritus at
University College Dublin

Dramaturgy of Form examines verse in twenty-first-century theatre practice across different languages, cultures, and media. Through interdisciplinary engagement, Kasia Lech offers a new method for verse analysis in the performance context.

The book traces the dramaturgical operation of verse in new writings, musicals, devised performances, multilingual dramas, Hip Hop theatre, films, digital projects, and gig theatre, as well as translations and adaptations of classics and new theatre forms created by Irish, Spanish, Nigerian, Polish, American, Canadian, Australian, British, Russian, and multinational artists. Their verse dramaturgies explore timely issues such as global identities, agency and precarity, global and local politics, and generational and class stories. The development of dramaturgy is discussed with the focus turning to the new stylized approach to theatre, whose arrival Hans-Thies Lehmann foretold in his *Postdramatic Theatre*, documenting a turning point for contemporary Western theatre.

Serving theatre-makers, scholars, and students working with classical and contemporary verse and poetry in performance contexts; practitioners and academics of aural and oral dramaturgies; voice and verse-speaking coaches; and actors seeking the creative opportunities that verse offers, *Dramaturgy of Form* reveals verse as a tool for innovation and transformation that is at the forefront of contemporary practices and experiences.

Kasia Lech is Senior Lecturer in Performing Arts at Canterbury Christ Church University. Her research and creative practice explore theatre through practice-based and traditional scholarship and primarily focus on verse, multilingualism, translation, and transnational experience.

Focus on Dramaturgy
Series Editor: Magda Romanska

The *Focus on Dramaturgy* series from Routledge – developed in collaboration with TheTheatreTimes.com – is devoted to the craft of dramaturgy from multiple contemporary perspectives. This groundbreaking comprehensive series is authored by top professionals in the field, addressing a variety of current hot topics in dramaturgy.

The series is edited by Magda Romanska, an author of the critically-acclaimed *Routledge Companion to Dramaturgy*, dramaturg, writer, theatre scholar, and Editor-in-Chief of TheTheatreTimes.com.

For more information about this series, please visit: www.routledge.com/performance/series/RFOD

Dramaturgy of Form

Performing Verse in
Contemporary Theatre

Kasia Lech

 Routledge
Taylor & Francis Group

LONDON AND NEW YORK

First published 2021
by Routledge
2 Park Square, Milton Park, Abingdon, Oxon OX14 4RN

and by Routledge
605 Third Avenue, New York, NY 10017

Routledge is an imprint of the Taylor & Francis Group, an informa business

Copyright © 2021 Kasia Lech

British Library Cataloguing-in-Publication Data
A catalogue record for this book is available from the British Library

Library of Congress Cataloging-in-Publication Data
A catalog record for this book has been requested

ISBN 13: 978-0-367-20193-7 (hbk)
ISBN 13: 978-0-367-70915-0 (pbk)
ISBN 13: 978-0-429-26005-6 (ebk)

Typeset in Times New Roman
by Apex CoVantage, LLC

Contents

4 Verse and new theatre forms 92

Figures

Introduction

From Greek drama, the Noh tradition, through Shakespeare, Calderón, Molière, Romanticism, and W. B. Yeats, to contemporary Dub Poetry and Hip Hop performances, verse has been essential for theatre but has remained on the periphery of theatre research. Verse dramas are often discussed as a work of literature or in the context of a single playwright or tradition. However, the twenty-first-century resurgence of interest in verse as a theatrical language creates an urgent need to examine dramaturgical operations of verse across different languages, cultures, and media, asking how it challenges existing ideas on the form and content relations in theatre. This is the aim of this book. It responds to how contemporary theatre has used verse and verse-like forms to create a platform for individual, generational, and class stories; for responses to local and global politics; and for artistic searches for new aesthetics. The wide selection of verse works is significant: new writings, musicals, devised performances, multilingual theatre, gigs, media projects, innovative stagings and translations of classics, and new theatre forms.

Dramaturgy of Form looks at verse as a tool for innovation and transformation in contemporary theatre and offers a new methodology for analyzing its dramaturgical operation. The book examines how verse functions as a critical architectonic feature of articulating the production, which brings it to the realm of dramaturgy. The central argument is that verse is heteroglossic – built on a dialogical interaction between often contradicting viewpoints – which has dramaturgical consequences, particularly suited for contemporary theatre practice within which heteroglossia is central as it reflects the globalized world's multifaceted and pluralistic nature. Verse dramaturgies in this book come from diverse linguistic and cultural contexts and explore timely issues such as global identities and multilingualism, precarity, global and local politics, digital theatre, and postdramatic aesthetics. Through them, verse is shown to be at the forefront of contemporary practices and experiences, contrary to perceptions that it is distinct from them

(Morra 5–6). While the book discusses works by Irish, Spanish, Nigerian, Polish, American, Canadian, Australian, British, Russian, and multinational artists, it also reflects my experience of theatre, which is rooted in Poland, Ireland, and the UK.

The book also reveals how verse dramaturgies affect power dynamics in theatre, simultaneously empowering and relying on the actor, suggesting a need to rethink acting training, so it reflects contemporary verse practices. The method for reading verse in and for performance that *Dramaturgy of Form* offers is based on the heteroglossic quality of verse. It can be applied to thinking about heightened texts in multiple contexts, from revisiting classical verse dramas, through dramaturging rhythmical texts, rethinking acting-training pedagogies, to engaging with contemporary aural and oral dramaturgies.

The book is divided into four chapters. The first chapter brings together scholars working across different disciplines, languages, and contexts to explain links between verse, heteroglossia, and contemporary dramaturgy. This theoretical section frames the text and performance analyses in the subsequent chapters focused respectively on verse dramaturgy in theatre translation and adaptation (Chapter 2), political theatre (Chapter 3), and new theatre forms (Chapter 4). Their arrangement reflects the history of verse in theatre: while White male playwrights dominate initial case studies, the marginalized voices – including female, Black, and queer voices – gradually claim their artistic agency.

The second chapter reveals ways in which verse empowers translation and adaptation and facilitates their dramaturgy, emphasizing their search for cultural and social change. The third chapter expands on this by investigating dramaturgies concerned with identities that escape boundaries, marginalization and precarity, and political protest. The final chapter takes this further and discusses productions in which verse fuels radical and often politically motivated formal intervention. Their verse dramaturgies use postdramatic tools to emphasize their own shift *towards form* and *towards dramatic text* (see Boyle et al. 2), suggesting that theatre is ready for "a return of conscious and artificial stylization" as a platform for a new dramatic theatre, as predicted by Lehmann (*Postdramatic* 144). And while the notion of verse challenging Aristotelian traditions and complicating the dominating Hegelian idea of the dialectical relation between dramatic content and form permeates all chapters, it is the final section that deals with these in the most radical context. It discusses anti-Aristotelian verse dramaturgies that embrace the relationship between form and content as a dialogic one, emphasizing multiple perspectives and refusing the possibility of a final conclusion. The form as presented in the fourth chapter is neither historical nor

ahistorical. Instead, its multi-voiced-ness highlights the coexistence of multiple (rather than one) and simultaneous contents and creates infinite potential for new contextual meanings. Through these, to use Theodor W. Adorno's point about Samuel Beckett's *Endgame*, verse dramaturgies discussed in the final section are "a test-tube study on the drama of the age" ("Trying" 260).

Many artists featured in the book (particularly Chapter 3) feed off the interlinks and overlaps between verse and Hip Hop as "a global, multiethnic, grassroots youth culture committed to social justice and self-expression through specific modes of performance" (Banks 2). The renewed interest in verse is connected to the popularity of highly rhythmic music like rap and Hip Hop culture (of which rap is part) making its way to the theatre. Hip Hop theatre features theatre artists investigating their relationship to Hip Hop and, arising from it, the tensions between content and form (Banks 2–3). In this sense, Hip Hop theatre relates to verse not only through its embracement of rhythmical language, but also through its dialogic tension between the rhythmic structure and the words it shapes, and questions about the content and form relations.

Unless stated differently, all quotations were translated by me. The annotation of verse rhythm, regardless of which language it organizes, is as follows. The numbers, if given at the end of the line, denote the number of syllables in this line. The symbol "|" marks a division between stress groups, ">" denotes enjambments, and "¶" marks the place of a caesura. Rhymes are marked by a small letter (a, b, c) at the end of the line. Within the text, rhythmically strong syllables are in bold and rhymes and assonances are additionally highlighted by being in italics (if they are analyzed in the associated argument). Within the annotation of verse structure, "X" marks rhythmically strong syllables, and "x" marks rhythmically weak syllables.

As this book immerses itself in the process of decoding the mathematics of verse and the activation of its rhythms that run through elements of the theatrical world, dramaturging it, I must look into the past and acknowledge people without whom it would never have happened. I want to thank my doctoral supervisors, Dr Cathy Leeney and Dr Catriona Clutterbuck, for support, for guidance on my research on verse, and for models of scholarship that are integral to who I am as an academic and theatre-maker. The Irish Research Council's funding helped me develop the project, and Dr Lisa Fitzpatrick, Professor Beata Baczyńska, Dr Audrey McNamara, Janet Morgan, Dr Kene Igweonu, and Dr Marissia Fragkou offered invaluable feedback on its different stages. The idea for the book stretches to 2002, and it was Professor Mirosława Lombardo, Professor Jerzy Bielunas, Professor Janusz Degler, Professor Bogdan Pięczka, Professor Mirosław Kocur, Iwona Mirońska-Gargas,

4 *Introduction*

and Jacek Przybyłowski who shaped my understanding of verse in theatre.

Many thanks to Dr Magda Romanska, the editor of the *Focus on Dramaturgy* series, who believed in the project and offered detailed and empowering feedback. Finally, this book is in memory of the woman of my life: Leonarda Fengler, my grandmother. Babciu, to dla Ciebie.

1 Heteroglossia of verse and its dramaturgical potential

"Verse" derives from the Latin *versus*, which means "a line or row", especially "a line of writing"; the term verse comes "from turning to begin another line", in Latin *vertĕre* (to turn). In Middle English, "verse" also denoted "reinforced by". The idea of verse as a reinforcing agent directly links with the enhanced heteroglossic quality of verse and its internal dialogization facilitated by verse structure, which is this chapter's main focus. Verse structure is a pattern of verse lines and formal elements that support the line arrangement like rhyme, enjambment, metre, and so on, and is a defining feature of verse that differentiates it from other modes of language (Attridge 225; Dłuska 21–22, 41; Bradford 15). Verse structure, as this chapter explains, underlies the potential of verse to influence key theatre elements (e.g. time, space, stage personae, actors) and their interrelationships. Thus, verse may reveal "the structure of the meaning" of the dramatic world, which is closer to the traditional concept of dramaturgy (Van Kerkhoven). It can also stage theatrical negotiations, conversions, and collisions; introduce multilingual and translingual contexts; and bring out the aspects of the process and performance, which are primary concerns of contemporary dramaturgies (Caplan 142; Trencsényi and Cochrane xii). Verse structure, as presented in this chapter, is also a platform for activating the audience, engaging them in the co-creation of performance (see "porous dramaturgy" in Turner and Radosavljević), and is "a tool of inquiry" connecting it even more strongly to today's dramaturgical practices (Romanska, "Introduction" 6–7). In all these cases, verse structure mobilizes "production of and reflection on communication of communications to society about society", as Janek Szatkowski has recently defined dramaturgy (6).

The dramaturgical consequences of verse structure are particularly suited for contemporary global theatre practice. By focusing on verse structure, my argument also echoes Magda Romanska's prediction that "Drametrics, a combination of mathematics and dramaturgy, will become more and more prominent" in contemporary theatre and particularly in dramaturgical

practices as theatre becomes entangled in algorithms of artificial intelligence, big data, and the Internet of Things ("Drametrics" 446). The chapter brings together voices from linguistics, poetry, literature, and theatre studies working in different languages and contexts. Their combined perspectives – discussed in the first part of the chapter – underlie the subsequent discussion on the dramaturgical potential of heteroglossia in verse for a hypothetical staging and its live performance.

Heteroglossia and verse

Mikhail Bakhtin defines heteroglossia as *"another's speech in another's language"* that thereby has the ability to express "simultaneously two different intentions" or worldviews that are "dialogically interrelated" ("Discourse" 324–25). Such a *"double-voiced discourse"* can facilitate multiple contradictions that deprivilege and reinvigorate language, increasing its self-consciousness in relation to an individual as well as to broader political, linguistic, social, and cultural contexts (Bakhtin, "Discourse" 324–26; Holquist 427). This makes heteroglossia a fascinating concept, and many scholars have interpreted it for different fields. In theatre, it was most famously Marvin Carlson who argued against "Bakhtin's attempt to deny heteroglossia to the theatre" (*Speaking* 4). Carlson's point was that heteroglossia is central for contemporary global theatre practice, as it reflects conditions of living in a globalized society (*Speaking* 18). In my application of Bakhtin's term, however, I follow its recent reading by Cristina Marinetti and Helena Buffery, who, in contrast to Carlson, both differentiate between Bakhtin's polyphony as "multi-language consciousness" and experience (including its representation) (Bakhtin, "Discourse" 11; Marinetti 4; Buffery 151) and heteroglossia. Marinetti proposes to interpret heteroglossia as "a subversive space where linguistic and performative practices challenge the monologic lens of authorial vision", facilitating "the juxtaposition of different and often contrasting voices and racialized bodies" (4). This definition is particularly suited to verse and its dramaturgical potential.[1]

Verse, as a mode of language, is organized not only by rules of grammar or syntax, but also by verse structure, to repeat: the patternized use of the verse line and within it, formal principles including metre, rhyme, and enjambment. A pattern is a key term here. Polish prosodist Maria Dłuska urges that none of these formal features practised on a once-off basis in a text can create verse. Only a repetition of these features, "through which the division into lines is imposed upon language, equips these elements with verse-creating abilities". This repetitiveness results in compositional predictability, marks Dłuska (*Próba* 21–22), which facilitates increased heteroglossia of verse and its dialogic potential.

The patternized verse structure, in addition to syntax, organizes the meanings and the thoughts in verse, but also heightens the rhythm of verse when it is spoken (aloud or not). Aristotle considered these secondary after plot, thought, and character (Aristotle 11–12; Ross 298). This anti-Aristotelian aspect of my analysis will play an extra important part in the final chapter, which explores the formal boundaries of verse, drama, and theatre. *Rhythm* is a problematic and ambiguous term, and Dłuska calls it partly worthless; at the same time, she admits that it is almost impossible not to use this term at all when speaking about verse (*Próba* 11–13). I use the idea of rhythm because it helps one to understand what happens with verse structure when it moves from paper into the realm of speech and, consequently, performance. Verse rhythm is energy generated by the speaker's voice (real or virtual – i.e. heard in one's head while reading in silence) and by verse structure. The speaker generates this energy through his or her voice; at the same time, this energy runs through verse structure; it becomes restricted and patternized by verse structure. Derek Attridge argues that verse structure heightens "our attention to its [verse's] rhythms" (5). As a result, in a live performance situation, both rhythmical and lexical levels can communicate with the audience independently and through interaction with each other; the heightened rhythm of verse emphasizes these interactions and the tensions evoked by them.

I am not alone in thinking that formal elements of verse can generate, at the very least, additional meanings to the lexical level of verse. This has been well established in studies of poetry and verse drama (e.g. Attridge 12–18; Dłuska *Próba* 63–108; Lech, "Metatheatre"; Morra 164; Wright 249–63). However, I take this further by arguing for the heteroglossic consequences of these interactions and their potential to facilitate contemporary dramaturgical practices. To begin, it is helpful to look at how lexical and rhythmical levels interact in verse. This frames the upcoming discussions, explains how verse and verse structure are analyzed in this book, and clarifies some of the key terminologies.

Lexical and rhythmical levels of verse

The pattern of lines facilitates the interactions between lexical and rhythmical levels of verse through its various appearances, disappearances, and variations that are easier to notice the stronger the pattern. For example the basic pattern of lines can be reinforced by a constant number of syllables in lines, for instance intertwining five-syllable and 12-syllable lines (syllabic verse). Metre, based on binary oppositions such as stressed and unstressed or short and long syllables, is another element strengthening the verse pattern. Metrical verse, called accentual-syllabic or syllabotonic verse, has a recognizable pattern created by count of syllables and, in most modern

languages, stressed and unstressed syllables arranged into metrical feet like iamb (xX), trochee (Xx), or amphibrach, (xXx), where a capital "X" marks rhythmically strong syllables. These stresses may or may not agree with the grammatical stress – this is one of the reasons for verse analysis being a subjective process. Another variation is an accentual or tonic verse, where the pattern is created by a constant number of stresses or beats, regardless of the numbers of syllables per line. The number of syllables within the stress unit and the place of a beat can also change, as opposed to metrical feet, wherein these are more or less constant. Finally, free verse relies mostly on verse lines that are not supported by linguistic units like syllable or stress counts. In any of these types of verse, the pattern can be additionally strengthened or broken by rhymes, caesuras, and enjambments. Caesuras, as an indication of a small pause within a line, usually occur in lines longer than eight syllables. A caesura may be additionally marked by punctuation, but it does not require any punctuation to occur. Enjambments are caused by lack of overlapping between the line ending and the syntax organization: it is a break in a clause caused by the end of a line, a pause imposed in the middle of a clause, which would not otherwise be there. Enjambment or caesura pauses may bring attention to the words they split.

This traditional, Western taxology of verse by no means exhausts the possibilities of rhythmical patterns. Upcoming chapters will show that contemporary theatre practice uses verse rhythm to challenge Western traditions of verse and verse drama; and it even questions whether the line is necessary to create the linguistic energy of verse and heteroglossia that it facilitates. However, while recognizing its Western roots and overly clinical perspective, the explained terminology of verse and methodology it facilitates – so-called scansion – provide a useful point of departure for understanding how verse structure, and verse rhythm by extension, generate meanings. In other words, I begin by looking at verse structure as a sign system, following Marvin Carlson's argument that semiotics provides "an effective starting point" and "basic orientation" for approaching new theory in a performance context ("Semiotics" 11).

The final stanza of Eavan Boland's "Anorexic", based on accentual verse, is a good example of verse structure generating meaning before I move on to the context of verse in theatre that adds further layers to verse and its patterns. In my approach to scansion, I am indebted to Derek Attridge's function of rhythm in poetry (11–18), Maria Dłuska's works on prosody (*Próba, Odmiany*), I. A. Richards's work on rhythm and its power of communicating ("Rhythm", "Science"), and the teaching of Mirosława Lombardo and Jacek Przybyłowski. Boland's poem's subject is an anorexic, talking about her female body that she disassociates from and tries to punish and expunge through self-starvation. She describes this body as falling

into \|forked \| **dark**,	Xx \| X \| X
into\| python \| **needs**	Xx \| Xx \| X
heaving \|to **hips** \| and **breasts**	Xx \| xX \| xX
and **lips** and **heat**	x X x X
and **sweat** and **fat** and **greed**. (Boland 76)	x X x X x X

Boland's lines are created by three stresses each, but the pattern changes in the final lines, when metrical feet (iambs) take over. Verse structure marks the importance of "into" (additionally repeated), "heaving", "hips", and "breasts" to create the image of the female body being drawn into inescapable alignment with heaving. This body is described as a "python", implying both its danger and its insatiability, additionally suggested by "needs" and "lips", as a symbol of "greed", through which the body heaves "heat", "sweat", and "fat". The appearance of an iambic metre in the final two lines reinforces the pattern of verse structure, particularly in the final line with its three iambs. This results in the "sweat", "fat", and "greed" almost being "screamed at" the reader from the page. This oppressive advantage of the last line corresponds well with Boland's poem, which addresses the body as experienced by the anorexic, simultaneously disavowed and all-encompassing.

Boland's verse structure creates a rhythm that can be also associated with the rhythm of vomiting; a double contraction happens after the first and second stress, while the release (and the actual vomiting) happens on the third stress. In the fourth and fifth lines, when accentual rhythm changes into accentual-syllabic, the vomiting happens on every iamb as in time the rhythm of vomiting speeds up and becomes more regular. The rhythm of this verse not only can be related to "heaving"; it also creates a stronger link between the experience of the body and the action, generally accepted as disgusting. In so doing, it strengthens the information communicated otherwise in the poem on how the anorexic sees their own body. Verse rhythm provides a conclusion to the poem through the monotonous rhythm of iambic heaving in the final lines, suggesting that heaving is the only thing left for this body.

It should be clear by now how verse structure can generate meanings and how its interaction with the lexical level of verse contributes to the overall experience of verse. In verse drama, the search for patterns goes beyond the lines' arrangements. It needs to consider theatre-specific elements such as the verse of a single character or a group of characters, various dramatic spaces or temporal periods. The forthcoming section takes my consideration of verse structure as a semiotic system further. I argue that verse structure interacts with other semiotic systems operating within the text and, in live performance, the mise-en-scène. The focus is on how

verse structure interacts with key theatre elements (e.g. time, space, stage personae, actors) and their interrelationships. This is possible because verse structure links with the actor's ambiguity as a performer and stage persona and can accomplish the core functions of theatre speech and thereby create a heteroglossic quality of verse, facilitating its dramaturgical operations. To explain the actor's ambiguity and its link to dramaturgy, I follow Bert O. States's advice and allow a phenomenological angle into this semiotic discussion (7–9). Afterwards, I will look at my second point about the two-layered communication in verse.

Verse structure, actor, and stage persona

Bert O. States highlights the ambiguity of the actor's identity on the stage: she or he is to be perceived both as performer and character (understood here phenomenologically as a persona that, through the body of the actor, may seem to exist on the stage). The weaker the illusion of actuality generated by the performance, the more highlighted is this ambiguity (States 119). Jerzy Limon argues that illusion in the theatre consists in the audience not distinguishing scenic speech (delivered by the actor) from the speech (or the thoughts, and so on) of the stage persona (*Piąty* 74–77). Limon stresses that this "overlapping" does not happen in verse performance, as the spectator recognizes the rules of literature (verse structure) that construct and organize the actor's speech. This lack of overlapping between the speech of the actor and the persona highlights the theatricality of the performance (*Piąty* 76–77) and, following States's argument, highlights the ambiguity of the actor's identity.

To take this further, verse structure can remind the audience that the speech they hear is not created by the actor who delivers it, highlighting the virtual presence of the playwright and their writing, and thereby emphasizing the tension between writing (the text) and orality (actor's performance). This, in turn, opens avenues for dramaturgy to ask important meta-questions about the nature of theatre, its texts, and the broader cultural landscape. According to Erica Fischer-Lichte, a "dissent as to whether drama should be considered under literature as writing or under theatre as orality" is underlain by the tension between writing and orality that both produces and is constituted by a dramatic dialogue (319–20). Writing is a technology (Ong 80–82), and the orality-writing interaction also brings about their mutual conflicts and co-dependency, which underlie the development of human consciousness, relationships between various cultures, and the current "age of secondary orality" that new technologies have created, as Walter J. Ong insists in *Orality and Literacy* (3, 5–15, 176).

By marking the ambiguity of the actor's identity and the presence of the actor onstage, verse structure also marks the liveness of the performance by extension. The latter is a value that the audience is attracted to. Even Philip Auslander, who devalues the role of liveness in the live performance, stresses pleasure that arises from it and "a socio-cultural value attached to live presence" that allows one to turn one's presence at the live event into "symbolic capital", prestige, which is the greater, the more unique and iconic the live event (66–68). At the same time, verse structure is a reminder of Rebecca Schneider's point that "the body performing live" is "a matter of record" (*Performing* 92).

Verse speech through its structure (and the rhythm ruled by this structure) both seems and is an artistic creation by three agents: the artist (playwright) who is absent and yet present through the verse rhythm, the production team that is absent and yet present through the elements of staging they created, and the artists who are present (actors). One could add the audience as a fourth "creative agent", as the ultimate creators of meanings of the performance, whose presence is highlighted by verse structure. By highlighting its artificiality and the liveness of the performance, verse speech also reminds the audience about the context of the event they are participating in, the performance. In doing so, verse structure focuses the audience's attention on the presence of other audience members; it highlights spectators' "togetherness", which according to Susan Bennett encourages collective responses and empowers the spectator as the ultimate meaning creator (124, 133, 156), underscoring the audience's freedom and responsibility for the meanings, facilitating active participation in the performance. This, in turn, opens avenues for porous dramaturgies that try "to engage the audience in co-creation – for instance, through interactivity, immersion and site-specificity" (Turner and Radosavljević). Porous dramaturgies, as defined by Cathy Turner and Duška Radosavljević, have democratic potential related to their exploration of community, especially in the context of various social-political, geographical, or historical pressures (Turner and Radosavljević).

The complicated and simultaneous presences and absences that verse in theatre brings about also link it with postdramatic practices for which this is a central issue (Lehmann 56–57, 79, 89). Chapter 4 directly addresses this connection, showing that a highly rhythmical and stylized language is a gate towards "a new theatre in which dramatic figurations will come together again, after drama and theatre have drifted apart so far", the arrival of which Hans-Thies Lehmann prefigured (144). For now, however, I turn to Roman Ingarden's 1957 landmark publication of "The Functions of Language in the Theater". I propose that verse structure can perform the core functions of theatre speech independently of its lexical level, thereby creating a heteroglossic quality of verse and facilitating its dramaturgical operations.

Verse structure as theatre speech

Roman Ingarden distinguishes four functions of theatre speech: representation of objectivities, expression, communication, and influencing. Theatre speech embodies objects (e.g. people, processes, things, events, states of affairs) that do not appear on the stage. This is the function of the representation of objectivities that occurs through the meaning of the words or sentences in which they occur (a linguistic representation). The function of expression allows theatre speech to reveal the feelings and psychological states of characters. Through the function of communication, theatre speech facilitates the transmission of information from one character to another (monologues rather lack this function, says Ingarden); in so doing the speech in the theatre accomplishes also the function of influencing: one character speaks to make an impact on the other character(s) and by extension on the action (Ingarden 380–84).

These, says Ingarden, are the functions of speech within the represented world of the play. Ingarden also notes that one cannot forget about the audience in the theatre. He claims that the functions of communication and of influencing can also be discussed as functions that refer the play to its spectators (383–84). The significance of these two functions as they refer to spectators may differ according to the nature of the performance, but in general, the function of communication, which refers the play to the audience, is performed when information is passed to the spectator (and it is the same information as that passed between characters). The function of influencing is accomplished when the speech influences the spectator, when it evokes feelings or understandings (anticipated or not by the creators of the performance) (Ingarden 386–96).

I am using Ingarden's ideas, but with three conditions. First, theatre speech is audience-focused rather than, as Ingarden argues, predominantly character-focused. Ingarden's preoccupation with the character arises from what scholars marked as a gap in his reasoning; he sees "the actor only as 'the psychological basis for existence' of the character" and does not recognize the actor as a creative artist and performer (Csató 131–32). This book understands a character as a collection of various functions and discourses. In doing so, it follows Elinor Fuchs's points that the Aristotelian character-as-human-being and Hegelian soul of tragedy is no longer needed for theatre to exist (23–26, 49). Even if a production presents a character as a coherent being, what one hears on the stage is not the speaking of this person, but at most the sign of this speaking (or thinking, processing, and so on) (Limon, *Piąty* 69–70). The importance of the actor and their presence is fundamental for the heteroglossic potential of verse. And it also arises from the advance of theatre studies since Ingarden's times from Peter Szondi's insistence that

drama must be "conscious of nothing outside itself" (195). Framing theatre speech as audience-focused means that verse structure, as part of speech one hears on stage, is also audience-focused and has, at the very least, the possibility of performing audience-focused tasks, which dramaturgy is (Romanska, "Introduction" 6).

My next condition is a consequence of that: not all of Ingarden's functions are equal. If one accepts that the actor communicates with the audience to evoke some reaction, then the function of influence (however problematic the term *influence* is) is superior to the function of communication, while the function of communication is superior to the functions of representation and expression. The actor talks to communicate with the audience. Through that, they may achieve some reactions which the production team may or may not have anticipated. I am following here the logic of John Langshaw Austin's speech act theory as reinterpreted by Mary Louise Pratt and her influential book *Toward a Speech Act Theory of Literary Discourse.*

Pratt follows Austin's idea that making an utterance is to perform an act and Austin's claim that by performing this act, one "does at least two and possibly three things" (Austin 80–81). One performs a locutionary act (produces the actual, recognizable, and grammatical utterance in a particular language); performs an illocutionary act for example "informing", "asking", "warning"; and may also perform a perlocutionary act, that is by saying what they say, they may be achieving certain effects in their hearer in addition to those achieved by the illocutionary act. By warning a person, one may frighten him; by arguing one may convince, and so on.[2] Pratt in her work argues for using speech act theory in the analysis of literary discourse. However, she makes three points that allow one to consider the delivering of theatre speech as a speech act and to consider Ingarden's functions of theatre speech in the context of the actor communicating with the audience.

First, Pratt explains that the speaker does not need to believe that what they say is the truth for the speech act to be performed. As an example she points out that "telling a joke" or "telling an anecdote" is a speech act and that the speaker performing it does not have to commit to its true or falseness. Second, Pratt shows that one can talk about speech acts in the context of a relationship between the audience and speakers, when one side voluntarily gives up their right to speak, as happens in theatre for example. In this situation, says Pratt, the speaker is obliged to the audience to deliver an utterance, and the audience gains the right to expect certain qualities of the speaker's performance; they are also entitled "to pass judgment" afterwards. This holds even if the reason for the participants' presence is to be the audience and the speaker has been invited to deliver an utterance (Pratt 113).

In addition, Pratt says that multi-sentence utterances can have a single purpose (85). In the context of theatre performance, this means that one can consider the theatre speech delivered throughout the whole performance by many different actors as one multi-sentence utterance. By making this utterance the actors perform a speech act in its three functions as identified by Austin; they perform a locutionary act (they voice the text written by the author), they perform an illocutionary act (the actors inform the audience about everything they need to know in order to follow the performance), and in so doing they may perform perlocutionary acts (they stimulate some audience's reactions). Finally, the third condition is that at least one function must be added: time and space generation. Jerzy Limon describes the theatre speech as TSGC: a time- and space-generating component; it can, on its own, "generate temporal structures of time and space" ("Waltzing" 222). Taking Ingarden's ideas forward on the three outlined conditions, the heteroglossic quality of verse is based on the premise that verse structure has the ability to communicate things and phenomena that do not appear on the stage, emotions and so on, and to generate time and space and so on. This underlies its ability to influence the audience in addition to the lexical level of verse, and thereby, the enhanced heteroglossic quality of verse. The next section provides examples of verse structure's capacity to communicate and affect spectators. The focus, for now, is on the texts and their – mostly hypothetical – performances to highlight a variety of dramaturgical avenues evoked by the heteroglossic quality of verse.

Verse script and its dramaturgical potential

I begin with looking at verse in relation to Ingarden's functions of representation of objectivities and expression. The ability of verse structure to create onomatopoeic effects (train, music, etc.), represent objects onstage, or to communicate emotions is well established in poetry, literature, and theatre. Attridge and Dłuska both talk about verse rhythm suggesting emotions of a piece (Attridge 13–16; Dłuska, *Próba* 63–108). Metrical structures as a source of text musicality have been discussed, for example, by Andrzej Hejmej (e.g. 176–79), Dłuska (*Próba* 220), and Attridge (16–17). Theatre provides plenty of evidence. For example David Wiles observes that actions in Greek tragedy were written in specific verse rhythms; for example the anapaest was often used for "marching" sections, and "the meters in which choruses were written presupposed specific dance steps" (138–39). For Konstantin Stanislavski, verse structure was a source of a character's subtext and emotional tempo-rhythm (50–52, 229–38). Voice coaches such as Cicely Berry (65–66), Patsy Rodenburg (134–35), Danuta Michałowska (31),

Barbara Houseman (75–78), and Kristin Linklater (50, 81, 127) talk about verse structure as a source of information for the actor about the character, and the world of the play (its imaginary, sounds) more generally. Playwrights express similar convictions. Seamus Heaney speaks about choosing verse rhythm that matches characters' emotions (Heaney, "'Me' as in 'Metre'" 171–72 and "A Note by Seamus Heaney"). The Irish post-Celtic Tiger playwright and screenwriter Stefanie Preissner explains that verse rhythm helps communicate and experience a piece's emotions (162–63). Paola Ambrosi speaks about the acoustic effect of verse form in José Bergamín's *La sangre de Antígona* (*Antigone's Blood*) and her attempts to recreate it in Spanish-to-Italian translation (62–69). And it is in no way a new phenomenon. One just need recall W. B. Yeats's fascination with the musicality of verse rhythm (Flannery 192–93) and 1609 Lope de Vega's formula for playwriting *Arte nuevo de hacer comedias en este tiempo* that assigned particular verse rhythms to particular emotional and dramaturgical effects (Brander 53).

The works of Polish Stanisław Wyspiański offer examples to illustrate how verse rhythm creates mimesis of objects, music, and emotions, revealing information about the world of the play, supporting traditional dramaturgical operation. In his *Wyzwolenie* (*Liberation*), the first stanza of the Girl Harpist's opening speech is presented through accentual-syllabic verse (created by trochees); the rhythm of this verse has a specific musicality which represents the music of the harp being played:

Harfiarka		*Girl Harpist*
Na tych **stru**nach nani**za***nych* > **a**	X x Xx X xXx	On these stringed strings
Serce **mo**je **gr***am;* **b**	Xx Xx X	I play my heart;
śmiej się **do** mych **lic** rum**i***anych*, **a**	Xx Xx X xXx	smile at my florid face,
duszę **two**ją **zn***am.* **b** (Wyspiański, Wyzwolenie)	Xx Xx X	I know your soul.

From these lines the spectator knows that the Girl Harpist plays some stringed instrument, even if the actor playing the part does not hold the harp; the attentive spectator may even know that she is playing a harp, as the lines of Father (one of the characters) provide this information upon her entrance (Wyspiański). However, the lexical level of verse cannot provide mimesis of the music created by the Girl Harpist, as this music is created on the level of verse structure. The trochaic rhythm of these lines can be associated with the rhythm of playing harp and, consequently, establishes a link

between the Girl Harpist's speech and the rhythm of the music created by the harp. This provides a strong opening to her "musical performance" and in turn allows for the regular beat of accentual-syllabic to be loosened in the later stanzas of her speech (it becomes, in general, the three-beat accentual). The loosening of the pattern combats a possible monotony of her lines and the music created by the harp by extension. However, this changed beat can be still linked with the opening lines, as they are in general created by three trochees. In so doing, this rhythm, supported by information provided on the lexical level, performs the function of representation and makes the appearance of the actual harp unnecessary.

Tadeusz Boy-Żeleński argues that the verse structure of another Wyspiański drama, *Wesele* (*The Wedding*), mirrors the rhythms of Polish national and folk dances (9). Most lines are eight syllables long, end with doggerel rhymes, and are often written in trochaic or dactylic metre. The octosyllabic trochee in Poland was at that time associated with musicality and folklore (Dłuska, *Odmiany* 245–46, 254, and *Próba* 220); the dactyl (Xxx) has the same rhythmic pattern as the Polish national dance the polonaise. The dancing is a key dramaturgical feature of Andrzej Wajda's 1973 movie adaptation of the play and, more recently, of Jan Klata's 2017 production at the Stary Theatre in Kraków. However, whereas in Wajda's movie the dancing enhances the representation of the wedding, in Klata's it moves beyond it. Klata's actors often move and speak robotically as if enslaved by Polish tradition. What I am trying to highlight is that verse structure, through what Attridge would describe as the verse rhythm's function of mimetic suggestiveness (or of mimetic effects) – the rhythm of verse can represent qualities of objects, events, people, and so on (13–16) – also supports the artists in expressing their critical and political position towards the play. And it is important as the heteroglossia of verse and its dramaturgical operation achieve their full potential when verse structure goes beyond representing the world of the play and communicates the production's or text's attitude towards an element of the play, challenging monologic perceptions and facilitating, to paraphrase Marinetti (4), the juxtaposition of contrasting and conflicted ideas.

A different example of that comes from Pedro de la Barca's *La vida es sueño*, an important meta-play concerned at a foundational level with self-reflexivity and the mechanisms of theatrical process that can be read as theatrical manifesto, as argued elsewhere (Lech, "Metatheatre" 175). The key to that manifesto is a verse structure that reveals the play's engagement with different models of actorship and spectatorship, mechanisms of meaning generation, and changes within relationships between the actors, spectators, and spaces. Central here is the character of Estrella, who is also the least scholarly discussed character in the play, and who conveys models

of active spectatorship and self-reflective performer. She is "the character who, in the context of metatheatre, is closer to Segismundo than any other character in the play" (Lech, "Metatheatre" 175).

Jarosław Marek Rymkiewicz, author of the most frequently staged Polish translation of Calderón's play, *Życie jest snem*, used verse structure to explore Estrella's metatheatrical potential further. In his version, verse structure becomes a comment on the relationship between Estrella and the roles she performs as an actor. Rymkiewicz translates Estrella's lines into notably accentual-syllabic verse. It is not the exact regular metre associated with this form, with a constant number of syllables. Estrella's line lengths vary. However, 94 of Estrella's 151 lines are accentual-syllabic-like, mostly iambic and trochaic. When read out loud, they sound more intense than the lines of the other characters. The verse lines in *Życie jest snem* vary from one to 18 syllables, but most oscillate between four and nine syllables, with typically two or three stresses per line. In Estrella's lines, a stress falls on every second syllable, which means there may be up to two or three stresses in five- and six-syllable lines and even four stresses in seven-syllable lines (Calderón, *Życie*). This causes the rhythm of her speech to be perceived as more patternized compared with the rhythm of the rest of the play's characters, whose lines often have three stresses only in lines of at least eight syllables long.

The departure of rhythm from a rhythmical norm established in Rymkiewicz's version highlights Estrella's importance; Attridge would refer to it as the rhythm's function of emphasis and the function of articulation (16). Estrella's accentual-syllabic lines expose her even though she *only* has 151 lines in the whole play – fewer than King Basilio speaks in his first monologue. There are also more accentual-syllabic lines when she talks either to Astolfo or about Astolfo, for whom she performs two roles: lover and throne competitor (Lech, "Metatheatre" 179). Her speech is also rhythmically intense, when she describes, exclusively in accentual-syllabic lines, the effects of the revolutionary bloodbath, admits she is afraid of it, and, despite all this, takes on the part of a soldier (Calderón, *Życie* 130–31). This suggests a certain emotional intensity in these scenes that imply Estrella's struggle as an actor with certain roles she must play. This is in the context of the metatheatricality of the play and the character, and Rymkiewicz's larger concern with the world as a theatre on the stage of which the human actor, even if struggling, cannot rid himself of his role (Woźniak-Łabieniec 64–65). In the performance context the presence of an actual actor opens up even further dramaturgical layers. For example Waldemar Zawodziński, in his 2006 production (Teatr Nowy, Poznań), staged the process of Estrella stripping herself of any form of identity (Lech, "Metatheatre" 182–86).

Another case in a point is Caryl Churchill's *Cloud 9*. The two acts of the play take place in two different eras. The first act, set in Victorian times, begins with the speech of all characters being written in doggerel-rhymed verse. These lines, which, according to the stage directions, are supposed to be sung by the actors, introduce the personae, the relationships between them, and the dramatic space of the action (colonial Africa) (Churchill 1–2). The doggerel rhymes and associated verse structure feel imposed on the text; they seem to restrain the lines and thus the personae, whose speeches they represent, which integrates with the association of Victorian times with a society which promotes self-restraint. As the verse form seems superior to the sense, verse structure not only helps describe the dramatic time and space under representation as full of restriction but also communicates the critical position of the play towards this period. This also shows verse structure's ability to establish temporal frames. The next section provides more evidence of how verse structure generates time and space and, in doing so, facilitates dialogically interrelated temporal and spatial frames.

Verse structure and generating time and space

For Harvey Gross, metre creates an illusion of time; one has the impression that every foot is the same length, which is not true, but the "metrical organization seemingly eliminates temporal discrepancies" (40). Gross compares metre to perspective in painting. If one measures with a ruler first the distance between Mona Lisa's nose and one of the rocks among which she sits, and then that between Mona Lisa's nose and the ends of her fingers, one discovers that the rocks are not farther from her nose than are her fingers, even if it seems that the rocks are two or three hundred yards distant; this is because perspective creates illusionary space; in the same way, metre creates illusionary time. Metre also exists in literal time, as it takes time to read a poem, but Gross argues that this "is irrelevant just as measurable dimensions of a painting in perspective are irrelevant" (40–41).

However, against Gross's claim, in the theatre the literal (physical) time of verse is as important as the fictional one, and this dialogical nature of verse's temporal frameworks has dramaturgical consequences, which can be demonstrated through Jerzy Limon's discussion of Faust's monologue as he awaits death in Christopher Marlowe's play (19.123–71). Twenty-four years ago, Faust sold his soul to the devil in an exchange for power which he – despite his plans – used for pleasure. Now he has one last hour left before he is "damn'd perpetually" (19.124). In that hour, Faust prays for salvation and for time to slow down (19.126). Limon uses this example to argue that two streams of time pass in the theatre: the time of the fictional world of the play (the fictional time) is different and is measured differently

than time in the actual world (the audience time). Sometimes these streams of time move together, sometimes they are separated. The existence of these two presences is the prime factor that enables the creation of the art of theatre – performance (Limon, *Piąty* 6). One can notice that, similarly to verse, theatrical performance also exists in both literal and fictional time.

However, verse in Faust's monologue facilitates also a third temporal structure connected to Limon's point that the representation of fictional time is changeable in relation to audience time: sometimes it passes more slowly, sometimes more quickly (*Piąty* 28–30), and to Henri Bergson's concept of "duration". David Wiles reads the latter in relation to theatre experience as "the awareness of time in its passing, a heightened consciousness of being alive" (*Theatre* 41). The "duration" is connected to change (Bergson 61). This is the time Beckett theatricalizes in his plays, creating acts of waiting for change that are "an aim in itself", in which time is simultaneously valueless and something one constantly hangs on to (Shalghin 112–15).

In Marlowe's play, Faust awaits his death. The monologue begins with "Now hast thou but one bare hour to live"; it finishes with the clock "striking twelve" – the hour is gone (Marlowe 19.123–71). This hour is 47 lines long; however, as pointed out by Limon, the first half-hour is longer (30 lines) than the second half-hour (17 lines). The passage of fictional time is marked by the clock "striking the half-hour" and by Faust's line "O, half the hour is past!" (19.154) For Limon this is a sign that the time of the condemned Faust is speeding up (*Piąty* 29–30), despite his prayers. However, Limon does not elucidate the further important point. In this monologue, the metre remains regular. It thus creates an illusion of time, as explained by Gross, generating a different time frame to that created by the lexical level of verse. It is a sign that although Faust perceives the fictional time of the play as speeding up, it remains constant.

Such dialogical temporal frameworks – here established by the lexical level of Faust's speech and its verse structure – are a dramaturgical scheme typical of Elizabethan drama and described as "double time". On the one hand, the time of the play is described as "short" because of the short duration of the action; on the other hand, the events are contextualized through references implying a much longer duration (Stříbrný 79). In turn, a spectator – who need not be aware of the contradictory structures – can be "carried away by the speed of the action and, simultaneously, moved by the inner and outer conflicts and tensions of the characters, by their complicated and complex fates", explains Zdeněk Stříbrný (79). In Marlowe's play, the apparent opposition between the physical and illusionary time of verse creates a second fictional time in the world of the play: Faust's time. This is time as psychologically "perceived" by Faust, and it speeds up. The verse structure not only generates time here but also – through the juxtaposition

of the psychological time of Faust with the fictional time of the world of the play, highlighted by the physical and illusionary time of the verse – informs about Faust's inner state. To paraphrase Wiles's point about "duration" (*Theatre* 41), verse emphasizes Faust's "awareness of time in its passing" and his "heightened consciousness" of having little "being alive" left while having the eternality of "being damned" ahead. This, in turn, enhances the affective power of the "double time" scheme by connecting it to the essential questions of human existence, which explains the multiple philosophical and religious lenses through which Marlowe's ending has been read.

In Western tradition, verse often connotes a dramatic world of tragic heroes, knights, or princesses (Aston and Savona 26); in other words, verse can be a sign of a fictional time as long-time-ago or of a particular social space (e.g. elite). The former arises from the fact that verse structure always relates to a temporal framework as an author has chosen it "within historically determined conventions and contingencies" (Hollander 77) and from Attridge's function of literary associations through which verse structure may relate to other works (15). Through that, verse may suggest a time frame that these works or conventions are associated with. The latter link between verse and elite is perhaps why Henrik Ibsen branded verse as the "language of Gods" (Ibsen 269). And while Chapter 3 of this book shows how contemporary theatre practice challenges such associations and reclaims verse as the language of underrepresented communities, the power of their work and the dramaturgical opportunities they utilize come partly because such associations exist.

W. B. Yeats's *On Baile's Strand* is a case in point. The language of the Fool and the Blind Man is represented by prose, while the language of the mythological heroes Cuchulain and Conchubar is presented through verse (Yeats, *On Baile* 49–72). Therefore, verse rhythm, through its absence or appearance, establishes the temporal and social spaces of the action. A similar situation occurs in *A Midsummer Night's Dream*: the speech of the elite is represented by verse (e.g. Helena and Lysander), while the underlings' language (e.g. Bottom and Snug) is presented through prose. When the Mechanicals perform elite, they begin "speaking" in verse (3.1.1–93). Caryl Churchill's *Cloud 9*, on the other hand, shows how verse rhythm at the beginnings of the play's two acts generates temporal and spatial structures that are in a dialogical relationship with those established by other elements of the play (lexical level, stage direction, etc.). I have already discussed how in the first act, set in Victorian times, doggerel-rhymed verse defines the dramatic space and time of the action and therefore becomes a time- and space-generating component.

The second act of the play, set in London in 1979, begins with a nursery rhyme that represents the speech of Cathy, a four-year-old girl who,

according to Churchill's notes, should be played by a man (47). The rhythm of verse associated with childhood and play supports the presentation of Cathy as a child and highlights the contrast between the persona and the actor, even though the theatre speech overlaps here with the fictional speech, as one may assume that the nursery rhyme that Cathy's speech is written in represents an actual nursery rhyme in terms of the action of the play. This short nursery rhyme is quickly stopped by the prose that represents Cathy's mother's speech (47).

This prose opening contrasts with the verse start of the first act, which parallels the contrast between the two dramatic times and spaces: Victorian times in Africa (a province of the British Empire) and 1979, the time of sexual liberation, in the heart of Great Britain. Prose, less restrained and less formal than verse, suits the later times well. In addition, sexual liberation is suggested by the lexical level of verse as Cathy talks about Jack's "balls on fire" and sticking "bubblegum" up "mother's bum" (47). At the same time, the very presence of verse in the second act creates a link between the two acts, strengthened by the appearance of the same characters (played by different actors), who did not age more than two decades, despite the hundred years that apparently have passed between the two acts. This link suggests that some Victorian attitudes were still present at the time of sexual liberation. The fact that verse appears in the form of a nursery rhyme, a form that flourished during Victorian times, additionally highlights this link. The rhythmical level of Cathy's speech, combined with the lexical level of her speech, works against the expectation of "high culture" verse form, which in turn additionally emphasizes both the change of time, space, and society and, at the same time, the lack thereof in the fictional world of the play.

So far, I have explained how verse structure facilitates the dialogic quality of verse by highlighting the actor's ambiguity on stage, marking tensions between writing and orality within a dramatic text, bringing issues of performance to the fore, and fulfilling the main functions of theatre speech. Dramaturgical consequences arising from these, as the chapter has illustrated, link to both representation of the dramatic world and traditional dramaturgy (Van Kerkhoven) as well as contemporary self-reflective practices. Crucially they relate to the key elements of theatre: an actor, space, and spectator. This underlies the powerful potential of verse in theatre and its particular applicability to engage with meta levels, examples of which I have demonstrated. Further on, any discussion on heteroglossia in theatre inevitably raises questions of multilingualism (see Carlson, Marinetti). Verse, through its enhanced dialogical quality, can perform interactions between different languages and offers opportunities to transcend individual

linguistic contexts and systems which are key qualities of translingual communication (Canagarajah 6).

The possibility has been used and developed by some of the Irish poets who attempted to reproduce Irish metrical systems in English. A popular manner of doing so was to apply an unrhymed accentual rhythm (characteristic of a certain period in Irish verse) instead of the usually rhymed accentual-syllabic rhythm typical of eighteenth-century English poetry (Carpenter 14). Initially, this practice became evident in the translations of Irish songs either less consciously, as in the case of Thomas Moore (Colum 6), or very consciously, as in the case of Edward Walsh's *Irish Popular Songs* (MacCarthy 54–55). Austin Clarke significantly enriched this tradition, one that poet Thomas MacDonagh advocated as a truly Anglo-Irish mode of verse (Garratt 110). Seamus Heaney, in *The Burial at Thebes*, builds on this tradition, as I discuss in Chapter 2.

Heteroglossia of verse can also challenge anxieties of intelligibility, which are a significant obstacle in experiencing multilingual theatre (Karpinski 162, 165). They arise from a monolinguistic need to understand every word rather than experience languages more holistically as multilinguals tend to do (Kucer 170). Peter Brook, discussing his production of *Orghast*, by Ted Hughes – a play in verse structuring an invented language, Orghast – suggested that the musical effect of verse can lull spectators' need to understand words when encountering a foreign language (Leeming 197–98). My choice of "lull" here is not coincidental. I am paraphrasing W. B. Yeats's famous words about the hypnotic effect of verse rhythm, as Hughes's *Orghast* echoes Yeats's attempts to create "new dramatic sound" through verse (Leeming 198). A more contemporary application of this idea is *YEMAYA – Królowa Mórz* (*YEMAYA – the Queen of the Seas*), written by Małgorzata Sikorska-Miszczuk and directed in 2016 by Martyna Majewska for the Wrocław Puppet Theatre.

Yemaya tells the story of a five-year-old boy, Omar, who lives with his father. One day, Omar wakes up to find his city taken by war. Omar and his father must escape on a boat. The play was written in response to the death of Alan Kurdî, a three-year-old Syrian boy who drowned in the Mediterranean Sea in September 2015 and whose image was imprinted on the global conscience. Verse appears only once in this production, but it is crucial in carrying the play's strategies to facilitate cross-national and cross-species empathy as an emotional connection and recognition of one another's responses and readiness to "constant and open-ended engagement" (Cummings 4–6). Hugo, the Dinosaur Molecule (Sławomir Przepiórka), delivers the following lines as his introduction:

Bo mnie tu nie ma już bardzo *długo* a	Because I haven't been here for a *long-time* a
Jestem *Hugo*, a	I am *Hugo*, a
Śpiewające molekuły	The singing molecules
Ułożyły się z powrotem	Felt again into
W kształt *ponury* b	The *gloomy* shape of b
Mej *postury* . . . b	My *posture* . . . b
Wypijaj herbatę z całej siły	Drink the tea as hard as you can,
A poczujesz moje *moce*, c	And you'll feel my *powers*, c
Prehistoryczne *noce* c	Prehistoric *nights* c
Przyśnią ci się już *niedługo* a	Will appear in your dreams *soon* a
Jestem *Hugo*. . . . a	I am *Hugo* . . . a
Spijaj herbatę w wielkim *skupieniu* d	Drink the tea with great *concentration* d
A nauczysz się grać na *grzebieniu* . . . d	And you'll learn to play on a *comb* . . . d
(Sikorska-Miszczuk)	

The text prioritizes rhyming structure (marked by italics and letters at the end of respective lines) over the actual sense of the words. In addition, Przepiórka delivers it as if rapping, using the heightened rhythm and rhyme to introduce a new linguistic form and aesthetics that require that the audience listen to the sound and rhythm rather than being concerned with the sense of the words. After his verse-entrance, Przepiórka begins communicating in a made-up language in which he teaches spectators to pronounce Omar's name. In other words, through double-foreignization, he makes Omar's "foreignness" familiar, but it is the initial appearance of verse that prepares the spectators for it. It also challenges the idea of language as unique to humans, which links with Yemaya (Marta Kwiek) often communicating through vocalizations that remind one of a dolphin's language.

This final example, which comes from an actual production, provides a transition for the rest of this book. The dramaturgical potential of verse outlined here frames the subsequent chapters, which focus on specific examples of verse dramaturgy in performance in relation to theatre translation and adaptation, political theatre, and works that explore the formal boundaries of verse, drama, and theatre. They reveal verse as a dramaturgical platform for challenging monolinguistic contexts, complicating the relationship between native and foreign, confronting dominant socio-political contexts, performing marginalized individuals and communities, exploring transnational and translocal contexts, and stretching existing boundaries of theatre and of verse.

Notes

1 One must differentiate between verse and poetry. Bakhtin questioned whether poetry can achieve heteroglossia ("Discourse" 285–98, 324–31), which some scholars have challenged (e.g. Pechey 76). I follow T.V.F. Brogan's compromise between formalist and essentialist views on verse, prose, and poetry that underlies his differentiation between verse and poetry. Brogan explains that both verse and prose are modes, while poetry "like drama and fiction, is, for lack of a better word, a genre" ("Verse and Prose" 1346–47).

2 Austin states that an illocutionary act is the "performance of an act in saying something as opposed to performance of an act of saying something" (99–100). This is why the earlier-made premise that the actor performs theatre speech not only to represent the act of the persona speaking (thinking, feeling, and so on), but also to provide the audience with information, is a premise crucial for discussing theatre speech as a speech act.

2 Verse in translation and adaptation

This chapter explores the dramaturgical operation of verse in theatre translation and adaptation, following Joanna Paul's point that translation and adaptation, although not synonymous, "form a critically productive partnership", and that framing one as the other allows us to "illuminate complexities of each" (163). In a performative sense, both translation and adaptation are "cultural (re)creations of meanings" (Bigliazzi et al. 2). In line with that, translation is understood here as both a process and an end product that is not only linguistic but also historical and cultural. As such, it implies the transferral of meaning between different temporal realms, between diversified geopolitical spaces and between spaces of various interpersonal and inter-communal relations. This chapter shows how verse, because of its heteroglossic qualities, is particularly suited to these inter-contextual and multi-contextual processes. Verse supports the process of translation by providing a dramaturgical bridge – Duška Radosavljević uses "bridge-building" as a metaphor for dramaturgical practice (41) – between source and translation; it re-energizes theatre conventions and facilitates the interconnectedness of multiple contexts, broadening the spaces of cultural representation and encounter.

This chapter builds its arguments through performance and text analyses of American, Irish, Polish, and Spanish-British contemporary stagings of classical plays. The first section looks at Seamus Heaney's *The Burial at Thebes: Sophocles' Antigone* and its two separate productions: the inaugural 2004 version at the Abbey Theatre (Ireland), directed by Lorraine Pintal, and the 2011 production directed by Marcela Lorca for the Guthrie Theater in Minneapolis (USA). Thereafter, the focus is on the Polish Radosław Rychcik's bilingual stagings of two Polish classics: the 2014 *Dziady (Forefathers' Eve)*, by Adam Mickiewicz, at the Nowy Theatre in Poznań, and the 2016 production of Stanisław Wyspiański's *Wesele (The Wedding)*, at the Śląski Theatre in Katowice. Finally, the works of the transnational company Teatro Inverso illuminate how verse works in the process of their bilingual

and devised translation-adaptation *Rosaura* from Pedro Calderón de la Barca's *La vida es sueño* (*Life Is a Dream*).

Each text or its source earned the status of theatrical monolith and has been translated and staged numerous times. The works discussed in this chapter rediscover their contemporary potential, vitally aided as they are by verse structure.

Heaney's *The Burial* is the closest to Roman Jakobson's "translation proper", and so to traditional interlingual translations, as "an interpretation of verbal signs by means of some other language" (139). However, the interlingual context is not that between Greek and English but between Irish and English and is brought about by verse. The Greek source was mediated by three pre-existing translations that Heaney used in his process.[1] Therefore, *The Burial* represents a celebrity translation, whereby a well-known artist – commissioned to create a new translation of a canonical work – becomes its new (co-)author (Stock). In this sense, Heaney's text and its stagings are created in the traditional; "paradigm of theatre as 'art in two steps'": from playwright to director (Danan 5–6). Verse allows Heaney to also act as a dramaturg and to write his ideas into the text without disturbing the tragedy of *Antigone*. Moreover, it supports transferrals between the play's and the stagings' different contexts by creating points of tangency between them, which removes the need of problematic searches for cultural equivalents.

The works of Rychcik and Teatro Inverso are bilingual and invite reflection on the relationship between translation and adaptation, challenging dichotomies between the two terms, as well as Jakobson's idea of "translation proper". They use verse as a performative tool to engage with and reflect on interlingual processes as a socio-political force and as a platform for dramaturgies of foreignness, which links this chapter with the next, on verse as a platform for marginalized voices. In Rychcik's productions, verse is a self-conscious tool that facilitates and interrogates foreignizing translation and how it "deterritorializes" the native and the foreign and the borders between them, echoing Lawrence Venuti's arguments on the political potential of foreignizing translation (*Invisibility* 12–19; *Scandals* 11, 79) as well as the ideas behind contemporary "ecological dramaturgies" (Eckersall et al. 20–21). Rychcik's approach is that of a "total creator" combining the roles of dramaturg and director. His work also exemplifies how verse challenges such a position of power and facilitates a more democratic creation. Sandra Arpa and Paula Rodríguez, from Teatro Inverso, work in a collaborative, actor-led, and transnational context, taking creative ownership of the work they perform. Their work – always open-ended and adapted for different audiences – builds on the heteroglossia of verse to engage with translation as "a cultural condition underlying communication" (Gentzler 7) that approaches cultures with "reciprocal hospitality",

thus "welcoming them as their hosts" and, at the same time, "becoming their guests" (Laera, *Theatre* 55).

Seamus Heaney's *The Burial at Thebes: Sophocles' Antigone:* translating conflict into a lament

The dominant in Western thought, Hegelian tradition of *Antigone*'s interpretation has focused on the conflict between Antigone and Creon as the "tragic core" of the play (Lehmann, *Tragedy* 177) or, as Heaney put it, as "an accumulation of issues" that feels "more like a pretext for debate" than a theatrical piece ("The Jayne Lecture" 414–15). Antigone and Creon stand up for *polis* in the two different respective contexts: social – centred around the household (*oikia* or *oikos*) – and political – standing on public roles (Hansen 80, 324). In *The Burial*, Heaney is both translator and dramaturg. He uses verse to re-energize Greek theatre conventions but also to offer an alternative to *Antigone*'s central conflict, bringing it closer to Hans-Thies Lehmann's reading of the play as "an allegory of tragedy" that interrogates the core structures that organize societies. Like Heaney, Lehmann stresses that the focus on the conflict distorts *Antigone*'s meanings (*Tragedy* 177–78, 182, 188). Verse in *The Burial* creates a score for reading Antigone's myth from the angle of omnipresent suffering and communal lamentation, echoing Heaney's repeated insistence on "the right of poetry/poetic drama to be something other than protest" and a force that encourages a consciousness- and conscience-led change ("Crediting Poetry" 98; "*The Cure at Troy*: Production Notes" 173). In doing so, Heaney also pays a tribute to W. B. Yeats as the co-founder of the Abbey Theatre, for which the centenary *Burial* was commissioned. In his 1910 essay, Yeats called for tragedy "to exclude or lessen" the importance of the character and instead to "summon rhythm, balance, pattern, images that remind us of vast passions, the vagueness of past times, all the chimeras that haunt the edge of trance" ("The Tragic" 243–44).

The Burial is also an example of why verse and theatre conventions are an inseparable issue in translating a Greek tragedy – against claims that verse structure is not important when translating Greek tragedy (Walton 111–13) – adding layers to Lorna Hardwick's suggestions that translation of Greek tragedy requires "translation of poetry and performance" ("Murmurs" 210). Heaney uses verse to relate *The Burial* to its Greek source, to the tradition created by this source within Western and Irish theatre, and to offer "a conditioned response" (Heaney, "The Jayne Lecture" 419) to *The Burial*'s multiple contexts. The latter also include the National Theatre of Ireland's centenary, and Heaney's own status as a Nobel Laureate, whose works always have had some political dimension; as he himself describes:

"being born in Northern Ireland, growing up called Seamus, everything I did was political in a way, in terms of representativeness" (Heaney qtd in Murphy 5). Verse facilitates Heaney's engagement with *The Burial*'s expansive outer frame without the play becoming "an accumulation of issues" (Heaney, "The Jayne Lecture" 414–15). Instead, verse marks points of tangency between multiple contexts, and, to illustrate this further, the upcoming text analysis is enriched by examples from Pintal's 2004 world premiere in the Abbey and Lorca's 2011 American production.

From the start, Heaney uses verse to expand the play's physical and temporal frames (without breaking the unity of time and space) and to present Thebes as a metaphorical accumulation of multiple pasts and histories and spaces of conflict and deaths, expanding Lehmann's idea that in tragedy "the dead remain with us" (177). The opening scene between Ismene and Antigone (1–7) is in three-stressed short lines (5–7 syllables in general):

Ismene, **quick**, come **here**!	xXx\| X\| x X
What's to become of **us**?	X\| x xX\| x X
Why are we **al**ways the **ones**? (1)	X x x\| Xx\| x X

The immediately following Chorus's song (*The Burial* 8) is presented by four-beat long lines (8):

Glory\| to be **brightness**, \| to the **gleaming**\| **sun**	Xx\| x x Xx\| x x Xx\| X
Shining\| **guardian**\| of our **seven**\| **gates**	Xx\| Xx\| x xx Xx\| X
Burn **away**\| the **darkness**, \| **dawn**\| on **Thebes**,	x xX\| x Xx\| X\| x X
Dazzle\| the **city**\| you have **saved**\| from de**struction**.	Xx\| x Xx\| x x X\| x xXx

According to Heaney's stage directions (and the Greek convention of the unity of place), the physical dramatic space does not change (8). However, the change of rhythm brought about by the appearance of the Chorus as the communal figure suggests that the space has changed. This dissonance manifests the main conflict in the play and its consequences, and it represents the polarized meanings of *polis* that underlie the Antigone-Creon conflict. But there is more to that. As highlighted repeatedly by the playwright and by different stagings' publicity materials,[2] the three-beat accentual was Heaney's "tuning fork" and the answer to how to address the play's extensive contexts. Heaney chose particular verse forms to refer to Irish heritage

(Heaney, "'Me'" 171–72). The three-beat accentual was taken from the opening lines of a famous Irish poem, *Caoineadh Airt Uí Laoghaire* (*The Lament for Art O'Leary*); the Chorus uses four-beat structures in long lines inspired by Anglo-Saxon poetry. The Anglo-Saxons are the English whom the Irish Christianized. This mixture of pagan and Christian cultural traces is also engraved in Irish history more generally, with Christian monks working to preserve Celtic myths (Brexina 51). And the iambic pentameter that Creon "speaks" for most of the play for Heaney has a strong imperialist association (see Chapter 1), which fits this context well.

Heaney justifies his choice of iambic pentameter for Creon by saying that it is a conventional rhythm and "the obvious medium to honour the patriots in life and death" ("'Me'" 173; "A Note"). Considering that Heaney himself marks Creon's arguments against Antigone as similar to those used by the administration of former US President George W. Bush "to forward its argument for war in Iraq" ("A Note"), and taking into account that the Republicans' traditions emphasize commemoration, there is a touch of sarcasm in this sentence. This connection between Creon and Bush highlights certain imperialistic qualities of the former, and the iambic pentameter encourages such a reading given its association with imperialistic, colonizing enterprises in Heaney's 1975 poem "Ocean's Love to Ireland", where he writes about "Iambic drums/Of English" beating the Irish woods (41; also see Lech "Roughening"). In short, the different verse rhythms connote Irish history but do not negate the play's connections to Greek, English, and broader European contexts.

Caoineadh Airt Uí Laoghaire is "spoken" by Ní Chonaill/O'Connell:[3] her husband (Uí Laoghaire/O'Leary) has been killed by a British official, Morris, and, says Heaney, "left bleeding on the roadside in Co. Cork, in much the same way as Polyneices was left outside the walls of Thebes" ("'Me'" 171–72). Heaney's choice to use three-beat rhythm and the similarities of the female protagonists' situations brings about the ingrained in the *Caoineadh* tension between its obvious "anti-colonial sentiments" (Wilmer, "Finding" 230–31) and how the poem exemplifies the complexity of Irish–English relations, wherein the tragedy of human lives turns any sustained dichotomy between victim and oppressor into an oversimplification.[4]

The presence of conflict and the Irish context are enhanced by the lack of rhymes in the opening (and majority of the play) playing with associations between *The Burial* and arguably the most famous of Heaney's lines (italicized section as in the play):

History says, *Don't hope*
On this side of the grave.
But then, once in a lifetime

The longed-for tidal wave
Of justice can rise up,
And hope and history rhyme.

(Heaney, *The Cure* 77)

The quote comes from the Chorus at the end of *The Cure at Troy* (from Sophocles's *Philoctetes*) presented by the Field Day Theatre Company in 1990 and is strongly contextualized within the discourse of Northern Ireland. In *The Cure*, the rhyme (between history and hope) is tagged with peace and compromise. At the time of the 1998 Good Friday Agreement, this line became, says Hardwick, "almost a cultural cliché" (*Translating Words* 94), with several politicians quoting it, including then-US President Bill Clinton, when he came to Northern Ireland to support the peace process. In *The Burial*, unrhymed verse may be immediately read as a comment on the time and space of the action: a time and space where hope and history cannot rhyme because compromise is not reached and seems impossible.

This description suits the Thebes of Creon and Antigone, and the lack of rhymes reinforces the references to the war present at the lexical level of the text and the specific context of post-Good Friday Northern Ireland.[5] The political situation in 2004 also brings to bear the context of the 2003–11 military conflict between the USA (and its allies) and Iraq. In fact, "rhymeless" post-war Thebes could be read, arguably, in the context of any military conflict. Heaney's rhymeless and rhythmically diverse verse expands the temporal frame of *The Burial*, playing with how the unity of time – following Anne Ubersfeld's arguments – imposes the necessity to bring the past to the events in the play (e.g. through choruses' songs) and thus theatricalizes past and history by taking it out of the real-world context and moving it to the performance. Consequently, history is also presented not as a process but as something that cannot be changed and yet which changes the present (Ubersfeld 128–30). The key is that the heteroglossia of verse allows Heaney to reference and theatricalize not one, but multiple pasts and histories of conflicts, opening the play to be read in multiple contexts.

In both Pintal's and Lorca's productions, this broad cultural and temporal space is further expanded by the diachronic representation of the dramatic space through multicultural and multi-temporal elements of the scenic space. The 2004 world premiere (Pintal) from the beginning works to describe the dramatic space as multicultural and as full of time. Ruth Negga (Antigone) is an actor with a Caucasian-Ethiopian background; Kelly Campbell (Ismene) is Caucasian. The set designer, Carl Fillion, covers the stage of the Abbey in sand, so it evokes images of deserts, and

incorporates elements of Greek amphitheatre into Creon's palace. The costumes, designed by Joan O'Clery, could be linked to Greek antiquity, the Middle East, and Latin America (as observed by Wilmer, "Finding" 239). The performance opens with the sound of a female voice singing stretched vowels that can be associated with both the Greek ancient tradition and a Middle East culture. Negga is sitting onstage, playing with sand and shadows (created by Paul Keogan's lighting), as if playing with a sandglass, playing with time.

In Lorca's staging, cross-racial casting is a key strategy. The cast includes actors of Asian American, Caucasian, and Afro-American backgrounds. The publicity highlighted how Elizabeth Caitlin Ward's costumes were rooted in antiquity, both world wars, and contemporary fashion, among other sources (Gross 27). The Chorus's dances incorporate elements from Zorba, Hora, as well as boybands. The Chorus sings and dances to the music in accordance with Heaney's verse structure. Composer J. D. Steele wrote the music listening to the actors speaking Heaney's verse, read this verse, and wrote his music to its rhythm.[6] In both Lorca's and Pintal's productions, the diverse verse rhythms audible in the actors' lines, supported by the staging, highlight the variety of contexts in which the play can be read.

However, the key operation of verse heteroglossia in *The Burial* is how it opens up a space of inclusive communal lamentation as an alternative to *Antigone*'s central conflict between the two exclusive ideas of *polis* and an alternative to the concept of *polis* as a base for community (Lehmann, *Tragedy* 182). Verse, by building on Irish and Greek conventions of lament, marking losses suffered on both sides of the conflict, and allowing each lament in the play to echo the others, facilitates a community of sufferers with existing political, philosophical, or cultural conflicts as the context for that suffering.

Sophocles's play featured two laments, so-called *kommos*: a dirge sung by the chorus and the actors (P. Wilson, 184): the last conversation of Antigone and the Chorus (Sophocles, vv. 801–82, 99–102; Griffith 260–65) and the finale of the play – the obligatory "scene of suffering" that evokes pity and fear leading to catharsis (Aristotle 11, 27) – when it is delivered by Creon, the Messenger, and the Chorus (Sophocles, vv. 1261–1346, 115–18; Griffith 341–54). Heaney's choice of the three-beat rhythm brings about another lamenting tradition: Irish keening (*caoineadh*). This rich tradition, as Angela Bourke clarifies, was connected to the lamenting of women that facilitated the grief of a whole community by allowing audiences to experience and express emotions. The Irish laments sometimes took the form of oral poetry and often included a dialogue between two women – both praising and criticizing the dead and even insulting each other, says

Bourke ("The Irish" 287–89). This description fits well the opening scene between Antigone and Ismene, marking a connection between *caoineadh* and catharsis.

The Burial opens with the rhythm of lamentation that unites a society, as the expression of communal grief suggests that lamentation is an alternative to the conflict present on the lexical level and through the lack of rhymes. This healing potential of lament is further suggested by the assonantal patterning present in Antigone's opening speech that is a recognition of the presence of this striking feature in the Irish text of *Caoineadh* (italicized in these two quotations, and additionally in bold in the Irish text) and a signal that the potential for rhyme between hope and history is connected to lamentation:[7]

Irish source	O'Connor's translation	*The Burial'* s opening lines
Mo ghr*á* go d*ai*ngean th*ú!*	My **love** and **my** de**light**,	Ismene, **quick,** co**me here!**
L*á* da bhf*aca* th*ú*	The **day** I **saw** you **first**	**What's** to beco**me** of us?
Ag ceann tí an mh*argai*dh,	Be**side** the **mar**ket**house**	**Why** are we **al**ways the **ones?**
Thug mo sh*úi*l *aire* dhuit,	I had **eyes** for **no**thing **else**	There's *no*thing, sister, *no*thing
Thug mo chroí t*ait*neamh duit,	And **love** for **none** but **you.**	Zeus **hasn't put** us **through**
D'éalaíos óm ch*ara*id le*a*t	I **left** my **father's house**	Just be**cause** we **are** who we **are** –
I bhf*ad* ó bh*ai*le le*a*t. (Ní Chonaill, *Caoineadh* 65)	And **ran away** with **you,** And **that** was **no** bad **choice** . . . (Ní Chonaill, "The Lament" 76)	The **daugh**ters of **Oe**dipus. (*The Burial* 1)

Heaney also uses the link between the three-beat rhythm and lamentation to increase the number of laments in the play. Because of this repetition, preceding knowledge of *Caoineadh* is not imperative, and the verse structure facilitates lamentation within and outside the Irish context.

The three-beat accentual is used by the Chorus, while lamenting on Ismene's misfortunes (24): "Ismene, **look,** in **tears!** / For her **sister. For herself**" (xXx| X| x X/ x x Xx | X| xX) and in the Chorus's song about love that follows Creon's and Haemon's fight. This is a dramaturgical reminder of the love that Haemon has for Antigone, important, as they never appear together. However, it can also be read as a lament since it follows the pattern of the three-beat line, already associated with that genre.

Love \|that **can't** be\| with**stood**,	X\| x X x \| xX
Love\| that **scatters**\| **fortunes**,	X\| x X x \| Xx
Love\| like a **green** fern\| **shading**	X\| x x X x\| Xx
The **cheek**\| of a **sleeping**\| **girl**. (36)	x X\| x x Xx\| X

On the lexical level, the Chorus is celebrating the power of love and passion. However, the rhythmic level puts it into the context of loss. This tension – brought about by the heteroglossia of verse – marks love as one of the qualities lost in the conflict and provides the context for Haemon's suicide. J. D. Steele in Lorca's production reinforced Heaney's verse by transferring it into a soulful, sensual, and contemporary ballad.

The three-beat lines appear also in the Chorus's prayer to Dionysus, after Creon changes his mind and decides to free Antigone:

Call **up**\| the **god**\| of **Thebes**,	x X\| x X\| x X
Son\| of **thun**dering\| **Zeus**,	X\| x Xxx\| X
Fleet **foot**\| and **open**\| **hand**. (48)	x X\| x Xx\| X

While the Chorus prays, the verse structure pre-laments the deaths of Antigone and Haemon, which are happening at the same time.

The *kommos* between Antigone and the Chorus also features three-beat lines (37–39):

CHORUS
(. . .)

Antigone, **you** are a **bride**,	xXxx\| X x\| x x X
Being **given away** to **death**.	x Xx\| xX\| x X

ANTIGONE

Given away to **death**!	Xx\| xX\| xX
Re**member this**, **citizens**.	xXx\| X\| Xxx
I am **linked** on **Ha**des' **arm**,	Xx\| X\| x Xx x
Taking my **last look**,	Xx\| x X\| X
My **last** walk **in** the **light**.	x X x X x X

Here, the verse structure creates a dissonance between Antigone's lamenting rhythm and her heroic words, a reminder that Antigone is a young woman believing in what she is dying for but still not wanting to die. The

last quoted line takes on an iambic pattern pre-echoing Antigone's final speech, which Heaney wrote in lines oscillating around iambic pentameter, and thus the rhythm introduced in the play by Creon. The lamenting rhythm that precedes "her final heroic utterances" (Heaney, "The Jayne Lecture" 426) highlights Antigone's humanity and supports the cathartic potential of *The Burial*. Per Andrea Nightingale's reading of Aristotelian theory, for catharsis to happen the audience needs to be both distanced from and emotionally engaged with the story and its personae who are presented as "good" (as Nightingale puts it: "no one feels sorry for an evil man if he comes to harm") but not perfect, as their human-like flaws make it easier for the audience to identify with them. This is important for the second emotion on which tragedy builds: fear. The spectator identifies with the persona and fears that similar misfortune might befall themselves (Nightingale 44–45).

The three-beat accentual also appears in the final *kommos* of Creon (52–56), in which he acknowledges his own misdoings as a father and a king:

Wr*o*ng-\|headed\| *on* the **thr*o*ne**,	X\| Xx\| x x X
Wr*o*ng-\|headed\| in the **h*o*me**,	X\| Xx\| x x X
Wr*o*ng-\|footed \|by the **heavens**.	X\| Xx\| x x Xx
And **you**,\| dear *son*, \| **dead** *son*,	x X\| x X\| X x
I was **wr*o*ng**\| to **harry**\| **you**. (53)	x x X\| x Xx\| X

Bourke explains that laments in the Irish tradition "were remembered and sung at subsequent funerals" and that one *caoineadh* "echoes another" in its traditional themes ("The Irish" 290). Verse structure highlights that Creon's lament echoes the previous ones in *The Burial* and is a reminder that suffering has happened on both sides of the play's conflict.[8] As Creon's final appearance in the play is marked by the rhythm in which Antigone opened the play – mirrored by Antigone's final speech being written in "Creon's" iambic – neither character nor side yields final moral authority to the other. In doing all that, verse allows Creon's lamenting to both echo and acknowledge the validity of other laments, uniting them as resulting from the same conflict in which he played a part. His lament becomes a communal lamenting of all who suffered, including those whose right to lament were not initially acknowledged, as in the case of Antigone. Lorca strengthens these association by adding cultural references closer to American audiences. Her production opens with a military burial that includes the ceremonial folding of the flag, which evokes American military funeral honours. The burial ends with the beating of drums, which is organized, similarly to Heaney's verse structure in the opening of the play, into a series

of three-beat units: boom, boom, boom, and a pause, and so on. The drums return during Antigone-Chorus and Creon's laments, linking the rhythms and contexts together.

In the text, Creon's lamenting is additionally highlighted by Heaney through the assonantal patterning in the words "wrong", "on", "throne", "home", and "son", emphasized by a close rhyme between "home" and "throne" (all are italicized in the earlier quoted fragment). This appearance of an assonantal pattern and of notable rhyme at the end of two consecutive lines may be read as a sign that a communal lament which unites the two sides of conflicts and allows the mutual recognition of each other's sufferings of pain caused and of pain endured is a chance for a full rhyme between hope and history, so far denied in this play. This has a very special resonance in the context of Irish history and politics, but also in that of the post-9/11 global world, and in the contemporary world in general. In this sense, verse dramaturgy in *The Burial* reflects and contributes to the politics of reconciliation, particularly in relation to the "mutual acknowledgement of the moral reality of the other" (de la Rey 257).

The heteroglossic quality of verse also allows Heaney to re-energize the messenger convention, writing it into the larger frame of lamentation, facilitating the dramaturgical consistency of *The Burial*. The poet plays with the Irish tradition of "mocking laments". Bourke explains that mocking laments existed outside the proper *caoineadh* tradition but that their satiric formulas were used in proper *caoineadh* as a form of protest at violence performed by the deceased. They often conveyed the most uncompromising statements of the laments. In doing so, they facilitated anger as fundamental to the grieving process and marked "the point of tension" within the lament (Bourke, "More" 173–74).

The Guard in *The Burial* carries this tension between satire, anger, and protest in relation to the loss of identity and language, which is relevant to the Irish and broader global contexts. At the same time, he performs his conventional roles as a guard (informing Creon about laws being broken) and as a messenger (describing the burials of Polyneices). Heteroglossia of verse enables this complex dramaturgical operation without disturbing the messenger's function as a conventional medium for the "the audience's imagination to visualize and re-animate" what they hear (Rehm 61). Heaney uses verse structure to develop the three moments from Sophocles's play that present the Guard outside his conventional roles. During his first entrance, he talks about his fear of being a messenger-of-bad-news (Sophocles, 81, v. 234; Griffith 177–78). On his exit, he suggests that Creon may feel that he is wrong in his decision about Polyneices (Sophocles, vv. 315–31, 83–84; Griffith 166). During his second appearance, he talks about Antigone as his

friend whom he cares for, but he says that his own life is more important (Sophocles, 87, v. 437–40; Griffith 198).

As in Sophocles's play, in *The Burial* the Guard appears after the short exchange between Creon and the Chorus about the breaking of Creon's law. In Heaney's version, this conversation is conducted in iambic pentameter, but the Guard speaks in colloquial prose: "Sir, I wouldn't exactly say I was panting to get here. . . . Only a looney would walk himself into this" (12). The disappearance of verse and the colloquialisms facilitate the change of theme from a serious conversation about matters of the state to the amusing prattle of the Guard, highlight the Guard, and suggest that he represents different communities than those Antigone and Creon defend. Pintal additionally marks it by putting the Guard (Aidan Kelly) on a stage level and Creon on a platform. The Guard-Kelly makes awkward press-ups while speaking and desperately trying to touch the platform (see Figure 2.1). In Lorca's version, the Guard (Brian Sostek) tries to be as close as possible to Creon-Yoakam, while the latter avoids him.

Heaney's Guard delivers his messenger speech in which he describes the mysterious burial of Polyneices and then he gets involved in a conventional

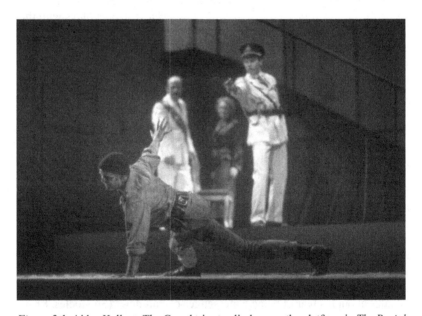

Figure 2.1 Aidan Kelly as The Guard tries to climb up on the platform in *The Burial at Thebes: Sophocles' Antigone* by Seamus Heaney. Directed by Lorraine Pintal. The Abbey Theatre, Dublin, Ireland, 2004.

Credit: Tom Lawlor/The Abbey Theatre. Courtesy of the Abbey Theatre Archive.

stichomythic exchange with Creon (15–16). The Guard tries to persuade Creon to reconsider his decision, while Creon tries to persuade the Guard to recognize his authority. While on the level of vocabulary the argument seems unresolved (Creon does not change his mind, and the Guard leaves the stage swearing to never come back) – some scholars even argue that the Guard in *Antigone* outwits Creon (Griffith 165) – the rhythmical level in *The Burial* acknowledges Creon's superiority; by the finale of this dialogue, the Guard speaks in verse that begins falling into an iambic pattern:

What's happening here, Creon is that the judge	x X xx X Xx Xx x X
Has misjudged everything. (16)	x xX XxX

The moment of "translation" happens near the end of the Creon–Guard exchange; the Guard says: "But I didn't do it" [I did not bury the body] (16). This line is the last prose from the "Guard's mouth". The Guard is distracted trying to defend himself, at the point when his language is changed; he is therefore vulnerable to this change. Both Pintal and Lorca highlight this vulnerability. Pintal stages the encounter as very violent, with Creon's bodyguard physically harming Guard-Kelly, for example by stamping on his hand. Lorca and Yoakam's Creon becomes violent after hearing the news about Polyneices and puts his hands on Guard-Sostek's throat, threatening him. As Brian Sostek explains, the Guard realizes that his life is at stake (Sostek).

The Guard's translation is also presented as a process. The Guard continues to oppose Creon on his first verse line ("What's happening here . . ."); the pattern falls into and falls out of the iambic. These attempts of resistance stretch until the Guard's last lines:

Yours truly won't be back here in a hurry.	x Xx X x X x X x Xx
Me that was done for!	X x x Xx
Ye gods!	xX
Ye gods!	xX
I'm off! (16)	xX

The penultimate line is "spoken" in pure pentameter, but in the final line a trochee and an amphibrach replace the first two iambs. The Guard tries to fight, but the end of the line falls into iambic pentameter. Heaney highlights it in the way he transcribed this final line. However, the Guard's vocabulary remains colloquial; his conversion or colonization (since iambic may function as a rhythm of colonization) is not completed. When he appears for the second time, carrying Antigone, he speaks mostly in pentameter, and

his vocabulary suits the convention of verse rhythm: "**This** is the **one**. We **caught** her **at** it, / **Attending to** the corpse. Where's Creon gone?" (Xx xX xX x X x/xXx X x X x Xx X) (18). He marks the completion of his change by saying "**Circumstances change** and **your** mind **chan**ges" (XxXx X x X x Xx) (18), highlighted paradoxically by the trochaic pattern. He needs to adjust his morals and his language to the new cultural situation. Pintal staged this particularly effectively. In his second scene, the Guard-Kelly walks straight onto the platform, emphasizing his social advance. Verse also marks this advance and the fact that the Guard is "performing". Kelly stands as if at attention, his body subordinated to this military form in the same way that his speech is subordinated to the rhythm of verse. The Guard-Sostek, in contrast to the first scene, keeps a physical distance from Creon-Yoakam. Both Kelly and Sostek evoke laughter in their first appearances but lose the comicality in the second scene.

The Guard in *The Burial* becomes an embodiment of the loss of identity, which can be read in the context of post-colonial nostalgia, the multicultural climate of Celtic Tiger Ireland, and the global world in general, echoing Alistair Pennycook's point that many countries insist on immigrants learning the host language as a "naturalizing" tool and "'immigrants' primary civic responsibility" (82). In this sense, Heaney's Guard embodies Pennycook's other point: "all questions of language control and standardisation have major implications for social relation and the distribution of power" (84). The Guard, by not speaking in prose, loses his distinctiveness, his "native language". On the other hand, however, his status rises. Thus, the loss of native language is presented as a process that cannot be explicitly defined as a loss or a gain, which simultaneously highlights that even those who gain throughout the conflict may be, at the same time, victims of this conflict. In Chapter 4, Caridad Svich's nomadic dramaturgy reveals different aspects of the loss of language. Here, Creon's iambic taking over can also be read outside of the language context in the context of the Iraq War and other conflicts of the global world where "victorious" or global structures are being imposed on native communities.

Heaney commented on his aims while translating *Antigone*: "I wanted to do a translation that actors could speak as plainly or intensely as the occasion demanded, but one that still kept faith with the ritual formality of the original" ("A Note"). The example of the Guard shows how Heaney's verse broadens the actor's possibilities. This adds another layer to my point that verse and theatre conventions are inseparable issues in translating a Greek tragedy. Most importantly, however, Heaney's words relate to how his verse dramaturgy facilitates the development of new receptive strategies for reading the play. By allowing verse structure to perform the lament, *The Burial* offers its audiences the choice to read *Antigone* via this lament,

which mobilizes a different understanding of the tragedy as acknowledging the mutual suffering on two sides of any conflict. The rhythmical variety of Heaney's verse structure also underscores the performance of diversified societies in the global world, which helps link the play to contemporary experience while allowing it to belong somewhere else. In turn, this allows a much broader spectrum of reflection and facilitates multiple levels of engagement with the play. The potential of verse dramaturgy to create simultaneous impressions of otherness and sameness – issues crucial in any translation process – will be echoed – if I may make this pun-tribute to Heaney – in the upcoming parts of this chapter.

Verse in Radosław Rychcik's foreignizing dramaturgies

Verse as a harbinger of political change and a platform for playing with traditions and rituals links Heaney's work with the next case studies: the 2014 staging of Adam Mickiewicz's *Dziady* (*Forefathers' Eve*) at the Nowy Theatre in Poznań and the 2016 production of Stanisław Wyspiański's *Wesele* (*The Wedding*) at the Śląski Theatre in Katowice. Both were directed and dramaturged by Radosław Rychcik. However, here the focus is on tensions between foreign and native that have been the subject of intense debates in translation studies (e.g. Venuti; Cronin; Caplan; Laera) as well at the forefront of current socio-political and cultural discussions, to name only the global refugee crisis as an example.

In *Wesele* and *Dziady*, verse facilitates foreignizing translation – as defined and championed by Venuti – that "resists dominant values in the receiving culture so as to signify the linguistic and cultural difference of the foreign text" and that disrupts the expectations of the source and target cultural and linguistic contexts (Venuti, *Invisibility* 12–19). Verse in Rychcik's productions invites the re-valuation of engagement with the two well-known plays, facilitating connectivity between different contexts and performances of cultural differences. Verse is a force behind the deterritorialization of native and foreign and the borders between them, fuelling key functions and the political potential of foreignizing translation as set by Venuti (*Invisibility* 12–19; *Scandals* 11, 79) and echoing the idea of ecological dramaturgies that act as "a deterritorializing factor in the connections that artistic production makes with social life" (Eckersall et al. 20–21).

Venuti considers a situation in which a foreign source is being translated into the language of the target audience. However, in Rychcik's productions it is the source that is native and familiar to the target audience and is translated into a foreign language and context. *Dziady* and *Wesele* were written when Poland, after losing independence in 1795, was divided between Russia, Prussia, and Austria and when Romantic ideas on the homeland were deeply rooted in

Polish society.[9] They are considered Polish masterpieces; they received numerous stagings and, whether one reads them or not, they are *engraved in one's* memory throughout the period of compulsory education. Both plays engage with ideas of the Polish nation, the fight for national independence, and the role of artist as a spiritual leader of the nation. Rychcik translates *Dziady* into the world of American and British icons, and pop culture figures. His *Wesele*, set in 1970s Belfast (instead of 1900s Poland), attempts to reproduce the soundscape of Northern Hiberno-English in Polish and employs characters from Irish history. Both productions feature the English language and play with linguistic ambiguity, vitally aided as they are by heteroglossic verse.

Rychcik's productions could be discussed in the context of adaptation as he reworks the texts from one culture to another (Barnette 9). However, his activity is best described – to borrow Jane Barnette's term *adapturgy* as "the cultivation of a reflective, textured research milieu within which adapted works for the stage will thrive" (2) – as transadapturgy. Building on Barnette's definition and Rychcik's work, transadapturgy draws attention not only to the complex intercultural, inter-temporal, and interlingual processes facilitated by verse in Rychcik's stagings, but, most importantly, to the tension between foreign and national, my focus here.[10]

Moreover, dramaturgical operations of verse in Rychcik's productions address the arguments that a foreignizing translation from a dominant culture is unlikely to have a foreignizing effect and may even threaten the target culture and language (Myskja 1–2, 20; Cronin 140–41). In *Dziady*, verse empowers the play between familiarity of both the source and target contexts. This mobilizes the process of emotional distancing from the play that, paradoxically, helps rediscover its themes and community-creating potential. In *Wesele*, verse highlights tensions and glitches that arise from unfamiliarity of the translation context, challenging existing traditions, and asking questions about representation. This, in turn, re-energizes the play's interrogatory power and paradoxically rediscovers part of the Polish tradition.

Dariusz Kosiński describes *Dziady* as a bastion of Polish theatre: "I do not know whether there is any other European theatrical culture, which identity is so much defined and marked by a single work" (117). The play was written by Polish national bard Adam Mickiewicz and is an artistic interpretation of Polish Romantic martyrology. It glorifies the suffering of Poles in the nineteenth century, presenting it as unique. The lead character, Gustaw-Konrad, is a model Romantic hero and an icon of Polish patriotic arts. The point of departure for Rychcik's staging is the historical and cultural timeline of *Dziady*, which is not a new idea. *Dziady* both onstage and onscreen is often interpreted alongside the history of Poland. However, Rychcik puts *Dziady*'s timeline into a global context.

At first, it seems that Rychcik's focus is only on pop culture and on 31 October as the date of *Dziady* and Halloween. The first appearances

of the characters bring to mind a Halloween party. Guślarz (Shaman) (Tomasz Nosiński) looks like the Joker, and the Maiden (Gabriela Frycz) is dressed as Marilyn Monroe. Maria Rybarczyk as Mrs Rollinson – a Polish Romantic icon of motherly, full of self-sacrifice, love – is dressed like Hattie McDaniel playing Mammy in the movie adaptation of *Gone with the Wind* (the character by itself based on the myth of Aunt Jemima: the faithful, full of self-sacrifice slave; Wolfe 684–85). The stage looks like a basketball hall from *High School Musical*; there is even a Coca-Cola machine. However, the colourful scenic space denotes a very dark dramatic space. As the performance proceeds, one realizes that the colourful characters not only are masked but that they mask the tragedies that happen onstage and pass by almost unnoticed. While Guślarz-Joker summons the spirits, and the audience, arguably, is involved in the who-is-who game, the all-White basketball team hangs the hotel boy, played by Black Anthony Juste, on the basketball hoop. The historical and cultural timeline of Rychcik's *Dziady* moves to the timeline of global oppression and suffering. This strategy gets the point in the moment of the so-called song of vengeance.

In the text, the song is performed by Gustaw-Konrad. Maria Janion calls it a "vampiric song of Konrad", loaded with "the most powerful expression of the patriotic wildness, hatred, and vindictiveness known to Polish literature" ("Polacy" 59):

Pieśń ma była już w grobie, już chłodna, -	Song lay cold within the grave,
Krew poczuła – spod ziemi wygląda -	It scented blood – from underground
I jak upiór powstaje krwi głodna:	It rose as vampires rise that crave
I krwi żąda, krwi żąda, krwi żąda.	The blood of corpses scattered round.
Tak! zemsta, zemsta, zemsta na wroga,	Then vengeance, vengeance on the foe,
Z Bogiem i choćby mimo Boga!	God upon our side or no!
(. . .)	(. . .)
Potem pójdziem, krew wroga wypijem,	Then we'll seek the foe at last,
Ciało jego rozrąbiem toporem:	Suck his blood from him, and hew
Ręce, nogi gwoździami przybijem,	His body fine and nail it fast
By nie powstał i nie był upiorem.	Lest he rise a vampire too.
Z duszą jego do piekła iść musim,	Then his soul to hell we'll snatch,
Wszyscy razem na duszy usiędziem,	Squeeze its immortality
Póki z niej nieśmiertelność wydusim,	From it. We will gnaw and scratch
Póki ona czuć będzie, gryźć będziem.	While it yet feels agony.
Tak! zemsta, zemsta, zemsta na wroga,	Then vengeance, vengeance on the foe,
Z Bogiem i choćby mimo Boga! (*Dziady*, Scene 1)	God upon our side or no! ("Forefathers' Eve" 521–22)

The song reinforces the idea that Poles must stop at nothing in their fight for independence and vengeance. It aims, as Janion puts it, to transform Polish into an "obligatory community of vampires-avengers" that sucks the enemies' blood and that chops and crucifies their bodies to ensure that they cannot revive ("Polacy" 66). This links with *Dziady*, in general, containing mechanisms that mobilize "the performative creation of community" (Kosiński 122). Rychcik uses verse to both re-energize these mechanisms and to shift their cogs, transforming patterns of their belonging rituals to work towards a new, more inclusive and equal community of Poland.

In Rychcik's production, the song follows the so-called Great Improvisation by Gustaw-Konrad, who dwells on the sense of existence and loss of independence, and who identifies himself with Poland's suffering. Rychcik replaces this monologue with Martin Luther King's "I Have a Dream" speech, delivered by Mariusz Zaniewski in English. During the speech, Gustaw-Konrad-Zaniewski is part of a group of naked, bent bodies, shaking as if freezing and positioned as if handcuffed, representing male students transported to Siberia for conspiring against the tsar. However, the bodies onstage are both male and female, Black and White (see Figure 2.2).

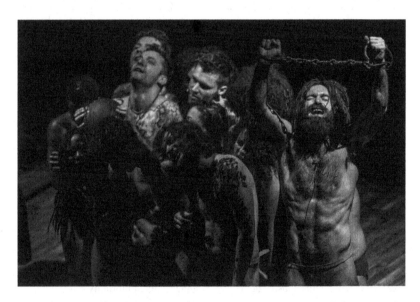

Figure 2.2 "A Song of Vengeance" by the cast in *Dziady* (*Forefathers' Eve*) by Adam Mickiewicz. Directed by Radosław Rychcik. Teatr Nowy, Poznań, Poland, 2016.

Credit: Jakub Wittchen/Teatr Nowy.

Gustaw-Konrad-Zaniewski does not initiate the song of vengeance; another actor, Michał Kocurek, does. He taps the beat using a basketball and starting the song; gradually, other voices join: first male actors followed by female voices that initially only vocalize between the verse lines. Later, the female voices overtake the song, only to be joined by the male voices, in both singing words and vocalizing. In that final moment, the song achieves its full power and aesthetic appeal. The importance of the diverse accents should not be underestimated. Polish theatre, in general, uses a standard, "neutral" Polish accent, which is linked with the Polish language being strongly standardized and unified. The main reasons for that are rooted in the post–Second World War resettling and the communist regime. In Rychcik's staging, it is the foreign voices that restore the quality of language that was long lost.

Verse rhythm and its heteroglossic potential, increased here by the performance choices, emphasize the issues of language and identity. Mickiewicz wrote each stanza of the song in ten-syllable lines built of two trochees and two amphibrachs with a caesura after the fourth syllable; the final two lines (the chorus) are ten- and nine-syllable lines built of trochees and amphibrachs:

Pieśń ma była ¶ już w grobie, już chłodna, -	X x Xx ¶ x Xx x Xx
Krew poczuła – ¶ spod ziemi wygląda -	X xXx ¶ x Xx xXx
I jak upiór ¶ powstaje krwi głodna:	X x Xx ¶ x Xx x Xx
I krwi żąda, ¶ krwi żąda, krwi żąda.	X x Xx ¶ x Xx x Xx
Tak! zemsta, zemsta, ¶ zemsta na wroga,	x Xx Xx ¶ Xx x Xx
Z Bogiem i choćby ¶ mimo Boga!	Xx x Xx ¶ Xx Xx

The actors, while singing, follow the metre precisely and mark the end of the verse lines with a stamp. The beat tapped by Kocurek has a pattern of two dactyls followed by an iamb, which are the opposites of amphibrachs and trochees. Trochees and amphibrachs are very "Polish" feet, in the sense that most Polish words that are longer than one syllable have *paroxytonic stresses*. The contrasting rhythms of dactyl and iambs neither drown out nor compete with the "Polish" rhythms; instead, they combine with them to create a new rhythmic quality, emphasized by a heightened verse rhythm. As a result, the song becomes aesthetically appealing and relevant, and the prominence of the words decreases; they become only one of the elements of this multilayered experience. In the end, the song stops being about vengeance, and it becomes about the rhythm, the beauty of accents, and a celebration of community and diversity. By shifting the song's focus, the performance also changes the pattern of its belonging ritual, and it works to transform the community built upon this ritual.

The disturbance in a belonging ritual is also at the heart of Rychcik's staging of the 1901 *Wesele*, by Stanisław Wyspiański. Rychcik plays on Wyspiański's dramaturgy and its use of verse. In the text – inspired by real-life events and people – the core tension is that between the reality and fantasy through which the national vices are revealed. The plot centres around wedding guests discussing social and political issues; they are also haunted by the ghosts of their past, Polish history, and legends. The appearances of ghosts reveal cracks in the realist setting, and the reality and fantasy slowly blend together, with the final ghost, Wernyhora, as pointed out by Jan Nowakowski, confirming his own "realness" through abandoned objects: a golden horseshoe, a golden horn, and a feathered cap (LVIII). The horn is supposed to sound a call to a national uprising, but it is lost by Jasiek when he bends for the feathered cap. The chance for liberation is lost, and the play ends with the Strawman taking charge over everyone, disarming them, and charming them to dance to his hypnotic trochaic song:

Miałeś, chamie, złoty róg,	Xx Xx Xx X	You oaf! You had the Golden Horn!
miałeś, chamie, czapkę z piór:	Xx Xx Xx X	You oaf! You had your feathered cap
czapkę wicher niesie,	Xx Xx Xx	Which was stolen by the breeze.
róg huka po lesie,	X Xx x Xx	The Horn resounds among the trees –
ostał ci się ino sznur,	Xx X x Xx X	You're left with nothing but the strap!
ostał ci się ino sznur. (3.37, 257)	Xx X x Xx X	All you're left with is the strap! (*The Wedding* 151)

Wyspiański's verse is part of the dramaturgical structure, with the first two acts establishing strong syllabic-accentual patterns with dominating octosyllabic trochee and dactyl, evoking rhythms of national dances, and echoing previous key works of Polish theatre and poetry; the regularity of the verse loosens in the final third act as the reality and fantasy blur (Prussak 39–48).

Kosiński says that Wyspiański charges Poles with stupidity, buffoonery, histrionic behaviour, and passivity; however, the Polish tradition found a way to engage with *Wesele* as a celebration of Polishness (169). Rychcik re-energizes the interrogatory power of *Wesele* by using the heteroglossic quality of verse to structure his dramaturgy that – like Wyspiański's – is based on tensions: between familiarity of the source and the foreignness of Belfast, between fluency and disturbance and, ultimately, between native

and foreign. Rychcik employs both foreignizing and domesticating strategies, blurring the lines between both and raising questions about their ethical underpinning and about the ethical right of translation or adaptation to "(mis)represent" (O'Toole et al. 8). All this serves to distance the audience from the celebratory idea of nation that the tradition of *Wesele* promotes.

In Rychcik's staging, verse and translation are used like technological devices – after all, language is a technology (Ong 80–82) – with strategically placed glitches. These seeming "malfunctions" of verse and Rychcik's translation, following Rosa Menkman's theory of glitches, connect his piece to the aesthetics of failure (Menkman, *The Glitch* 34). Łukasz Mirocha explains that glitches reveal the presence of software and its manipulation of the digital product and, by doing so, its weaknesses (61–62). Verse in Rychcik's *Wesele* is simultaneously a malfunctioning element, a revealer of what Menkam would describe as "commodification processes" (*The Glitch* 9), the breaker of its own hegemonic coding, and a technique to aestheticize malfunctioning and commodification. The latter brings Rychcik's *Wesele* closer to how contemporary art and media engages with glitches (see Menkman, *Manifesto*).

Rychcik's audience is promised a translation with high accuracy. Publicity materials and the programme speak about the context of the Troubles, report on the actors practising Belfast accents, highlight the efforts of scenographer Anna Maria Kaczmarska to obtain "authentic" artefacts, and – without directly saying so – highlight connections between Polish and Irish post-colonial conditions[11] (*Wesele*). The programme – presented in both Polish and English – gives all characters their new counterparts. The Poet, in Wyspiański's text based on Kazimierz Przerwa Tetmajer, becomes Seamus Heaney. The matchmaker Klimina is Jean McConville, one of the so-called Disappeared.[12] The Groom and his family become loyalists, the Bride and her family are Catholic; the Jewish Rachela is "translated" into an IRA soldier. Radio announcements that appear throughout the production are delivered in English with a Belfast accent that sounds believable enough to a Polish ear. These details write the text of *Wesele* into a chain of signifiers supposedly evoking an accurate representation of 1970s Belfast and, therefore, following Venuti, could (mis)represent the source and the target context as semantic equivalents, creating an illusion of transparency and hiding the violent, ethnocentric, and translational process built on cultural commodification and inequality (*Invisibility* 13–16): in this case, the cultural dominance of the source domestic context over the target foreign context.

However, in Rychcik's *Wesele*, verse rhythm has a foreignizing effect and disables a transparent translation (and its consequences) through signifying its own (and the play's) cultural difference from the target context. This

paradoxically arises from the familiarity of the play's verse rhythms. Many of *Wesele*'s lines are known by heart by general Polish audiences and not only as a piece of literature but, most of all, in a performance context. *Wesele* is one of the most frequently staged Polish plays. In Rychcik's production, verse rhythm, rigorously obeyed by the actors in the performance, fulfils its functions of memorability and literary associations (Attridge 13–15), connecting his production with the Polish tradition of *Wesele*. This is particularly given that the majority of *Wesele* lines are octosyllabic, take a metrical form, and end with a rhyme. The pattern is therefore very strong, supporting both functions per Attridge's arguments (13). Dactyl and trochee dominate, and octosyllabic trochee – the play's main metre – is more easily embedded in one's memory than any other rhythm in the Polish language (Dłuska, *Odmiany* 267).

Verse rhythm and its signifying of cultural differences between the target context are paradoxically crucial for Rychcik's dramaturgy working to challenge perceptions of native and foreign and the differences between them. First, verse highlights the liveness of *Wesele*'s performances and spectators' and actors' "togetherness" in the space. This is magnified here as the actors are the permanent members of the Śląski Theatre ensemble and thus well known to at least some of its audiences. And the shared space is theatre and Poland, but also Silesia, where Katowice lies. Some spectators may notice a connection between the Northern Irish communal boundaries and rivalries to the Silesian context, particularly given that Silesian communities are divided linguistically,[13] which provides another context in which the "deterritorialization" of native and foreign through verse happens in Rychcik's *Wesele*.

Second, verse facilitates Rychcik's play with different oralities, raising anxieties of what is being heard and its identity. While the actors speak verse precisely, their speech is foreignized by the director's attempt to partly reproduce the soundscape of Northern Ireland. Some actors' delivery of Polish verse mirrors the sound pattern of Northern Irish by lilting upward at and extending the end of his phrases. This is introduced from the first scene by Artur Święs, who plays the Journalist, or, in Rychcik's translation, Stephen Nolan. He opens the performance saying (italics as in the play; the capitalized letters mark where the lilting and the vowel extension happens):

Choć kurtyny zaklętE,	Although the curtains enchanted,
widowisko zaczętE:	The spectacle has started:
oto wszedł ktOś – puściła go wartA.	Someone has just come in – the guards
(Wyspiański, *Wyzwolenie*)	allowed him in. (My translation)

Some actors, like Anna Wesołowska, as the village matchmaker Klimina/ Jean McConville, even mix the regional Cracow dialect drawling with a "Northern Irish" accent. This "Northern Irish" accent appears and disappears throughout the performance in speeches of different characters and, as opposed to Rychcik's *Dziady*, is clearly manufactured. It also does not create a pleasant aesthetic effect, as it does not fit the verse structure that patternizes it; the extended vowels shift the grammatical stress of Polish words and disturb the metre, as Polish metrical verse (and standard Polish) are based on all syllables and vowels being virtually the same length. The dissonance emphasizes verse heteroglossia, and consequently, highlights verse structure's (Polish) literacy roots, and the presence of two different oralities: Polish and "Northern Irish". This, in turn, brings about the tensions between the writing and two different oralities and between these oralities themselves. In other words, verse heteroglossia creates glitches in these oralities, raising anxieties about what is being heard in relation to the familiar and the unfamiliar. This glitching effect follows a process similar to how "whatever" is a glitch in orality that – as Jodi Dean argues (131) – raises anxieties of being heard. In the case of Journalist-Święs's opening lines, the effect is particularly striking, as these are the opening stage directions from a different Wyspiański play, *Wyzwolenie* (*Liberation*); the stage directions are written in verse and meant to be spoken as *Wyzwolenie* through metatheatre addresses the Polish Romantic tradition. In a sense, this momentary glitch is a harbinger of the production's dramaturgical strategy.

Rychcik's *Wesele* also uses other momentary glitches. These are both literal (the radio announcements are repeatedly disturbed by sudden statics) and metaphorical. For example one of the radio announcements talks about the 2016 UEFA European Championship. A careful reader of the programme may have spotted that although the production sets itself in 1974, Kasia, one of the bridesmaids, loves *The X Factor*, Jean McConville disappeared in 1972, and the Journalist, Stephen Nolan, as the programme states, was born in 1973. Verse also malfunctions; for example during the early conversation that the male characters of the play have about politics, one of the villagers says:

A jak my, to my się rwiemy	we peasants, though, if pushed too far,
ino do jakiej bijacki.	are not the ones to dodge a scrap!
Z takich, jak my, był Głowacki.	Głowacki was our kind of chap!
(Wyspiański, *Wesele*, 1.1 9)	(Wyspiański, *The Wedding*, 1 121–22)

In Rychcik's production, Głowacki (an eighteenth-century Polish peasant and a national hero) is replaced by Bobby Sands, which does not rhyme with "bijacki" (scrap). Later on, the Poet comments on the importance of rural Poland for the independence of the country and reminds that the legendary Polish king Piast was also once a peasant:

W oczach naszych chłop urasta	Peasants we see as strong and bold,
Do potęgi króla Piasta! (Wyspiański,	Like the Piast king of old. (Wyspiański,
Wesele 1.24, 58)	*The Wedding* 1.24, 46)

Rychcik replaces King Piast with King Arthur, and the absence of the rhyme is highlighted even more by the fact that it is the Poet who speaks it. There is another glitch: King Arthur was English. These glitches reveal the presence of the source hidden behind the translation and Rychcik's manipulation thereof, which in turn encourages critical engagement with the work.

Through such operations, verse in Rychcik's *Wesele* paradoxically simultaneously reminds about the difference between foreign and native contexts and works to raise anxiety in the audience about foreign and native, challenging its dichotomy, disturbing and destabilizing its own hegemonic rhythmical flow, and – as per Menkman's points (*The Glitch* 29) – discourses attached to it; in this case, those connected to issues of representation and ideas of native and foreign in particular. By doing so, again following Menkman (*The Glitch* 29–33, 38–42), it hinders comfortable encounter with the production, encouraging a more critical reception.

By using verse to reveal failures and manipulation of the language, translation, and representation, Rychcik paradoxically – after Ong (78–80) – makes a case for these phenomena and for *Wesele* to represent complex cultural contexts and to raise urgent ethical and political questions related to representation. In particular, Rychcik offers his audiences, to paraphrase Venuti (*Invisibility* 12–19), new "positions of intelligibility" and "conditions of readability" of *Wesele* as a portrait of Polishness. As the performance happens, Rychcik adds to the play tragedies and vices that the celebration of the wedding onstage, and of Polishness in general, has silenced. As in *Dziady*, the tragedies happen outside the text. One sees the gang-rape of bridesmaid Kasia, a priest who is more interested in the young girl Isia than in a conversation with the Groom, and Isia giving birth to a child, while still wearing her rollerskates and asking to be allowed to dance.

Wesele also exemplifies how verse empowers the actors' dramaturgical activity and challenges the hegemony of the individual in a performance context changing a broader theatre ecosystem (see Kershaw, *Theatre* 15–16). While Rychcik was initially interested in playing with foreignness as a virus

inserted into a Polishness and in breaking verse rhythms, it was the actors who insisted on speaking verse, obeying its structure (Rychcik). Therefore, not only is *Wesele*'s dramaturgy articulated through verse heteroglossia and tensions it facilitates; the architectonics of its making are heteroglossic (see Turner and Behrndt 148). The case of verse as facilitator of a new dramaturgy – which is "multi-perspectival, provisional, non-hierarchical, and enquiring" (Trencsényi and Cochrane xix) – and its democratic impact are all the more striking as the production is created within a context of a mainstream theatre ensemble led by a director-dramaturg, a well-established combination in Polish theatre tradition. And such a heteroglossic process in which actors and the director become conflicted partners in shaping the dramaturgy offers another model for challenging the "paradigm of theatre as 'art in two steps'" (from playwright to director; Danan 5–6) and also the idea of "total creator" that Polish theatre has traditionally embraced.

Both of Rychcik's productions built on the heteroglossia of verse to challenge and reconstruct images and myths of nation and its relationship with the foreign, to enrich the value of the foreign, and to challenge dichotomies. In other words, they fully explore possibilities of the foreignized translation that Venuti argues for. Through verse, Rychcik also links the two plays with contemporary aesthetics, responding to urgent socio-political issues and experiences of living in a globalized society, bringing him closer to the work of Teatro Inverso.

Devising verse translation

It feels appropriate to end this chapter with a devised bilingual translation-adaptation of Calderón's *La vida es sueño* (*Life Is a Dream*), by Teatro Inverso (literally Theatre in Verse): an actor-led, low-funded, and trans-national theatre company operating in and in between Spain and the UK. *La vida es sueño* – one of the most important meta-plays in the European canon – is in itself concerned at a foundational level with the mechanisms of theatrical process; and one that, through verse, highlights the importance of actors who are not well known to their audiences in a very broad meaning of not-knowing (Lech, "Metatheatre" 179). *Rosaura* – as Paula Rodríguez (London-based Spanish actor) and Sandra Arpa (Argentinean-trained and Madrid-based Spanish actor) title their work – shows how verse drama-turgy can facilitate "reciprocal hospitality" in translation that recognizes and emphasizes that, as Margherita Laera stresses, "through theatre translation we receive the stories of others in our home, welcoming them as their hosts, and on the other we inhabit them, becoming their guests" (*Theatre* 55).

Rosaura also speaks to verse in a very different translational process than those discussed before: collaborative and created in a precarious context of

a low-funded, independent theatre company. This foreshadows how verse offers a dramaturgical platform for marginalized voices (the focus of Chapter 3) and, following arguments by Katharina Pewny and Tessa Vannieuwenhuyze (Meerzon et al. 268), reveals very different ethics and politics of engaging with language to the previous examples of the government-funded stages.

Rosaura was an inaugural production of Teatro Inverso, formed by Rodríguez and Arpa to find new ways of staging Spanish Golden Age texts, especially ones in verse (Rodríguez). First created in Spanish in 2015, *Rosaura* was translated for the British stage in 2016 and performed in London in the aftermath of the Brexit referendum, which divided the country through "a debate about who should or should not be in the UK" (Burnett 88), making the issue of "hospitality" particularly urgent. Both "Spanish" and "English" versions of Rosaura are bilingual, but the Spanish/English proportions differ depending on whether the show is performed in Spain, Mexico, the USA, or the UK (Rodríguez). My focus is the "English" version. Arpa and Rodríguez devised it as a mixture of Calderón's verse in Spanish with minimal addition of prose in Spanish (written by the actors), English-verse translation of short (but dramaturgically significant) excerpts from the source play, and English prose, also written by the two actors.

Verse in Calderón de la Barca's play fulfils important dramaturgical functions, as it marks the moments when the two plots – the so-called Rosaura's plot and Segismundo's plot (Sloman "The Structure") – overlap. These overlaps reveal the play's metatheatrical strategy and how the two characters operate within and in between their different identities (Sloman, "Introduction" xxiii–xxv; Lech "Metatheatre"). Although *Rosaura* does not follow the larger dramaturgical structure of *La vida es sueño* regarding verse, it retains links between verse, metatheatre, and negotiation of identity, expanding on them in the context of foreignness, hospitality, and cultural negotiation. Teatro Inverso's response to Calderón focuses on Rosaura seeking revenge after Astolfo seduced and abandoned her. Rosaura's native Moscow is replaced with "Hispania" and the unwelcoming-to-foreigners *Polonia* – as Rosaura describes Poland in the opening lines of *La vida es sueño* (1 vv. 17–18) – with "the Court of Europe" ("El Norte" when performed in Mexico to denote the USA) (Rodríguez). Rosaura follows Astolfo to the Court of Europe as spectators witness a reality-show-style election in which he competes with Segismundo.

In the performance, Arpa and Rodríguez use heightened physical gestures and movements to perform Calderón's verse in Spanish, and they address the audience directly to explain the plot in English. For example Arpa describes Rosaura seeing Segismundo's tower for the first time:

Rosaura looked up. She could make out something on the mountainside that rose up above her, like an enormous wave that could well engulf her. Cloaked by the mountain, blended with the rough crags there was a small tower, brief and hidden in the darkness.

RODRÍGUEZ:

Rústica yace, entre elevadas peñas,	A palace born within these barren hills
una torre tan breve,	So rustic and so crude
que al sol a penas a mirar se atreve,	The sun is loath to look on frames so crude; (. . .)
la puerta abierta está	Its door/Stands open (. . .)
y deste rudo centro	And night springs from its jowls,
nace la noche, pues la engendra	Engendered in the cavern of its bowels.
dentro.	(Calderón and Racz, *Life*, vv. 56–58, vv. 69–73, 3)

ARPA:

She entered. (Rodríguez and Arpa 6)

Arpa and Rodríguez are using lines 60–62, 73–75, and 79–80 from Jornada Primera (Day 1) from the first edition of the play (Calderón, *La primera* 131–32). The line "la puerta abierta está" is made of words taken from lines 73–75: "La puerta, / – dirè major, funesta boca – abierta / está". Arpa and Rodríguez take out the metaphor in the parentheses that Racz translates as "a gaping mouth mid roar". The line "que al sol a penas a mirar se atreve" is a line 58 in the second edition (Calderón, *La vida* 4). The quote helps show how verse in *Rosaura* supports its multilingual dramaturgy by highlighting changes between language and engaging the audience with its meta level as "the realm of theatre practice where cultures converse and collide" (Caplan 142).

The changes between verse and prose – emphasized by the change of language and the performance styles – bring up issues of language, performativity, and identity and highlight that Arpa and Rodríguez are in a constant process of negotiating in between their roles. They perform multiple personae from Calderón's play and contemporary culture (e.g. Oprah Winfrey and British politician Boris Johnson) and, on the top of that, they tell the story of Rosaura negotiating her identities. While cutting the majority of Calderón's lines, Arpa and Rodríguez keep scenes that mark moments of changes and collisions between Rosaura's roles: the three meetings with Segismundo and the so-called medallion sequence. In each of the three meetings, Rosaura plays someone else (a boy, the maid Astrea, and finally Rosaura). The medallion sequence brings together Rosaura's

multiple identities. Astolfo's fiancé Estrella sends Rosaura (who pretends to be her maid Astrea) to request the medallion he wears, and which has an image of Rosaura in it. As Francisco LaRubia-Prado explains, the original (Rosaura) is brought together with the copy (her portrait) and the role she plays (Astrea) (399). Laura Bass points out that Rosaura herself is a copy of her mother (seduced and abounded by Rosaura's father) and her mother's fate (64). Rodríguez and Arpa extend it by staging a scene between Violante and Rosaura that the latter recalls in Calderón's play (3.10) and comparing the medallion to Facebook.

Moreover, the rhythm of the verse references Calderón (as does a physical copy of the play on the stage) and his cultural context, reminding us that Arpa and Rodríguez also negotiate between several cultural contexts. In each of these, they occupy a different position: foreigner, migrant, native, guide, guest, host, actor, storyteller, dramaturg, and translator. As hosts, they continuously check with the audience to ensure that they feel welcomed but not patronized: "Paula they got it", says Arpa, when Rodríguez engages in a lengthy explanation (Rodríguez and Arpa 8). Their hospitality – and the metatheatrical level it highlights (further emphasized by verse) – is a reminder that their cultural negotiation is created with spectators in mind, reflecting an idea of a translation as "a cultural condition underlying communication" (Gentzler 7) and inviting the audience to reciprocate simply by listening. Their reciprocal hospitality also operates on a meta level with British theatres rarely staging translations (Laera, *Theatre* 67) but it speaks particularly powerfully to the socio-political context in the 2016 Brexit with UK Prime Minister Theresa May's "hostile environment" policy (introduced to reduce the number of immigrants).

Verse's facilitation of the hospitality underlain by an idea of identity that is constantly in flux reaches its point in the finale when Rodríguez refers to hostility by paraphrasing Rosaura's lines from the beginning of Calderón's play: "Badly Europe, you receive a foreigner, if with blood you scrawl its entrance in your sand and they barely make it, when they make it in despair" (Rodríguez and Arpa 24–25). The reference to Europe, followed by a description of war, broadens the context of London's performances beyond the UK, evoking images of refugees dying in the Mediterranean Sea – in 2016 it was more than 5,000, according to Stephen Wilmer (*Performing* 1). The hostility is juxtaposed with a dream, that begins with the two performers talking about a world in which people welcome a stranger with the line "Don't worry, there's space for everyone" (27). It is followed by the second appearance of verse in English (the first is at the beginning, introducing Rosaura as the storyteller):

The king dreams that he is king 7
and lives with this illusion ruling, 9

declaring and govern*i*ng; 7
and the applause, he rece*i*ves 7
borrowed, is wr*i*tten in the w*i*nd 8
and *i*n ashes it's transformed 7
by death, misfortunate sign! 6
(. . .)
What is life? A frenzy. 7
What is life? An *i*llusion, 7
a shadow, a f*i*ction. 6
And the greater good it's but small: 8
that all of life is a dre*a*m, 7
and dre*a*ms themselves, dre*a*ms are . . . 6

This is Arpa and Rodríguez's translation of Segismundo's monologue from the end of Jornada Segunda (Day 2), in which the prince muses about the difference between life and a dream; his conclusion, that one never knows if one only dreams who one is, is a turning point in the play that starts Segismundo's conversion into a just ruler. Arpa and Rodríguez approximately stick to the eight-syllable length of the décima rhythm in the source text. They also reference the rhyming structure in the Spanish text through assonances. The arrival of verse in English shifts the general compositional rule of *Rosaura* so far – verse in Spanish and prose in English – which stresses the importance of this final moment and the theme of identity (and fates attached to it) inviting self-reflexivity from the audience. Even more so, Arpa and Rodríguez deliver the lines "reading" from the book – that one assumes is Calderón's play – as if translating it live for the audience. Verse rhythm brings up here the tension between writing and orality in the context of the translated passage, but also in the context of the Spanish source that the audience has encountered so far. In doing so, verse emphasizes both the theme of cultural negotiation and hospitality and the multiple levels on which these are staged in *Rosaura*.

The dialogic quality of verse also played a part in their process of translating *Rosaura* for English-speaking audiences, reinforcing how transcultural dramaturgy opens collaborative possibilities (Rudakoff 157). Rodríguez and Arpa worked with William Hudson, a bilingual actor and translator, who spent many years living in Spain (Rodríguez). They wanted an actor with transnational experience, so the translation process was performance-focused. In practice, Rodríguez and Arpa translated the lines and sent them to Hudson, who suggested edits. These were tested in a rehearsal room in a performance context, with all three of them present. One of the key priorities and points of tension was a negotiation between requirements of English syntax while keeping the rhythmic effect of the source text (Rodríguez),

reflecting the ontology of verse and revealing complexities of ownership in theatre, translation, and transcultural dramaturgies. And in this sense *Rosaura* – while echoing Caplan's point that in multilingual productions "dramaturgy is a mode of translation" (143) – also shows how verse invites actors to take on roles and tasks traditionally associated with translators, dramaturgs, and directors.

Conclusion

This chapter explored various ways in which verse empowers translation and adaptation and facilitates their dramaturgy in diverse processes and socio-political contexts. Verse, through its dialogic structure, enhances and performs inter-contextually and multi-contextually and facilitates constant collisions and negotiations between native and foreign, source and translation, translation and adaptation, and, on a meta level, between playwright, translator, dramaturg, director, and actor. On another level, verse becomes a meeting point between theatre practitioners, traditions, conventions, and audiences of different societies. At the same time, it interrogates them, reprogramming one's engagement and inviting self-reflexivity. In doing so, verse pushes translation towards a radical and idealistic reconfiguration of "the theatre as a permanent border zone in which identity is neither here nor there, but eternally heterogeneous, porous and open" (Laera, *Theatre* 59). The idea of verse as an agent of critical interrogation and reprogramming recurs in the upcoming sections.

This chapter recalls Caplan's point that in multilingual productions "dramaturgy is a mode of translation" (143), which was the case for Rychcik's and Teatro Inverso's works. However, verse also required translation to be a mode of dramaturgy – transadapturgy – allowing the translators to propose their own receptive strategies for the encounter with the text (both the source and the translation) and its performance. In doing so, they not only explored contemporary theatre aesthetics and concerns but also responded to significant challenges in contemporary translation. The works discussed here show that verse supports a deconstruction of linear ideas on the relationship between the source and translation (Marinetti 130; Polezzi 350), bringing the inseparability of performative and linguistic aspects of theatre translation to the fore (Marinetti 128–29; Gentzler 3). It facilitates the texts' and productions' engagement with meta-translation (Delabastita 112; Hermans 41–51), testing hierarchies between different cultural and linguistic frames (Bhabha 58–59; Bassnett 44; Cronin 140–41), creating both links and a much-needed space between metaphoric, creative, and political approaches to translation (Bassnett 56), and bringing to the fore ethical aspects of translation and adaptation (O'Toole et al.; Venuti, *Scandals*,

Invisibility; Myskja). Verse dramaturgies also echo post-translation ideas of "transdisciplinary, mobile, and open-ended" translation that challenge existing definitions and emphasizes its search for cultural and social change (Gentzler 2–7; Nwegaard and Arduini 8).

In short, this chapter shows that verse is at the forefront of contemporary practices and experiences. The next chapter expands on this by investigating the political potential of verse dramaturgy in works engaging with identities that escape simple social, physical, geographical, national, or cultural boundaries; staging marginalization, precarity, and post-colonial resistance; and performing a protest.

Notes

1 Translations by Richard Claverhouse Jebb (1904), Edward Fairchild Watling, (1947) and Hugh Lloyd-Jones (1994) (McGuire 10).
2 See Heaney, "'Me'"; Heaney, "A Note"; *The Burial at Thebes. Play Guide*.
3 The time and the ownership of *Caoineadh Airt Uí Laoghaire* is not a concern of this book. For more, see Cullen 29–36.
4 L. M. Cullen shows that the conflict between Morris and Uí Laoghaire was complex and that the association of Uí Laoghaire with the innocent victim is problematic (15–29).
5 I refer here to fractured communities represented, for example, by the tensions between Sinn Féin and the Democratic Unionist Party (two main parties leading the Northern Ireland Assembly).
6 J. D. Steele spoke about using verse structure for music during *How Do They Do That* at the Guthrie Theater in 2011. On some occasions Lorca and Steele consulted Heaney and asked him to change certain words to facilitate the music of the Chorus. These changes, however, were minor and do not affect my argument (*How Do They*; Lorca).
7 I am following Heaney with regard to the choice of translation (by Frank O'Connor) and the choice of quoted lines ("'Me'"; "A Note").
8 The perception of Creon's suffering may be additionally enhanced by the association with King Hrethel's lament over his dead son from *Beowulf*, encouraged by the virtual presence of Heaney as the translator and by Heaney's repetition of some lines from this lament in "On His Work in the English Tongue", from *Electric Light*, a collection published in a relatively similar period as *The Burial* (2001): "Alone with his longing, he lies down on his bed / and sings a lament; everything seems too large, / the steadings and the fields" (*Beowulf* 167; "On His Work" 63).
9 Poland lost its independence for a period of 123 years over the course of three Partitions (1772, 1793, 1795), that is, the division of the Polish-Lithuania Commonwealth's territories between Russia, Prussia, and Austria (Austria did not take part in the Second Partition). For more, see Davies 393–408.
10 Barnette offers a model for analyzing adaptation in relation to its source which includes tools, or, as she calls it, "coordinates", for considering cultural aspects. She compares them to Venuti's foreignization and domestication (39–44). And while the appropriate coordinates (Barnette's z-axis in particular) could be used

to discuss Rychcik's work, they would illuminate its other aspects rather than spotlighting an interlingual operation of verse dramaturgy and their political context.

11 For more, see Skórczewski 26–27, 279; T. Wilson.

12 The term Disappeared refers to nine people from the Catholic community who disappeared during the Troubles. For more, see Gillespie 84–86.

13 The conflicts in Silesia are complex and rooted in history. A key issue is the unrecognized status of Silesia as a nation (rather than part of the Polish or of the German nation) and Silesian as a language rather than a dialect derived from Polish, Czech, and German. For more, see Szmeja; T. Wilson.

3 (No-longer) Ibsen's "language of the Gods"

Verse and marginalized voices

On 23 May 2017, a day after the Manchester Arena bomb attack, at a vigil at Albert Square in Manchester (UK), Mancunian poet Tony Walsh performed his poem "This Is the Place". It was a tribute to victims of the attack conducted by a local young man. However, it was also a call to active participation in and celebration of the city and its communities, challenging narratives of threat, powerlessness, and feelings of loss and rage. It ended thus:

> Because this is the place in our hearts, in our h*omes*
> Because this is the place that's a part of our b*ones*
> 'Cos Greater Manchester gives us such strength from the f*act*
> That this is THE place. We should give something b*ack*.
>
> (Walsh)

The homes-bones approximate rhyme linked architectural aspects of the city with the psychophysical experience of the community that needed to come back from the tragedy, as marked by the final assonance. And Walsh reinforced it, adding: "Always remember. Never forget. Forever Manchester" (Walsh).

While "This Is the Place" is not a play, it showcases how verse seeks to shape major dramaturgies by shifting structures of broader contexts (Van Kerkhoven "The theatre"), which is this chapter's main concern. The discussion shows how in recent years, instead of being Ibsen's "language of the Gods" (269), verse has become a theatrical language of the marginalized. Verse stages their artistic responses to global, national, and local politics, and to contemporary theatre. The heteroglossic quality of verse facilitates contexts and identities who escape simple social, physical, geographical, national, or cultural boundaries. Verse is far from the everyday language that Ibsen insisted on (367–68), but it allows artists to reflect on how languages

are spoken in the contemporary world and to shape a multifaceted, multifocal, and pluralistic theatre. This, in turn, reinforces theatre as a political platform by bringing it closer to Peggy Phelan's arguments on tensions between visibility and agency (5–7) and Hannah Arendt's view on politics as a platform where everyone can be "seen or heard" (50) and action understood as ways in which people disclose to others "their unique and distinct identity of the agent" (175–76, 179–80). This chapter has three sections. "Dialogic Dramaturgies of Self" looks at verse in works that respond to dialogic tensions within individual identity and relate it to broader socio-political contexts. These are often semi-autobiographical or autobiographical and solo performances. The second section presents theatre and film productions that invite their respective audiences to recognize, question, and shift their engagement with vulnerability, whether in the context of disability, teenage pregnancy, gender, age, the refugee crisis, or the environmental crisis. The final section investigates productions that use verse to stage a theatrical protest. The three sections do not attempt to categorize the works I discuss – that would be limiting, as some of them clearly relate to more than one section – but to emphasize aspects of their dramaturgical structures that verse facilitates.

Dialogic dramaturgies of self

Some theatre-makers choose verse to shape, to use Yana Meerzon and Katharina Pewny's term, "dramaturgies of self" (2). While Meerzon and Pewny use it in relation to migrant artists, I apply it here to dramaturgical endeavours that, paraphrasing Meerzon and Pewny (2), reflect experiences of theatre artists whose voices have been marginalized. While using rhythmical language in semi-autobiographical or autobiographical works, often written and performed by the same person under their own name or under a fictional character's name, is a major trend in contemporary theatre – one that perhaps deserves its own book – the works presented here do not always fit the realm of autobiography. However, their authors use verse dramaturgy to resist marginalization and obtain self-agency, which is typical of autobiographical creations (Heddon 3; hooks 43). Verse, through its heteroglossia, suits artists who want to dramaturge tensions and multiple contradictions within their identities in relation to their individual experiences as well as broader political, linguistic, social, and cultural contexts. They often choose a formal language to structure their vernacular. In other words, the works presented in this section strongly echo Carlson's point that heteroglossia reflects conditions of living in a globalized society (*Speaking* 18).

The most obvious quality that verse brings to dramaturgies of self is a certain distance from the issues explored onstage. Verse takes personal experiences out of the realm of confession and broadens its dimension to facilitate a discussion on difficult issues in a more detached manner and in broader contexts. At Moscow's 2018 Liubimovka Festival, Olga Shilyaeva debuted with *28 дней. Трагедия менструального цикла* (*28 Days. The tragedy of a menstrual cycle*), a verse play about menstruation, one of the most "unspeakable and unrepresentable" aspects of female bodies in contemporary culture (Brook 51). Shilyaeva's play uses Greek conventions and features Her, His Voice, and the Chorus of Women in different stages of their life dressed – per stage directions – in clothes with blood in the crotch. *28 дней* explores the experience of menstruation, its representation, and how it affects the representation and perception of women, including the consequences thereof such as inequality and violence. The point of departure is the normalization of suffering. The Chorus reassures Her "Это нормально" ("It's normal"; *28 Days* 1) as She confesses:

Кровь.	Blood.
Из меня	Blood
течет	flows out of me. (*28 Days* 1)
кровь. (*28 дней*)	

The play, produced by Teatr.doc, directed by Yuri Muravitsky and Svetlana Mikhalischeva, had already made its Polish premiere in 2019 at the Polski Theatre in Poznań, translated by Agnieszka Lubomira Piotrowska. Director Kamila Siwińska enhanced the musical aspects of the text through chanting, dances, and melorecitation of the Chorus, juxtaposing the Greek references with the cosmos-inspired scenography (by Alicja Kokosińska) and marking menstruation as a universal female experience.

At the same Moscow festival where Shilyaeva debuted, teacher-playwright Alexei Oleinikov used verse and rap to translate his experiences into a debate on the role of education in his 2018 *Хлебзавод* (*The Bread Factory*). The topics of female bodies and education meet in Michał Telega's *Aktorki, czyli przepraszam, że dotykam* (*The Actresses, or Sorry for Touching You*). He created the piece while studying directing at the National Academy of Theatre Arts in Kraków (Poland) and presented its rehearsal reading in 2019 for his assessment. *Aktorki* uses verse and the chorus to both mask and formalize accounts of sexual harassment experienced by the Academy female students interviewed by Telega. The play reveals, as Monika Kwaśniewska argues, the "mechanism of exploitation and submission" in acting training and professional career as well as the female actors' awareness of "the

violent mechanisms to which they are surrendering" (Kwaśniewska). As the Chorus confesses:

MOJE CIAŁO TO	MY BODY IS
NARZĘDZIE	A TOOL
INSTRUMENT	
MOJE CIAŁO TO MOJE SACRUM	MY BODY IS MY TEMPLE
MOJA POSTAĆ TO NIE JA	MY CHARACTER IS NOT ME
ROZEBRAĆ SIĘ. (Telega, *Aktorki*)	TO GET UNDRESSED. (Telega, *The Actresses*)

Telega's play evoked heated discussions but also some limited yet positive actions from the National Academy (Kwaśniewska), foreshadowing this chapter's discussions on verse dramaturgies in the context of precarity and protest. The themes of the body, abuse, and education continue in Neil Watkins's *The Year of Magical Wanking*. He was writing and performing in 2010 in Ireland as the country was dealing with its own "architecture of homophobia" (McAlesse qtd in Kelly) and facing the aftermath of the 2,600-page report on residential institutions for children run by religious congregations published in May 2009 by the Commission into Child Abuse. Watkins recalls experiences of his body in the context of HIV, sexual abuse, porn addiction, drugs, self-destruction, and the Catholic Church over a period of one year. The one-man play, directed by Philip McMahon, is another – and yet very different to Heaney's work – example of how verse's connotation of ritual has contemporary dramaturgical applications. In *The Year*, verse frames Watkins's "resurrection" – or, as Cormac O'Brien describes it, his "journey from being shamed . . . into embodying and performing a profound sense of queer pride" (265) – as a performative ritual. The ritual not only marks Watkins's transition but also deconstructs

> a dark underbelly of HIV-related stigma and homophobia in the nation's social welfare and healthcare structures, particularly in terms of meeting or even understanding the mental health needs of queer citizens.
>
> (Cormac O'Brien, 265)

Watkins divides the play into 12 months (November to October) and each month into four-line stanzas that, in the great majority, follow the *abba* rhyming pattern (sometimes through an assonance), which strengthens the sense of ritual; the number of stanzas varies from 12 to 23. Verse also foreshadows the celebratory end of the ritual in the first lines of the play:

> Great Spirit and Great Mystery hear my pr*a*yer. a
> Bless all the beings gathered in this r*oo*m. b

I bid your tastebuds welcome to my w*omb*. b
This is my truth. I bare my fruit. Let's sh*are*. A
(Watkins 293)

The reference to Watkins's womb – emphasized by a rhyme – contrasts his looks that connote patriarchal masculinity and, in turn, queers one's perception of his body; Watkins wears a beard and is dressed in a suit; he has two warrior streaks on his cheeks. At the same time, verse highlights the presence of Watkins (as playwright and actor) and his creative ownership of what has been said and the queerness he revealed. He closes the prologue, reinforcing both his queerness and the promise of an empowered ending to the ritual:

I'm 33. The age when Jesus *died*. a
Rose from Dead, ascended out of *Hell*. b
If she can resurrect, I can as *well*. b
Me bell end's battered and my hands are *tied*. a
(Watkins 294)

The Hell-well rhyme both is a metaphor for his story and foreshadows, for some, the blasphemy of queering Jesus's body and comparing the Passion of Christ to an act of masturbation that the tied-died rhyme highlights. This emphasizes Watkins's confidence in making such a statement on Irish stages, pointing towards an empowered end of the ritual.

The play is written in Dublin slang structured by mostly ten-syllable lines that sometimes take an iambic pentameter form. On the one hand, this creates a tension between normative ideas on high and low cultures; on the other hand, it provides a starting point for the audience to encounter the story; arguably, ten-syllable lines and iambic pentameter is a form that many spectators are used to receiving. There are two moments when this formal protection disappears. In February, as Watkins faces his alter ego Heidi Konnt (pronounced as "cunt"), the form loses its regularity and the lines begin to vary from short interjections like "Yes?" to prose confession: "I won [Alternative Miss Ireland] as Heidi Konnt. So I could be somebody when I went out on the scene" (304). It includes some iambic pentameter:

I gave you the best handjobs, Neil. Fuck you. A	x X x x X Xx x X X
You faggot little wanker. "I'm so true." A	x Xx Xx Xx X x X
You tell the people all the things you've done? (304)	x X x Xx X x X x X

The true-you rhyme highlights Heidi Konnt's sarcasm and plays with the idea of "a true" versus performed identity, while the verse rhythm marks that both Heidi and Neil are performed. There are also short rhymed exchanges:

NEIL

Get off the st*age*.

HEIDI

You need my r*age*. Come on. (304)

The formal struggle to establish one rhythm represents the tension between Watkins and the personality he created to protect himself, and that now torments him, pushing him towards suicide (307). In October, Watkins speaks in prose and expresses his will to live: "I want to stay" (326). The disappearance of verse is a dramaturgical signal that the ritual has come to an end.

Another artist who embraces vernacular through formal language and uses it to structure her journey through pain is the actor-writer Stefanie Preissner, originally from Irish Cork. In her two plays, *Our Father* (2011) and *Solpadeine Is My Boyfriend* (2012), written in the context of the post-Celtic Tiger recession, the verse structures dramaturgies of pain. It facilitates Preissner's flirtation with autobiography and her multiple identities "as the character she performs, as the performer, the writer, and a voice of a young generation of Ireland facing the drastic political, social, and personal changes and desperately looking for predictability" (Lech, "The Role" 157). Preissner uses rhythm and rhyme to perform the psychophysical experience of pain that arises from the death of a mother (*Our Father*) and loneliness and addiction (*Solpadeine*). In *Our Father*, the ability to rhyme is connected to her distancing herself from her pain, as she confesses she (or "Ellie" – the character Preissner performs) cannot tell a story about purple socks, because nothing except "curple" rhymes with "purple"; later she says she must rhyme "(b)ecause then I can breathe and it's not so cha*otic* . . . something something anti-bi*otic*" (41). It is the rhyme, and not the narrative, that pushes the story Ellie tells. This also reflects Preissner's writing process during which verse is not only a key dramaturgical tool but also a navigator (Preissner, "Personal interview" 163).

In *Solpadeine*, verse form is connected to a young post-Celtic Tiger female's reaction to painkillers that she takes to escape the lonely reality of recession in Ireland, from which her friends keep leaving:

Because everyone thinks you can just es*cape*,
that moving to some tropical bay or *cape*

will change the fundamental fact that your life isn't *great*,
but it rains in Australia too *mate!*

(13)

Both plays also use formal language to challenge audiences' strategies to deal with their own and other's suffering (Lech "The role"). In *Our Father*, Preissner in the middle of the show removes the aesthetic protection of rhymes and the formal audience/actor division and, standing in the auditorium with all lights on says: "Am . . . thank you all for coming, I eh . . . I don't really have anything prepared, I'm Ellie, by the way, most of you will know that. I'm Niamh's daughter" (*Our Father* 35). In *Solpadeine*, she structures rhymes and rhythm to equate emigration and addiction as forms of escape (exemplified in the previously mentioned quote), challenging the audience to stay and fight for Ireland (Lech, "The role" 160–61).

Contemporary verse dramaturgies of self not only seek to shift major dramaturgies arising from the local context but also perform the cities they are rooted in, their stories, and soundscapes. Dorota Masłowska's 2018 *Inni Ludzie* (*Other People*), Emmet Kirwan's *Dublin Oldschool* (2014), and Niall Ransome's *FCUK'D* (2017) – all performed in theatre and also adapted into movies which retain their verse forms – use rhythmic language to evoke the urban spaces of Warsaw, Dublin, and Hull respectively, and the tensions between local, national, and global contexts within them. The three plots are structured around the stories of siblings from underprivileged urban areas. *FCUK'D* is a one-man play about two brothers. Ransome wrote it in drama school and initially performed but, later on, focused on directing the piece and was replaced by Will Mytum and, later, by George Edwards.

Like Tony Walsh, Ransome uses verse to write the architecture of Hull into the "bones" and fates of the characters, but it is much less spirit-raising than "This Is the Place". While performing a unique Hullensian aesthetics, Ransome's verse airs an indictment of British society for abandoning its response-ability for young people. Boy and his younger brother, Mattie, live on an estate filled with the same houses and atmosphere of neglect, "[t]he same image on rep*eat*. / Like the artist painting this town gave up when he got to our str*eet*" (9); the short line together with the rhyme street-repeat evokes the vision of the council estate. The play tells a story of the brothers' desperate, and unsuccessful, escape from social services, who came to take Mattie, as their mum could not take care of them:

It's not like she didn't try,
Me mam,
You know you do what you can
But sometimes it's just/

(8)

Verse highlights "me mam" as the only two words in the line and pushes *FCUK'D* towards a narrative of abandoned and precarious children, a larger trend in the British theatre (Fragkou 51–52). However, the main dramaturgical operation of verse dramaturgy in *FCUK'D* is how it seeks to distort narratives of the working-class male in the UK as – as Marissia Fragkou puts it – an "'unarchivable spectre' disposed by cultures of wealth and waste" (161) or an uncultured "yob" from the North of England with limited vocabulary (Fragkou 162; Garner 2009). Ransome engages with these and with the association between one's accent and one's "location within the notoriously hierarchical class structure of British society" (Laera, "Performing" 384). And he puts them in tension with Hull's rich poetic traditions and their centrality in contemporary British verse (Barry 105–6).

FCUK'D describes Hull as deprived and ugly; however, the form of verse and poetic means – including metaphors, assonances, alliterations, and onomatopoeiae – create a dialogic tension that echoes Charles Baudelaire's searches for the aesthetics of what is commonly perceived as ugly, and what Polish poetry scholars would describe as *"turpizm"*, from the Latin *turpis*, which means ugly or hideous (see Fabiszak 115–16). *"Turpizm"* challenges modes of a normative concept of beauty and value and seeks to shift modes of perception. And this *"turpizm"* is at the core of being a Hullensian in *FCUK'D*. For example Boy (the narrator) and his brother, Mattie, return home from Mattie's school:

We l*u*mber past the H*u*mber Bridge.
Ov*e*r f*e*nces,
Thr*ough* fi*e*lds.
Fridges ab*a*ndon*e*d,
Cars without wh*ee*ls.
W*ee*ds left un*a*ttend*e*d,
I know how they f*ee*l.

(8)

The lines evoke the iconic architecture feature – the suspended bridge in Hull – and the city soundscape as the density of assonances (in italics) is specific for the Hull accent; although Ransome points out that they can be carried by any Yorkshire accent ("Personal"). This is why the casting of Mytum (from York), and later, Edwards (from Sheffield), works. In the performance, "lumber", "humber", and "through" are all pronounced with a sound similar to [ʊ] (like in blood) rather than the so-called standard English [ʌ] or [u:] for "through", while the neutral schwa in "over" or "abandoned" takes a sound resembling more like [e] in "fences" or "unattended". These assonances together with the line-breaks bring about and heighten the

aesthetics of Hull's accent, simultaneously challenging and rooting the image of waste – that provides a metaphor for Boy's experience of self (highlighted by a line at the start of a new stanza) – firmly in the context of the city of Hull.

Verse continues to be the vehicle for Boy's experiences – supported by Peter Wilson's music written to be in dialogue with the verse rhythm (Ransome, "Personal") – and a stage for Hullensian *"turpizm"*. When Boy and Mattie must jump out of their window to run from the social services knocking at the door, Boy's "HOW THE FUCK ARE WE GUNNA GET DOWN THERE?" (18) is followed by a poetic description of the flight that takes an iambic pattern; one trochee marks the painful moment of hitting the ground, highlighting how the experience of pain comes before the utterance:

My eyes are gunna burst,	x X x Xx X
Air rushes up my shirt,	x Xx X x X
And when my feet touch ground,	x X x X x X
Gravity hits,	Xxx X
IT HURTS! (20)	x X

Another example of a *"turpizm"* moment is the description of rain. The onomatopoeic effect, combined with the growing number of syllables per line, performs how the rain is getting heavier:

And just like that,
A little drip,
drop,
drip,
drop,
pitter,
patter,
splatter,
!
splashing,
splosh,
splooshing of rain.

(26–27)

And this is immediately followed by the contrasting comment "We're getting soaked but I don't give a shit" (27).

As well as a platform for renegotiation of what it means to be Hullensian, the verse supports Ransome's storytelling, highlighting and foreshadowing

key moments through a metric pattern. For example the moment of jump has extra-dramaturgical importance. As well as performing the *"turpizm"*, it foreshadows the play's finale, when the audience is left guessing whether Boy has jumped from the edge of the cliff. In this sense verse, by highlighting the first jump, supports the production's larger dramaturgical frame, leaving spectators with a sense, as Fragkou would describe it, "of responseability and witnessing against the backdrop of urban alienation" (75). And this sense of "response-ability" is facilitated by how verse throughout the play contextualizes Boy's story within UK politics and the pressure that years of Conservative governments' cuts have put on local services, echoing Jenny Hughes's point – which she develops from Zygmunt Bauman's "wasted lives" – that the contemporary politics can be "defined by the production of waste and wasted life" (Hughes 21). As a case in point, Boy describes his council estate thus:

Dogs are barking,	X x Xx
Babies crying.	Xx Xx
Corner shoppers shopping,	Xx Xx Xx
And the council's fucking lying.	X x Xx Xx Xx

The trochaic beat emphasizes these lines but also the subsequent description of the impact that these political decisions have had on Hull's people:

> These are the streets of young m*ams*,
> Pushing pr*ams*.
> Fourt*ee*n's the dr*ea*m for the new wave pregnancy plan.
> Tight tracksuits and t*ops* we nick from sh*ops*.
> Zip *ups* and Reeb*oks*. ["ups" is pronounced so it sounds more like "ops"]
> C*an* you lend us 20*p?*
> You looking at m*e* for?
> C*ans* of Stella and b*ags* of Qu*avers* litter the floor from misbeh*aviors* [sic].
> Lend us a cig,
> Be a m*ate*.
> **Flags** rem**ind** us why **Brit**ain's so **Gr**e*at*.

(Ransome 11)

The trochaic start of the final line (X xX x x Xx x X) connects it back to the lines about the council. Mytum delivers this entire part emphasizing the assonances and rhymes, speeding up with every line, creating an

overwhelming effect of a busy street (enhanced by assonances) and its noise. The rhyming scheme, connecting words and senses, is the main point of orientation for the audience, especially given that the play is performed on a bare stage.

FCUK'D also exemplifies how verse brings performativity and performance to the fore, including issues of language and identity, facilitating identities escaping or rejecting simple geographic or cultural boundaries. At the 2020 Vault Festival in London, Peyvand Sadeghian performed *Dual* دوگانه. Written by Sadeghian, directed by the Polish Nastazja Somers, and dramaturged by an artist under a nickname of Gary The Hamster, the play stages the experience of being British-Iranian in the context of a war, revolution, and the UK Home Office. Sadeghian uses verse poems – placed at different stages of the production – to reveal her personal perspective and moments of trauma, while simultaneously protecting herself from reliving it at each performance (Sadeghian). Omar Musa's *Since Ali Died* – adapted in 2018 from his 2017 music album under the same title – is a mixture of Hip Hop and verse that challenges Australia's image as a welcoming, equal society. Musa recalls growing up as a boy with Malaysian and Muslim heritage in Queanbeyan and reflects on Australia's attitude: "all need not apply / if you're Black, brown, Muslim, woman, queer, smart, proud" (Musa). The YouTube project *The Other Solos* is a response to anti-migrant sentiments in the UK and the world. Produced by Paula Rodríguez (from Teatro Inverso), it presents selected monologues from Shakespearean plays performed by actors based in the UK and with various mother tongues, none of which is English. The project premiered in June 2017, the first anniversary of the Brexit referendum.

The exploration of one's identity in new verse works has sometimes inter-generational or generational contexts. The British Kae Tempest mixes classical conventions of chorus and unity of time in *Wasted* (2011) with Hip Hop rhythms to express the fear of decision making in three South Londoners in their 20s. In Poland Andrzej Błażewicz combines Polish and English in rapped verse for *Polskie rymowanki albo ceremonie* (*Polish Rhymes or Ceremonies*). The one-man play evokes rituals attached to Polish family meetings as seen by a young Pole born in the 1990s, the first generation born in a free Poland. The narrator searches for his identity through the tension between the global aesthetics of English interjections and rap and the traumas of Polish histories retold at family gatherings. The play was supposed to premiere in the Wrocław Puppet Theatre – directed by Marta Streker – but because of the COVID-19 pandemic, it has been adapted as an audio-visual Hip Hop album (with Polish Sign Language translation) which was released online in September 2020.

In Kae Tempest's more recent play *Hopelessly Devoted* (2013), verse-poetry is performed to beat music as a platform for voices who have "nothing / But locked doors" (3). A young female prisoner signs up for a song-writing course and through it finds her way towards personal freedom. The meta-narrative of verse as a platform for freedom and fulfilment is also evident in Lin-Manuel Miranda's *Hamilton* (2015, discussed later in this chapter), Benjamin Zephaniah's 2002 *Listen to Your Parents*, Zodwa Nyoni's *Ode to Leeds* (2017), the earlier-mentioned Masłowska's *Inni Ludzie* and Kirwan's *Dublin Oldschool* (2014), and Daniel Ward's *Canary and the Crow* (2019) staged by Hull's Middle Child company, confirming the city's centrality in contemporary British verse. The semi-autobiographical piece uses verse, Hip Hop, and grime to explore the class system and racism in the UK – including its compulsory and higher education – as well as the alienation and displacement which are integral to dramaturgies of self (Meerzon, Pewny 2). Ward – who performs in the production – sings: "I know you don't see what I see / You don't understand what I speak" (Ward). The play's engagement with the issue of systemic racism in British drama schools preceded a public debate on racial discrimination in acting training (see Bakare). Performances open with Nigel Taylor, aka Prez 96 (also co-composer), who uses the rhythmic music and words to "warm up" the audience, challenging theatre etiquette and, following Kirsty Sedgman's arguments, opening it to more diverse experiences and responses (3–4, 112–13).

Ward is an example of the UK's newest generation of young Black playwrights who resist the dominating tropes of Black male violence and "neo-colonial ideas about Black male bodies 'natural' propensity for physical strength over intellect" (Goddard, 122–23). Inua Ellams is another one. His *The 14th Tale* (2009) – directed by Thierry Lawson, produced by the Fuel Theatre, and invited to the UK's National Theatre after its Edinburgh Fringe premiere – uses verse to challenge narratives of young Black males, gang cultures, and knife crimes. These dominated British public discussions in the first decade of 2000s as the UK faced "a moral crisis regarding youth criminality associated with race", as observed by Fragkou (66), and are well exemplified by Prime Minister Tony Blair in 2007 blaming an increase in knife and gun murders on Black culture (Wintour and Dodd). Ellams's verse stages a renegotiation of these narratives and plays on a popular dramaturgical formula according to which a promising young Black male faces a problem and acts out violently or engages in crime, gets caught, and ruins his future. *Othello* is the obvious example; others include plays like Kwame Kwei-Armah's *Elmina's Kitchen* (2003) or *Luce* by JC Lee (2013), and the movies *Save the Last Dance* (2001), *Moonlight* (2016), and *Waves* (2019).

The 14th Tale exemplifies how verse empowers autobiographical resistance of marginalization and claim of self-agency (Heddon 3; hooks 43).

And – what is particularly striking about Ellams's self-dramaturgy – how verse facilitates dialogue between different tropes of the young Black male and, through that, pushes for a shift within major dramaturgies surrounding the production. The one-man show performed by Ellams tells about his growing up in Nigeria, the UK, and Ireland. It is written in almost entirely unrhymed free verse with lines oscillating between eight and 15 syllables that sometimes slip into iambic pentameter and on a few occasions lose their structure and become prose. The opening stanza has, in fact, six lines that strive towards blank verse and also one trochaic pentameter (in italics):

The light that limps across the hospital floor >	x X x X xX x Xxx X
is as tired as I feel; it is the pale green of nausea >	
the shade that rises slowly, pushes upwards >	x X x Xx Xx Xx Xx
and out. I want to burst, out, through past >	x X x X x X X x X
the sliding doors to the windy wet night, wind >	x Xx X xx Xx X x X
my way to the kind of corners I am used to >	x X xx X x Xx Xx X x
the kind of troubles I know and climb my way >	xX x Xx x X x X x X
out. But I still myself, swallow till the light >	X x X x Xx Xx X x X
shallows, count five, four, three, two, one . . . (7)	

Nowhere else in the play do iambic lines happen with such density, and here they foreshadow how Ellams uses the dialogic nature of verse to shift dramaturgies of violence associated with young Black men to a dramaturgical play on prejudice. First of all, opening *The 14th Tale* with "the most pervasive" of the metres in English literature (Adams 37) and freely coming in and out of this rhythm throughout the play is a powerful statement of postcolonial resistance and migrant agency. The context is the iambic metre's association with the tradition of verse drama in England and with William Shakespeare in particular, who, in turn, strongly defines not only English but also British cultural identity (Dobson 7). Ellams announces here his readiness to shape the cultural landscape that he grew up in as a migrant and the one that colonized his native country. His disclosure of cultural agency opens the door for challenging the "socially peripheral" and "symbolically central" status of migrants and for reconstructing their visibility (Stallybrass and White 5). Following David Jefferess, by doing so, Ellams begins transforming "the structure of power assumed within colonial discourse by recognizing and fostering" a new order that sets the relation between self and other, colonized and colonizer, or foreign and native as "one of mutual interdependence rather than antagonism" (17).

The rhythmical statement of the agency is accompanied and juxtaposed by a stereotype that the opening lines evoke and that the iambic pentameter also

highlights. Ellams is in a hospital, emotional, and in trouble. Enjambments (>) at the end of eight of nine opening lines break up his thoughts and emphasize his psychophysical state. Later one realizes that enjambments are a frequent feature in the play, but at this moment, one does not know that. Ellams is wearing, per stage direction, a T-shirt and trousers stained "with red liquid giving the impression of blood" (5). In other words, verse together with visual clues help evoke here a stereotype of a young Black man whose passion has led him to some violent act. Later, Ellams asks whether some unnamed "he" is okay (22), creating a scope for assumptions that this "he" is a victim.

As the trochaic pentameter of the penultimate line changes the rhythm, the calming counting appears and Ellams is ready to introduce himself: "I'm from a long line of trouble makers" (7). This line is actually an alternative clue for how to read Ellams's story. It could be read as reinforcing the violent stereotype, but most importantly, it highlights the generational roots and the tropes of growing up and growing old. Rhythmical pointers reinforce such a reading. Ellams talks about his grandfather's and father's childhood mischief and how each "st*ory* never left mem*ory*" with a rare rhyme reinforcing the generational frame; he asks: "I wonder which story will reach / my **son** and won**der more** what **he** will **do**" (9); the iambic pattern (x X x Xx X x X x X) emphasizes the second line. Ellams paraphrases it at the end: "I wonder when this story / will **reach** my **son** and won**der more** what **he** will **do**" (48). The second line here is an iambic hexameter (x X x X x Xx X x X x X), linking it back to the start of the show. It reinforces Ellams's co-ownership of English-language culture and highlights the shift that has happened in the act of performing the play. This shift arises from the dramaturgical operation of verse and autobiography (Heddon 6, 157) facilitating an encounter between Ellams, his audience, their experiences, and prejudices. This encounter is contextualized by the dialogic tension – enacted by verse – between two alternative dramaturgical frameworks: the stereotypical narratives of Black violence and a transnational coming-of-age story. Through this tension Ellams desconstructs spectators' assumptions of what his appearance means, echoing how Kim Solga reads Phelan's idea of "active vanishing" (Phelan 19; Solga 26).

Throughout the entire performance, Ellams is in constant movement as he recalls his experiences of childish mischief or learning Shakespeare while playing basketball in Dublin. This physical movement fits well with the transnational character of his coming of age. Enjambments remain the frequent feature of the lines (e.g. in Part 1, 68 of 101 lines end with enjambments; in Part 5, the ratio is 40/66). They support the organization of the lines, highlighting verse form and, by extension, the fact that Ellams's memories are, as José van Dijck would put it, "filtered through the prism of culture" (270). Ellams, by enacting his memories, provides a platform for encounter and mediation between multiple individuals, collectives, and cultures that he

and his spectators experienced (van Dijck 270; Lech "Claiming"). The rare appearances of prose introduce a formal diversity that corresponds to the different temporal, cultural, and linguistic (through accents) contexts to which Ellams's stories relate. The contrast between verse and prose – used for some words delivered by Ellams's teachers, family, or friends – also makes the act of mediation seem live: there was no time to arrange some memories into a verse form. This potentially makes the memories and the encounter more valuable for spectators (Auslander 66–68), which is reinforced by how verse in general highlights the liveness in performance (see Chapter 1).

The context of encounter and the value attached to it is vital for how verse facilitates the turning point of Ellams's story and of the interplay between the play's alternative dramaturgical frameworks. This comes when Ellams talks about his love for a woman called Donna. It overlaps with a unique density of rhymes, assonances, and alliterations in the play and the only moment of Ellams's stillness in performance:

> A week l*ate*r, shelt*er*ed
> from London's l*azy* rain, we first-kissed, our t*on*gues
> like d*anc*ers, lips the d*anc*e floor, he*ar*t beating
> the backing *t*rack to *t*ongue *t*ip *t*ango, kissing as though
> Sh*ango* flu*ng* *s*mall *s*weetened lightening bolts
> Between us like *f*irework-*f*lavoured m*ango*es. . . .
> (38–39)

Verse operates here in several different dramaturgical functions. The rhymes, assonances, and alliterations highlight the importance of love; Ellams says that the repeated sounds were the only way he could express the beauty of this love ("Postshow"). The rhyming pattern also emphasizes Ellams's complex identity and his diverse cultural references. Finally, rhymes, by taking over the energy of the body, manifest a broader shift within the space. On the one hand, they suggest a more intimate atmosphere (which fits the love context); on the other hand, they signal a turning point in Ellams's story. As Ellams begins "whispering her first/name" with his surname (39), Donna breaks off the relationship:

> . . . she tells me this has gone too far, has
> pushed past friendship to something *greater*. That type
> of feast she just cannot c*ater*. She stays away for a week.
> (41)

The audience is then moved outside of Donna's apartment, and Ellams describes his feelings as he sees Donna with another man: "And all I see is black, all I taste is venom, all I feel / is anger, the dark fired kind, such rage,

such rage" (42). Rhymes, by highlighting this sequence as a turning point, also evoke an association with stereotypical tropes of young Black masculinities. While verse in *14th Tale* leads the audience on to think that Ellams's story follows a similar formula, it in fact emphasizes how the play distorts it. Ellams breaks in to Donna's apartment in the middle of the night to take his revenge; but it is not to hurt the man she is seeing, but to unscrew her shower head and fill it with red paint (together with the thorns of the roses he brought, the paint explains the stains on his top). And the moment IS the turning point because he gets a phone call that his father has had a stroke. In the hospital, awaiting news of his father, he recalls his childhood. The play (almost) comes full circle, as the already mentioned final line, arranged into iambic hexameter, acknowledges the shift and offers a compositional bridge not only to the opening of *14th Tale* but also to Ellams's later work *The Half God of Rainfall*.

Premiered in 2018 and adapted into a two-hander, *The Half God* is an epic poem in lines with five and six beats arranged into three-line stanzas. It tells a story of a Nigerian demigod, called Demi, born out of Zeus's rape of a Nigerian woman, Modupe, echoing post-colonial traumas as well as the #MeToo movement. The six beats per line reference the Homeric-epic style that Ellams plays with and that in the performances – directed by Nancy Medina and performed by Rakie Ayola and Kwami Odoom – is accompanied at different points by beats of drums and of a basketball. Tercet-stanzas also recall Dante Alighieri's *Divina Commedia* (*The Divine Comedy*). Such a rhythmical "dialogue" fits the transcultural and transtemporal quality of the poem.

The Half God features Greek and Yoruba gods, the NBA, and ends in a powerful description of Modupe killing Zeus, fuelled by grief over the death of Demi (murdered by Zeus) and the power of Yoruba and Greek gods and goddesses – who until now have remained silent about and silenced by Zeus's violence (italics in the published poem denote dialogue):

You must \| kill him \| and kill him \| now. \| Modupe \| took	X x X x x X x X xXx X
her gaze \| to Hera, \| Queen \|Goddess, \| Zeus' \| own wife	x X x Xx X Xx X x X
who seeing \| her lucid \| truth \| shaped \| her hands \| like so.	x Xx x Xx X x X x Xx
Modupe \| did \| what she \| planned to. \| She took \| his life.	xXx X x X Xx x X x X
she knelt on, \| crushing \| his broken \| neck, \| she chased what	x X x Xx x Xx X x X x
life \| glowed in \| him\|, to darkness, \| to the a\|fterlife. (80–81)	X X x X x Xx xx XxX

Ellams uses verse to claim his creative agency over the "inherently" European forms, challenging Western ownership of verse and verse drama traditions (see Chapter 1) – particularly significant considering how canonical Western verse operated to bestialize Blackness (Jackson 173–75) – and the divisions between European and non-European. In doing so, he engages with a major challenge in the European culture and politics (Braidotti 108–11). The journey from vulnerability towards empowerment is also a perfect bridge to the upcoming discussion on verse performing and restructuring precarious contexts.

Renegotiating vulnerability

Fragkou proposes that precarity as a concept can be "a vehicle which allows us to reimagine the contours of the 'human' and ways of living together in contemporary Western societies" (7). The verse dramaturgies seek precisely that and make an effort to reach across the Western/non-Western division. Verse underlies their efforts to highlight vulnerability in different contexts and thus, following Judith Butler, "to change the meaning and structure of vulnerability itself" (43). In doing so, they resist victimization and paternalism as two alternative and limiting models of vulnerability (Butler et al. 2–3). Instead, they stage, as Athena Athanasiou would put it, "a new, radical humanness" (41). Verse suits such aims, as its dialogic quality can facilitate simultaneous and mutually disruptive performances through which normative, patriarchal narratives surrounding Otherness and vulnerability can be deconstructed (see Athanasiou 41).

The first example is the Polish director Anna Augustynowicz's take on Shakespeare's *The Tempest* (in Polish, *Burza*) in an iconic translation by Stanisław Barańczak; the production was one of three finalists for the 2016 Golden Yorick prize for the best Polish staging of a play by Shakespeare in a given theatre season. Verse in Augustynowicz's *Burza* structures its metatheatrical questions about individual, social, and political responses to vulnerability, and about contemporary theatre, including the place of verse on a contemporary stage. Augustynowicz, one of the most renowned Polish directors, has been making her theatre for the past three decades as the Artistic Director of Współczesny Theatre in Szczecin. In her work, she is supported by an ensemble of around 30 actors, which she created and constantly credits with the success of her productions (Cieślak 57). Her work is equated in Polish theatre with minimal scenography (often by Marek Braun), oscillating in shades of white and black, the emphasized live presence of the audience and actors, and the layered soundscape inspired by the text she stages, and created by actors, scenography, and music.

In this sense, *Burza* is a typical example of her work. Considering the occasion – the fortieth anniversary of the Współczesny Theatre – this is very fitting. But her exploration of the play through a frame of vulnerability and, in particular, an aged, disabled, and abandoned body is also strongly contextualized in the socio-political contexts of Szczecin, Poland, and Europe. Szczecin has been criticized for its low level of integration for elderly and disabled citizens (Gieracka; Adamowska). The 2010s have featured several turning points for the disability movement in Poland and in Eastern Europe in general (Pamuła et al. 5), with the 2014 occupation of the Polish Parliament by parents and carers of disabled children a prime example.

At the same time, European conscience, countries, and institutions face questions raised by refugees abandoned and immobilized by and on the physical and metaphorical borders of Europe (Daddario et al. 221; Wilmer 1). Symbolic of this abandonment are the "life vest graveyards" created by orange vests dumped on the European beaches. They carry the precarious notions of hope, abandonment, and ecological disaster, echoing Bauman's links between acts of human waste disposal, "wasted lives", and inequality (5–13). Poland refuses to accept any refugees. In 2016, with right-wing media and politicians promoting fear of the foreign, Polish schoolchildren used the word *refugee* as an insult (Anannikova). Augustynowicz brings up these contexts in the opening of her staging and juxtaposes them with symbols of Christianity – crucial to the nationalistic concept of Polishness – the love Christianity connotes, and of the Polish past and its reliance on other countries' hospitality. Verse facilitates key moments of this dramaturgical interplay in relation to socio-political and metatheatrical contexts.

Burza departs from an idea that Caliban in *The Tempest* is "the focus for disability as otherness and moral-conundrum" (Quayson 42). However, in such a context, everyone and everything in Augustynowicz's *Burza* is Calibanesque, including verse and its delivery. Costumes and props – Miranda's striped pyjamas, hospital bed and chair, wheelchairs, orange vests – look used. They remind one that Miranda (Adrianna Janowska-Moniuszko) and Prospero (guest appearance by Bogusław Kierc) are refugees, referencing the items Gonzalo gave to Prospero years ago. But they can also be connected to other precarious contexts such as a civilizational crisis, hospital, and mourning.

For example in the opening, Krystyna Maksymowicz, Iwona Kowalska, and Paweł Adamski – as Iris, Juno, and Ceres respectively – arrive dressed in black tops and skirts, as if announcing their readiness to mourn. They wear life vests and have their heads covered, reminding one of hijabs. Adamski's beard highlights his cross-dressing. The multiple and conflicted symbolic significances of their costumes foreshadow, following Athena Athanasiou's points, how the production undermines the normative patriarchal and

nationalistic discourses and their engagement with vulnerability, performing its own "radical humanness" (41). Kowalska, Adamski, and Maksymowicz do not talk in the opening. Instead – like an airplane crew – they demonstrate how to use the jackets, sign the announcements, blow whistles, and pretend they are jumping off the stage or a plane, or a boat. At the beginning, one also sees several people on wheelchairs, including Arkadiusz Buszko (well known for his work as a movement director in several productions) as Caliban. He is embracing Miranda (Janowska-Moniuszko). Their bodies seem naked, suggesting they have just had intercourse.

Throughout the performance, Augustynowicz continues to bring up images of contemporary precarity and explores them through issues of identity, sexuality, visibility, Christian love, and moral obligations. Maciej Litkowski as Ariel describes the storm (Act I, Scene 1), holding a large picture of Christ teaching on a boat. He delivers Ariel's lines mirroring the intonation and melody that Polish Catholic priests use during masses:

Tak, co do joty. ¶ Na królewski statek Spadłem i siałem ¶ płomienistą grozę	To every article. I boarded the King's ship; now on the beak,
Wszędzie: na dziobie, ¶ rufie i pokładzie,	Now in the waste, the deck, in every cabin,
W każdej kajucie. ¶ Dzieląc się na części,	I flamed amazement. Sometime I'd divide,
Płonąłem w wielu ¶ miejscach jednocześnie –	And burn in many places; on the top-mast,
Na maszcie, rejach, ¶ bukszprycie – by znowu	The yards and bowsprit, would I flame distinctly;
Złączyć się w jeden ¶ płomień. Błyskawice	Then meet and join. Jove's lightning, the precursors
Nie są tak nagłe ¶ jak mój ruch, za którym	O'th' dreadful thunder-claps, more momentary
Nie nadążało ¶ oko. Żar, Trzask ognia (1.2, 12)	And sight-outrunning were not. The fire and cracks (1.2, vv. 196–204)

The pattern of five stresses in the predominantly iambic 11-syllable lines (caesura after the fifth syllable) adds an extra stress to Polish words longer than three syllables, which additionally enhances the already existing musicality of Ariel's accentual-syllabic lines. This supports his delivery and helps highlight the tension between Christian love and the atrocities of Ariel's action (and their contemporary equivalents). Later, Litkowski interrupts trochaic chanting of his **"Zbieram z łąki pył** jak **pszczoła,** / **Spi**jam rosę, **wącham zioła"** (5.1, 91) ("Where the bee sucks, there suck I: / In a cowslip's bell I lie") (5.1, vv. 88–89) to look at

the audience and say, simply: "Wesoło się żyje, wesoło, / Gdy drzewa zakwitną wokoło" (5.1, 92) "Merrily, merrily shall I live now / Under the blossom that hangs on the bough" (5.1, vv. 93–94). Behind him, one sees the entire cast (without Prospero-Kierc) standing on the edge of the platform in life jackets, some also in wheelchairs, looking at the audience. This visual metaphor carries the notions of hope, tragedy, urgency, and abandonment and is an example of the many tensions that Augustyno-wicz stages, and through which she challenges normative structures of Othering, encouraging questions that she never answers, inviting the audience to respond. Verse supports her relational dramaturgy, putting spectators "in an ambiguous distance" from their own acting and actions (Boenish 237–40).

One of the key moments of that comes in Act Four when Maksymow-icz, Kowalska, and Adamski (still dressed in Islam-connoting clothes and life jackets) return as Iris, Juno, and Ceres (4.1, vv. 60–117). Augustyno-wicz requested that they deliver their lines in a "good" Polish school of verse-speaking (Maksymowicz). This means that they obey the lines, caesuras, and enjambments, but without additionally heightening the rhythm; they carry the thoughts through intonation. This is important, as Barańczak translated their lines into 13-syllable rhymed verse with clear caesuras. This is a rhythm associated with Polish classical poetry, verse drama traditions and, in particular, the Romantic epic poem *Pan Tadeusz* (*Master Tadeusz*), by Adam Mickiewicz. Barańczak's choice of verse structure emphasizes the similarities between the opening to *Pan Tadeusz* (so-called "The Invocation" and learnt by heart in Polish schools) and Shakespearean goddesses' lines. And the delivery style that Augustyno-wicz requested stresses this further. For example Maksymowicz as Iris says:

Cerero, porzuć pola, ¶ gdzie gęstwą obfitą a	Ceres, most bounteous lady, thy rich leas
Rośnie owies, pszenica, ¶ jęczmień, groch i żyto; a	Of wheat, rye, barley, vetches, oats and pease;
Wzgórza, na których pasą ¶ się wełniste trzody, b	Thy turfy mountains, where live nibbling sheep,
I równiny, gdzie bydło ¶ używa swobody; b (4.1, 79)	And flat meads thatch'd with stover, them to keep; (4.1, vv. 60–63)

In Mickiewicz's Invocation one hears similar references to countryside and fields of wheat and rye, underlain by his nostalgia for Poland and Lithu-ania, as *Pan Tadeusz* was written in 1830s Paris, where Mickiewicz emi-grated from occupied Poland:

Tak nas powrócisz cudem ¶ na Ojczyzny łono! . . . a Tymczasem, przenoś moją ¶ duszę utęsknioną a Do tych pagórków leśnych, ¶ do tych łąk zielonych, b Szeroko nad błękitnym ¶ Niemnem rozciągnionych; b Do tych pól malowanych ¶ zbożem rozmaitem, c Wyzłacanych pszenicą, ¶ posrebrzanych żytem; c Gdzie bursztynowy świerzop, ¶ gryka jak śnieg biała, d Gdzie panieńskim rumieńcem ¶ dzięcielina pała, d (Mickiewicz, *Pan Tadeusz*)	Meanwhile, transport my yearning soul and with Thy hand Reveal to me the wooden hills, the meadows green So widely spread along the Nemen shores pristine; Show me the fields of grain that on the landscape lie, That have been gilt with wheat or silvered thick with rye, Where amber-coloured reapeseed and white buckwheat grow, Where clovers with a maiden blush in summer glow, (Mickiewicz, "The Invocation" 91–93)

Augustynowicz's choice of delivery style broadens the ways in which verse highlights the presence of writing. The context of Shakespeare and the similarities of his description to the landscapes recalled by Mickiewicz challenges the (nationalistic) sense of Polish uniqueness. Maksymowicz's, Kowalska's, and Adamski's performances also reference Mickiewicz, and through him, Polish mass emigration in the nineteenth century (and indirectly throughout history), and Polish Romanticism as a sacred part of Polish cultural heritage, but also a source of Poland's "jingoistic, sanctimonious stereotypes" that contemporary Polish right-wing narratives turn to, as Maria Janion observed in 2016 ("List"). This is even more so as Barańczak translated a reference to Juno as "the Queen o' th' Sky" (1.4.70) into "Królowa niebios" ("the Queen of Heavens"), which has Catholic connotations and mirrors Mickiewicz's invocation to "Panna święta" (Holly Maid). However, at the same time, Maksymowicz, Kowalska, and Adamski reference other religions through both the text (Roman and Greek myths) and the costumes. These multiple and conflicted layers create a form of Verfremdungseffekt – enhanced by metatheatrical references: Ariel-Litkowski "prompts" Iris-Maksymowicz when she forgets a line – that, in turn, prompts questions about audiences' and Poland's response-ability to the Other and their vulnerability, linking it to broader questions of ethics in precarious contexts (Fragkou; Pewny).

Augustynowicz's specific stylistic choice of verse delivery for the goddess's lines is also part of her engagement with metatheatre in *The Tempest*. Augustynowicz asks about the place of verse on a contemporary stage and, by extension, about contemporary theatre. Different actors deliver verse

differently, and verse rhythm draws one's attention to it, highlighting not only the different groups of characters they perform and what they stand for, but also the different delivery aesthetics and theatre styles they reference. This, in turn, broadens the conflicts between the characters beyond the play and into the aesthetics sphere. Augustynowicz does not resolve this but rather allows it to enrich the play's metatheatrical layers, bringing it closer to the contemporary Polish theatre in which these aesthetic tensions exist.

Grzegorz Młudzik, Marian Dworakowski, and Przemysław Walich as Antonio, Alonzo, and Sebastian respectively deliver their verse (and prose) hardly opening their mouths, adding minimal or no colouring, but strictly obeying the verse lines. So do Janowska-Moniuszko as Miranda and Paweł Niczewski as Ferdinand, although Miranda at times adds more colouring. Such a delivery fits the metatheatrical notion of their being marionettes in Prospero's hands, but it also references a "postdramatic" or anti-performance style of speaking. Ariel's playfulness suits Litkowski's eclectic delivery that explores different ways of chanting verse such as religious mass, counting-out, or a children's rhyme. These styles are sharply contrasted by Kierc. As Prospero, he tends to recite – rather than speak – his lines. He often vocally and, occasionally, physically explores verse melody and over-enunciates vowels, consonants, and the rhythm of Prospero's verse, which in Stanisław Barańczak has mainly lines oscillating between ten and 12 syllables and many following the iambic pattern. For example:

Co uczyniłem, to w trosce o ciebie,	x XxXx x Xx x Xx	No harm.
O ciebie, córko moja, która nie wiesz,	x Xx Xx Xx Xx Xx	I have done nothing but in care of thee,
Kim sama jesteś – bowiem nie wiesz nawet,	xXx Xx Xx Xx Xx	Of thee, my dear one, thee, my daughter, who
Skąd ja pochodzę, i nie podejrzewasz,	x X xXx X x XxXx	Art ignorant of what thou art, nought knowing
Żem jest czymś więcej niż twój ojciec. (1.2, 2)	x X x Xx X x Xx	Of whence I am, nor that I am more better Than Prospero, master of a full poor cell, And thy no greater father. (1.2.15–21)

The melodic delivery seems awkward and dated in comparison to other actors, especially when Kierc begins moving to the rhythm in a way that reminds one of a staccato-moving snake. While perhaps an association here with Kierc's collection of poetry (also adapted as a one-man show) *Zaskroniec* (*Grass snake*) may be too far-reaching, his real-life identity – highlighted

by verse – is of extra importance as it emphasizes the consciousness of his performance and the metatheatrical frame.

Kierc is a renowned poet and was for many years a verse-speaking lecturer at the National Academy of Theatre Arts in Wrocław. He is also the person from whom Augustynowicz took over the artistic leadership of the Współczesny Theatre in 1992. *Burza* acknowledges this metatheatrical tension through the presence of the pregnant Sycorax (Ewa Sobiech) and linking her to Prospero as both stuck on the island and in their vulnerable bodies. Sycorax-Sobiech often comments on Prospero-Kierc's lines by laughing or pre-empting his lines. For example Sycorax-Sobiech says, "Wszystko układa się po mojej myśli" (1.2, 24) ("It goes on, I see, / As my soul prompts it") (1.2, vv. 423–24), and Prospero-Kierc repeats it and stresses "mojej" ("my"). Kierc often watches events on the stage with his back to the audience, as if he were a director. And verse, by emphasizing the performance context in the space so tantamount with Augustynowicz, invites a spectator to imagine Augustynowicz's presence in the audience.

Kierc's Calibanesque verse delivery reaches its peak in the epilogue which brings together Augustynowicz's dramaturgical frameworks to an anticlimactic ending. Kierc speaks a shortened fragment of Prospero's final monologue:

Klaśnijcie w dłonie a moc zaklęta	xXx Xx xX xXx	But release me from my bands
Pryśnie i spadną ze mnie pęta;	Xx x Xx Xx Xx	With the help of your good hands:
Zaśmiejcie się – a wasze tchnienie	xXx X x Xx Xx	Gentle breath of yours my sails
Żagiel mój wydmie i na scenie	Xx x Xx X x Xx	Must fill, or else my project fails,
Spełni się sztuki zamiar prawy:	Xx x Xx Xx Xx	Which was to please.
Dobrej dostarczyć wam zabawy.	Xx xXx X xXx	(. . .)
Każdy z nas ma do łaski prawo,	Xx x X x Xx Xx	As you from crimes would pardon'd be,
Więc mnie rozgrzeszcie – bijąc brawo. (105)	x X xXx Xx Xx	Let your indulgence set me free. (vv. 9–13, vv. 19–20)

Barańczak translates the Shakespearean tetrameter of trochees and iambs into one built of trochees and amphibrachs (the last line is iambic); Barańczak's lines here, in general, follow the trochee-amphibrach-trochee-trochee pattern. These feet suit the Polish paroxytonic stress, which helps recreate the musical quality of the epilogue in the source text. In his delivery, Kierc distorts the pleasant regularity of the beat. He prolongs some stressed

vowels, and metre in Polish language relies on vowels and syllables, all of the same audible length. Kierc also plays with register, using low and high sounds randomly. His body continues the staccato-snake movement, which here looks physically tense. The result is a stylized performance of an ageing and failing body trying to keep up with the metre that escapes it. This works as an epilogue in the context of the play and of Prospero losing his powers, but also in relation to the dramaturgical exploration of vulnerability and the queries it poses, and the metatheatrical questioning of aesthetics. The delivery of the final two words "bijąc brawo" (clapping hands) accentuates the lack of resolution to the ethical and aesthetic questions in the production, extending its invitation to the audience to respond. Kierc releases any tensions and delivers the words with heavy simplicity, contrasting the celebration that "clapping hands" connote. He turns his back to the audience, looking at the platform that just minutes ago was occupied by an ensemble well known to the Szczecin audience (see Figure 3.1).

Such an anticlimatic finale suits well Augustynowicz's dramaturgical strategy. Her investment in vulnerability is articulated through her challenging of othering and the questions she poses and never answers. In contrast the next example makes a clear statement about the vulnerability it stages.

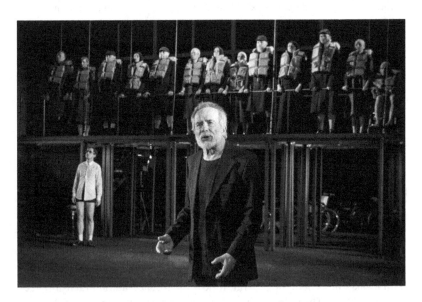

Figure 3.1 Bogusław Kierc as Prospero frees Maciej Litkowski as Ariel in *Burza* (*The Tempest*) by William Shakespeare. Directed by Anna Augustynowicz. Teatr Współczesny, Szczecin, Poland, 2016.

Credit: Piotr Nykowski/Teatr Współczesny.

The short movie *Heartbreak* – written and performed by the aforementioned Emmet Kirwan – was released on YouTube in January 2017 and two days later had almost a million views (McNeice); it received the Irish Film and Television Academy 2017 Best Short Film Award.

The six-minute movie in verse and a Dublin accent tells a story of Youngone (Jordanne Jones), a pregnant teenager growing up and raising her son in contemporary Ireland. The country that is struggling with, as Miriam Haughton says, "sociocultural engagement with notions of sex and the body that have been shaped and informed by history, politics and [the Catholic] religion". The female body and sexuality constitute "the battle ground on which religious and juridical struggles are fought as the various power regimes compete for dominance to manage and regulate the public and private social spheres" (Haughton 69). Haughton refers here to the Eighth Amendment of the Constitution Act 1983 which marked the equal right to life of the pregnant woman and the unborn and made abortion in Ireland practically impossible (finally repealed in Ireland in 2018). She also talks about "the lack of public discourses in relation to sexuality, the body and individual agency in Ireland throughout the twentieth century" (Haughton 70). Even though the 1990s introduced the so-called Relationships and Sexuality Education, most schools are run by the Catholic Church, with its ethos overshadowing the fear- and abstinence-based teaching as highlighted in the 2019 review commissioned by the Irish government (Carl O'Brien).

The lack of agency constructed by the inequality ingrained in Irish society, governmental indifference, and the lack of proper sexual education underlie the vulnerability of Youngone in *Heartbreak*. Verse stages her journey towards claiming her agency. The camera flips between Kirwan delivering the poem in different Dublin locations and the images from Youngone's life. Neglected by parents (one never sees her father and mother's struggles with addiction), school, and government, she faces alone her first catcalls and first intercourse in "a wet patch of grass" (01:39). She has no support during the patronizing talk by a pharmacist refusing her a morning-after pill, pregnancy (she has no money to go to the UK for an abortion), and motherhood in a house where her mother's boyfriends keep making sexual innuendos. Verse marks these moments with the "C'mere, / c'mere, / c'mere" lines that one hears anytime Youngone faces sexism and neglect. Rhymes help us to follow Kirwan's dynamic delivery and emphasize key points in Youngone's story that challenge the dominant association of vulnerability and passivity (Butler et al. 1), like when Youngone moves out of her mother's house and asks her "Blueshirted TD" (Irish MP) for help:

And the problem compounds
when he says
Go back to your mum's.
(3:10–14)

"Blueshirts" is a nickname for Fine Gael, the Irish conservative party, that references its violent and far-right past (Gallagher 61–62). An approximate rhyme reinforces the government's neglect of the young mother. Rhyme also highlights when an individual (male) member of the public exacerbates his vulnerability to Youngone's lonely motherhood, which, as Butler et al. point out, supposedly justifies the neglect and containment of the Other (3–4):

> Look at her
> She looks fine to me
> My tax Euros mean
> She gets everything for free.
> (3:27:3:32)

Working zero-hour contracts, Youngone enrols in education courses and, inspired by a teacher, gets a "yearning for learning" and earns an undergraduate degree:

> She is not l*earning*
> For *earning*
> No, she is just l*earning* for l*earning* sake
> So that she can articulate this is incandescent rage between
> All the young women of Ireland in 20*16*.
> (4:19–33)

The density of assonances and rhymes here (in italics) – that Kirwan extra-emphasizes with his delivery – marks the turning point in Youngone's story. They also reaffirm the absence of her voice in the movie narrated by a male and facilitated by patriarchal structures. Verse highlights this from the start by bringing up the virtual and physical presence of Kirwan as writer and performer. This is a conscience dramaturgical choice that facilitates both the individual story of Youngone and a larger narrative of Ireland's journey towards equality. *Heartbreak* reveals this when Youngone faces more sexist remarks on the street, but this time one hears Jordanne Jones (as Youngone) responding. Jones and Kirwan speak together with the pattern of three instances of "C'mere" highlighted by rhyme with "here" and linking this moment to all others in which one saw her being abused:

> Stop!
> H*ere*,
> C'm*ere*
> C'm*ere*

C'm*ere*
I'm not defined by the fact
I am some man's daughter,
sister, cousin, mother.
I am a woman
And I have agency just because I'm breathing air mother fucker.
I'm standing here mother fucker
and you and the state are the ones trying to fuck me.

(5:00–20)

And, as she finishes, the camera moves from her to her son's face, and one begins to realize that he is the narrator in *Heartbreak*. The movie ends with the son's "invocation" to his mother "Here, Ma" (echoing previous "here-c'mere" rhymes and marking its own subversion) and a promise that he will work towards an Ireland "That will stand in awe / Of all mná" (6:05–19). The rhyme between "awe" and Irish "mná" (women) emphasizes the promise and echoes Anglo-Irish traditions and Ireland's fight for independence, by extension, articulating that the historic fight for Ireland is still in process and must be intersectional. Kirwan relates it also to a global context reflecting how Youngone's "fifteen-euro boohoo" is "made by her counterpart on the other side of the globe" (3:23–27).

Heartbreak's final call for a fight is the element that links Kirwan's work with verse dramaturgies that structure a challenge, to use Baz Kershaw's definition of protest, to "the entropic resistance of histories shaped by dominant socio-political forces" (*The Radical* 90). Verse supports the productions in forming "a direct political action, enacting and making visible opposition to existing conditions", which, as Lara Shalson argues, is a key difference between theatre as protest and theatre that "merely illustrate[s] political issues" (12–13). In doing so, the verse dramaturgies I discuss pose a challenge to those questioning how theatre – especially theatre performed in traditional spaces – can have an actual impact in the social world (Shalson 6, 18; Kershaw, *The Radical* 16; Handke 9); even more so, as they are created and performed in institutional and mainstream contexts of New York's Public Theatre, the Globe, Broadway, and the West End.

Versed dramaturgies of protest

In November 2016 Donald Trump – known for his anti-immigrant and racist sentiments – was elected president of the United States. A week after the election, the cast of *Hamilton*, led by Brandon Dixon – and cheered by the audience – delivered a speech at the curtain call to US Vice President Mike Pence (present in the audience) expressing their anxiety about the impact

of Trump's administration on equality, the environment, and democracy in the US. The protest drew much international publicity, fuelled by the fact that *Hamilton: The Revolution* (2015) itself – considering its themes, title, and that it became a global brand – has been arguably the most publicized theatre protest against right-wing politics in recent history.

Lin-Manuel Miranda wrote and composed *Hamilton*, dramaturging it carefully to deconstruct the WASP-ness of the mainstream discourses of US history and how it underlies the inequalities and racism of American society. To do that, Miranda uses, as Philip Styrt points out, audiences' familiarity with "racially biased history" and challenges it through a radical choice to retell it in rapped verse and with a cross-racial cast (Styrt 14), which verse, through its performativity, emphasizes. Miranda's use of rhyme and the performances' liveness (highlighted by verse) helps contextualize this retelling and the protest attached to it as an answer to increased right-wing narratives in the US and, arguably, the world. It also reminds audiences of the performers' identity beyond the cross-racial casting. For example after the curtain call protest, the media highlighted that Javier Muñoz (Hamilton on Broadway between 2016 and 2018) is an HIV activist, openly gay, and HIV-positive (Schulman). In the 2019 Puerto Rico run, Miranda's performance as Alexander Hamilton and his Puerto Rican roots were extra-emphasized, highlighting the meta-narratives of the story of Hamilton as a man born in the Caribbean and pursuing his dreams in New York (Paulson and Henríquez).

Miranda's verse also highlights the story's contemporary relevance by emphasizing words through rhymes and rhythms. An example is "Guns and Ships", a song in which the anachronistic rhyme shower / global super-power gives contemporary context for the line about immigrants as "a secret weapon":

> How does a ragtag volunteer army in need of a sh*ower*
> somehow defeat a global superp*ower?*
> How do we emerge victorious from the quagm*ire?*
> Leave the battlefield waving Betsy Ross' flag h*igher?*
> Yo. Turns out we have a secret weapon!
> An immigrant you know and love who's unafraid to step in!
> He's constantly confusin', confoundin' the British h*enchmen.*
> Ev'ryone give it up for America's favorite fighting Fr*enchman!*
> (Miranda, *Hamilton* O.B.C.R.)

At a live West End performance I attended in 2018, despite the anti-British sentiment, the immigrant line received loud cheers from the audience. Even louder was the reaction to "Immigrants / We get the job done", sung by the

Hamilton-Lafayette duet (James Westman and Jason Pennycooke) in "Yorktown (The World Turned Upside Down)". The lines were relevant to the UK context because of Brexit and its xenophobic sentiments (Burnett) and the verse rhythm supported that by highlighting the liveness of the show.

Verse in *Hamilton* is also a powerful example of how its heteroglossic form challenges authorial vision by revealing Miranda's stereotypical portrayal of females and, arguably, his dramaturgical glitch. I am not alone in seeing the issue with female representation and agency in *Hamilton*. Stacy Wolf delivered a compelling study on how the show "puts women on the sidelines and relegates them to the most obvious and timeworn stereotypes of wife, muse and whore" (167). Wolf stresses that rap is a form associated with men in *Hamilton* (173) and – which links with Wolf's point – free speech, agency, and revolution, emphasizing the lack of female agency. This is particularly given its subtitle "Who lives, who dies, who tells your story", also reinforced by its song "History Has Its Eyes on You" and the reprise in the finale. The paradox becomes obvious at the end of the show when one learns that it was Hamilton's wife Eliza (played by Phillipa Soo and Rachelle Ann Go amongst others) who carried his story and, therefore, should have been the one rapping the opening "Alexander Hamilton":

> How does a bastard, orphan, son of a whore
> and a Scotsman, dropped in the middle of a
> forgotten spot in the Caribbean by providence,
> impoverished, in squalor,
> grow up to be a hero and a scholar?
> (Miranda, *Hamilton* O.B.C.R.)

The finale puts a spotlight on Eliza but, as Wolf puts it, "This gesture cannot undo what the past 150 minutes have been about: men" (168); or, as Phelan would put it, Eliza's "visibility is a trap" because the terms of this visibility means that she is refused any political agency (Phelan 6–7), as revealed by the absence of rap in her lines.

I want to focus on the only moment of the show when one hears a female rapping. The song "Satisfied" features Angelica (Eliza's sister and Hamilton's "muse", played by Renée Elise Goldsberry and Rachel John amongst others) rapping:

> So so so –
> so this is what it feels like to match wits
> with someone at your level! What the hell is the catch? It's
> the feeling of freedom, of seein' the light,
> it's Ben Franklin with a key and a kite! You see it, right?

> The conversation lasted two minutes, maybe three minutes,
> ev'rything we said in total agreement, it's
> a dream and it's a bit of a dance,
> a bit of a posture, it's a bit of a stance. He's a
> bit of a flirt, but I'm 'a give it a chance.
> (Miranda, *Hamilton* O.B.C.R.)

This moment, as Wolf rightly observes, reveals that "she ably communicates in the same competitive, athletic musical genre that the men use and that Hamilton values most: rap" (173). However, "Satisfied" seems to link Angelica's ability and wit with her quasi-phallic qualities, further associating masculinity with power and femininity with the lack thereof. Hamilton sings to Angelica "You're like me"; and she raps: "My father has no sons so I'm the one / who has to social climb for one". The enjambment that creates a pause after "one" – clearly audible in the performance of the song – suggests that Angelica is a substitute for a son and therefore – re-marked with a quasi-phallic power (Phelan 5) – is allowed this momentary freedom of rap. Moreover, this short appearance of rap only highlights the lack of female rapping in any other songs and how their political agency is silenced. Therefore, while Miranda uses verse to challenge the racial prejudice of American history, he also falls into the expectations for stereotypical gender representation in commercial Hip Hop (Bradley 181–82), reinforcing connections between gender and language. These connections underlie the critical role of language in constructing both the agency of and violence against women, which is precisely what *Emilia*, a play by Morgan Lloyd Malcolm, interrogates and protests.

Emilia premiered in 2018 the London's Globe, just as the #MeToo movement was at the top of news feeds and front of newspapers; and in 2019 it transferred to the West End's Vaudeville Theatre. The play is inspired by the life of Emilia Bassano, a seventeenth-century English poet and, according to some theories, the "Dark Lady" of Shakespearean sonnets (Green) or even an author of works attributed to the "Bard of Avon" (Hudson). Malcolm entertains both theories. Her Emilia(s), performed by three different actresses from ethnic minorities "to represent the three ages of her" (Malcolm, "A Note" vii), is, as Malcolm describes, "fiercely intelligent, a writer, a survivor, a fighter, a mother and an educator" ("Introduction to the Poems" 77).

Commissioned by the Globe, directed by Nicoe Charles, and performed by an entirely female and multiracial cast (putting its themes in the intersectional context), the play is not a verse drama; its dialogue, with one exception, is written entirely in prose. However, it uses poetry in verse – placed in strategic moments – to carry its key themes of female solidarity, male-to-female oppression, and writing. Verse, through its formal structure,

highlights these key moments and allows them to echo each other. This adds an inter-temporal dimension to the story of oppression in the play and pushes for an inter-temporal community of women. In turn, the play and the production become carefully dramaturged theatricalized protests; and the echoing dramaturgical structure that verse establishes helps push the protest beyond the time frame of the performance into the social world.

One first encounters verse in *Emilia* when she meets Shakespeare (Charity Wakefield). As he attempts to woo and test her (as a poet) with his "Sonnet 128" ("How oft, when thou, my music play'st"); Emilia1 (Saffron Coomber) responds in verse that one may recognize as Rosaline's response to Berowne in *Love's Labour's Lost* (5.2 vv. 67–71):

> How I would make him fawn, and beg, and seek,
> And wait the season, and observe the times,
> And spend his prodigal wits in bootless rhymes,
> And shape his service wholly to my hests,
> And make him proud to make me proud that jests!
> (Malcolm, 1.5, 25–26)

Even if one does not recognize the lines, it is clear that Emilia answers to Shakespeare in the form he proposed and is equally fluent in it. This could be read as Emilia quoting work that Shakespeare has already written. However, as he never acknowledges it and the verse appearance is preceded with his question "You write?" (1.5, 25), one understands that these are supposed to be Emilia's verses. Malcolm builds here on the tension between orality and writing that verse emphasizes, and how the form references the virtual presence of the playwright and their writing. On the one hand, the verse rhythm brings about Shakespeare as the author of *Love's Labour's Lost*; on the other hand, one witnesses these lines being authored by somebody else. The orality-writing issue comes back one scene later as Emilia2 (Adelle Leonce) accuses Shakespeare: "You used my words and stories . . . and yet only your name is known" (1.11, 39) and he refuses to grant any ownership to Emilia: "No one owns words spoken. . . . It means nothing until it is on a page" (1.11, 37–38). This tension between writing and orality also frames Emilia's later quest to publish her and other women's poems as a quest for socio-political change and for the right to have their voices heard and remembered. Malcolm plays here with the tensions and co-dependency between writing and orality in acts of social remembering (Misztal 29, 100) and with links between enforced orality and patriarchal containment (Klarer 130).

This is even more so, as poetry in verse continues to carry the themes of oppression and female solidarity. Lady Anne (Tanika Yearwood) – Emilia's

student – reads a stanza from an English verse translation of Ovid's *Meta-morphoses*; it comes from Book VI and tells about Procne's anger as she finds in the woods her sister Philomela, raped by Tereus (Procne's husband), who has also cut Philomela's tongue out, so that she cannot tell what happened. Emilia2 and Lady Anne's subsequent discussion explains the passage and Philomela's story and, crucially, how she found a way to write her story into an embroidery that she sent to Procne (2.2, 48–49). Later on, Eve (Jackie Clune) – one of the women from the then disreputable area of South London whom Emilia teaches literacy skills – writes a poem inspired by Emilia's works:

Where are you going to horrible bastard?
You owe me coin for that tr*ick*
Don't run from me if you now what's good for you
I'll make a tree of you with this st*ick*
I don't care how much you hit me
My husband does it so much I'm blue
But if you take my coin I'll kill ya
That's just what a girls gotta do.

(2.6, 60)

The pair of rhymes that connects "stick" and "trick", on the one hand, carries an innuendo; on the other, it reveals the lack of emotion with which Eve perceives her profession. Such a representation challenges the perception of Eve as an object of pity and instead highlights her agency, resisting patriarchal tropes, and echoing both the feminist scholars like Phelan, Elin Diamond, and Kim Solga (Phelan 5–7, 19; Diamond 48–49, 83; Solga 27, 33) and the 1997 "Sex Workers' Manifesto". To paraphrase the manifesto (Sex Workers' Education Network), the rhyme highlights the radical shift from representing Eve as from "the margins of society and history" to portraying her as a legitimate worker and an equal part of the inter-temporal female community the play seeks to facilitate. The stick-trick rhyme also carries another allusion. It is hard not to think that there is a third unspoken rhyme here and that the audience is meant to hear in their heads "fucking prick". This is in the context of human attraction to patterns and pleasure in mastering them (Costello 173), and in the frequency with which the word "fuck" is used in the play, carrying both the anger and the challenge of gender roles (Lakoff).

Eve's quest for knowledge in *Emilia* becomes the reason for her punishment, helping connect her name with the Biblical Eve and, consequently, adding more temporal layers to the story of female oppression that underlies *Emilia*. Verse emphasizes the critical moments through its form and through

references to verse works. Women come together to publish Emilia's work at the same time as one learns that Emilia's friend Lady Katherine (Nadia Albina) has been abused by her husband (2.7, 66–70). They also distribute pamphlets with their own poetry. Eve writes another poem for the pamphlet about her experience of being marginalized and silenced:

> There is volume in my silence
> If you stop to listen
> Look into my eyes and you will
> Hear quite clearly what I'm trying to say
> Be careful, I am saying
> Be careful
> What you have taken is not yours
> And one day, loudly, I shall take it back.
>
> (2.8, 71)

The poem carries the essence of the play's call for female agency, but it also marks the development of Eve as a poet. Her writing is more diverse now; the play makes a point of not marking which of Eve's poems is better; in fact, it is the first one that gets more cheers (2.6, 60). The reading of Eve's second poem is followed by the news that she has been arrested, caught with the pamphlets, as her poem was "the devils work" (2.8, 72). Emilia3's (Clare Perkins) lines help link Eve's fate with that of Philomela, expressing anger that they "could not go to her like Procne went to her sister" (2.8, 72).

The play ends with a scene between Emilia3 and the ghost of Shakespeare, and her reclaiming of her creative space. As Shakespeare calls any theatre "My gaff", Emilia responds: "Not right now it isn't" (2.9, 73). The line had extra meaning when performed in the Globe, and reviewers reported cheering and howling (Sadler; Taylor), but the fire power of *Emilia*'s final moments was no less during its West End run, which I experienced. The cheers and hollering continued during the final appeal of Clare Perkins as Emilia3 delivered directly to the audience and with all the cast cheering onstage (see Figure 3.2):

> Listen to us. Listen to every woman who came before you. Listen to every woman with you now. . . . The house that has been built around you is not made of stone. And if they try to burn you, may your fire be stronger than theirs so you can burn the whole fucking house down.
>
> (2.10, 75)

The final call turns into a dance in which many spectators participate, continuing to holler.

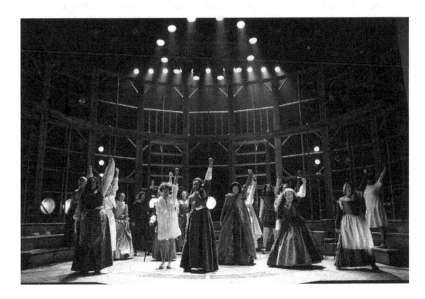

Figure 3.2 Clare Perkins as Emilia3 leads Emilia's final appeal as the cast cheers on the stage in *Emilia* by Morgan Lloyd Malcolm. Directed by Nicole Charles. The Globe. The Vaudeville Theatre, London, UK. 2019.

Credit: Helen Murray/ArenaPAL.

And the hollering continues on social networks with hashtags #ForEvery-Eve, #IAmEmilia, and #EmiliaFamilia taking over from verse in connecting different women and their experiences. This from-verse-to-Twitter-rally is also an example of how verse facilitates the transfer of the theatre's political investment into the social world. Furthermore, the creative team works to broaden "Emilia Familia", with Nick Hern Books making the performance rights available for free to educational institutions.

Conclusion

Verse in this chapter revealed itself first and foremost as a site of agency. Artists discussed in this chapter used the dialogic quality of verse to explore tensions and contradictions between visibility and agency, echoing Peggy Phelan's (5–7) and Hannah Arendt's arguments (50, 175–76, 179–80). Verse as a site of agency operated in relation to the marginalized individual and communal experiences but also in relation to theatre-making, with actors turning to writing verse plays to take control of their creative destiny. This is

what – together with low funding – perhaps underlies the lack of dramaturgs in this chapter. Verse seems to encourage a more collaborative and flexible approach to theatre roles, enhancing my call from the introduction to prepare actors to take the opportunities that verse gives them.

The heteroglossia of verse in works discussed here facilitated deterritorializing dramaturgies, making and seeing connections between the theatre and social worlds and between the individual, local, and global "as potentially expanding, transcultural, and open-ended" (Eckersall et al. 20). Verse staged, investigated, and challenged dichotomies and hegemonies operating within various cultural, temporal, and geopolitical contexts, and interrogated the tensions and connections between. However, the artistic responses to pertinent social and political issues varied dramaturgically and aesthetically, corresponding to a wide selection of works that included classical dramas, musicals, new writings, and films. In several cases, the dialogic quality of verse supported the artistic search for new aesthetics, which the next chapter charts further. It shows how a highly rhythmic and stylized language can be a gate towards "a new theatre in which dramatic figurations will come together again, after drama and theatre have drifted apart so far", the arrival of which Lehmann prefigured in *Postdramatic Theatre* (144). And some productions analyzed in this chapter support that point. Postdramatic aesthetics in Augustynowicz's take on *The Tempest*, for example, suggest that the potential for this new theatre has already been inscribed within the verse and waits there to be rediscovered.

4 Verse and new theatre forms

Thus far, this book discussed verse as a platform for dramaturgical structures and deconstruction, political and social interventions, encounter, and artistic search for new aesthetics. This chapter builds on that, engaging with productions that explore the formal boundaries of verse, drama, and theatre, and in which verse fuels radical and often politically motivated formal intervention, rooted in both dramatic and postdramatic traditions. The discussion shows that verse both facilitates a search for new hybrid forms and functions as a model for a relationship between dramatic content and form.

The preceding chapters suggested that verse in theatre complicates the dominating Hegelian idea of the relation between dramatic content and form as dialectic and challenges Aristotelian ideas on form as ahistorical (Boyle et al. 2–3; Ainsworth). The examples in this chapter embrace this relation as dialogic. They bring to the fore and embrace the coexistence of multiple perspectives and contradictions. In other words, the forms they are built on follow Theodor W. Adorno's idea and are rooted in the "world from which they recoil" (Adorno, *Aesthetics* 6); however, they also reflect this world's multifaceted and pluralistic nature. In turn, rather than carrying a unifying function – as Aristotle insisted (Ainsworth) – these forms become decomposing agents. A visual equivalent would be a prism decomposing white light into multiple colours. By extension, the dramaturgies of form discussed in this chapter facilitate not one but multiple contents that coexist and interrogate each other through an infinite dialogue, without the possibility of a final conclusion. And this emphasized infinite potential for new contextual meanings is a key difference between the dialectic and the dialogical (Bakhtin, *Speech* 162; Wegerif 18–20). In turn, the discussed productions offer new self-consciousness in relation to literary and performance roots of drama and theatre, representation (that often takes a dialogic form), individual and community, past and present, as well as larger political, social, and cultural contexts. In short, following Adorno's reading of Samuel Beckett's

Endgame (to which I return later in this chapter), they become "a test-tube study on the drama of the age" ("Trying" 260).

This is even more so as the discussed works explore levels of presence, structures of liveness, and the impossibility of mimesis; emphasize theatricality; enhance musicality; and increase the importance of orality as means of interacting with and affecting audiences during a performance. These are qualities associated with postdramatic theatre (Lehmann 69, 91, 143, 149; Szatkowski 234–35). Crucially, however, these postdramatic qualities in selected works grow out of the text's rhythmical levels. The heightened form of the text also structures these works' self-reflexivity and self-referentiality, key concerns for postdramatic dramaturgies (Kaynar 393). In other words, while postdramatic theatre shifted "*toward form* and 'away from' drama" (Boyle et al. 2), the dramaturgies discussed in this chapter use postdramatic tools to emphasize their shift *towards form* and *towards dramatic text*, attempting to reformulate the importance of the staged text in the performance via its rhythmic levels and finding new ways of representing dramatic dialogue (see Szondi 195).

If, as this chapter suggests, theatre is ready for "a return of conscious and artificial stylization" as a platform for a new dramatic theatre, as predicted by Lehmann (*Postdramatic* 144), then this chapter is a starting point for documenting a turning point for contemporary Western theatre. And for this reason, its structure differs from the previous chapters of this book. The first section is a survey of international verse-based experiments in theatre in the twenty-first century. In the latter part of the chapter, I focus on how the Polish Marta Górnicka creates and uses a verse-derived form for her anti-Aristotelian exploration of nation, community, and theatre in *HYMN D✿ M✝ Ł♡ ŚCI na orkiestrę, chór pluszaków i innych* (*HYMN TO LOVE for Orchestra, Stuffed-Animal Choir, and Others*).

Testing the boundaries of forms and genres

One way in which artists explore the formal boundaries of verse, drama, and theatre is by mixing elements of different modes. An example is the Irish Mark O'Rowe's *Terminus* – a prose play enriched with superimposed internal rhymes that help interlock the monologues and stories of a young woman, her mother, and a serial killer. The Polish Julia Holewińska employs rhymed prose for a Female Chorus and Male Chorus in her *Ciała Obce* (*Foreign Bodies*). The play explores issues of sexuality and freedom in pre- and post-1989 Poland but also, on another level, deals with undervaluing the role of women in overthrowing communism.

A rhyming chorus is also a key feature in Antonina Grzegorzewska's adaptation of Sigrid Undset's short story *Thjödolf*. *Migrena* (*Migraine*) is

written in prose but features rhymes and the chorus of three Pigs, who comment on the events, while awaiting their death in a slaughterhouse:

Świnia 1: Mięso na stole.	Pig 1: Meat on the table
Świnia 2: Jabłka w *ryj. a*	Pig 2: Apples in a *snout. a*
Świnia 3: Gdzie knury	Pig 3: Where are the boars?
Świnia 2: Wrzeszcz, z rozkoszy *wyj. a*	Pig 2: Yelp, with sexual pleasure *yowl. a*
Świnia 1: Gdzie nasze koryto, zapomnieli dziś o nas.	Pig 1: Where is our trough, they forgot about us.
Świnia 3: Już niosą *pomyje. b*	Pig 3: They are bringing *hogwash. b*
Świnie 1, 2, 3: Już zakładają stryczki na *szyję. b*	Pigs 1, 2, 3: They are putting nooses round our *necks; b*
Świnia 3: My też mamy mleko. Nie tylko Fanny wyciera piersi. Nam też kapie. (1)	Pig 3: We also have milk. Fanny is not the only one drying her breasts. Our breasts are also dripping.

The rhyming patterns explore the anthro-patriarchal structure of society and language and speak to a vegan feminism that integrates the oppression of animals into the analysis of patriarchal culture (Adams 58). Anna Augustynowicz explores connections between language and the circle of oppression in meat-eating and sexual consumption (see Adams 158) in her 2010 production, emphasizing the oppressive structure that the rhymes highlight. Her actors speak and move mechanically as if detached from emotions; they use various elements of scenography to beat the rhythm to which other actors move. The formal structure pushes the slaughterhouse (evoked by the scenic space) beyond a role of a metaphor's vehicle, facilitating its vegan feminist interest, and, on a meta level, its awareness of its own failure or refusal to create a mimetic representation, in terms of both reality and the source text.

Some artists take the mixing of different modes further and stage their "wrenching" with the form. This term is used by Pedro de Senna to describe *Carthage/Cartagena*, by the nomadic artist Caridad Svich, as she describes herself ("Visions of Migration" 13). De Senna says that the languages in *Carthage* "are being wrenched from one another" (86). *Carthage/Cartagena* is written in English and Spanish and verse and prose that are additionally geographically organized on the page. With no conventional characters, scenes, or acts, *Carthage/Cartagena* is divided into what Svich describes as "ten cantos and a prayer for performance" ("*Carthage/Cartagena*" 99). "El canto" in Spanish means "singing", "a song", but also "an edge". In line with that, the text interrogates displacement and isolation in the context of forced migration,

human trafficking, and slavery. De Senna – whose enlightening essay positions Svich's work in dialogue with Federico García Lorca, Samuel Beckett, Antoine Artaud, Elinor Fuchs, and others – describes *Carthage/Cartagena* as a "landscape". This is a reference to the ancient city Carthage and the text's postdramatic qualities (de Senna 84). With the latter, he appropriates Elinor Fuchs's use of landscape (Fuchs 104) to highlight how "the prevalence of imagery, the arrangement of the words on the page itself, camouflages" *Carthage* and its meanings and, at the same time, reveals the play's "doubleness". De Senna refers not only to the title, bilingualism, but also to certain themes like hope and memory, pastness and presentness, victim and perpetrator, and the nomadic structure that travels through the world, and in particular its English, Spanish, and American parts (de Senna 90–96). It also refers to *Carthage*'s use of postdramatic tools to reinforce the role of the text in theatre. As de Senna argues, the text is the protagonist here (86). And, it could also be used to reveal de Senna's epistemological perspective in the essay as a scholar and a dramaturg for Signdance Collective International's staging *Carthage* (2017). In it the poetry of the play is adapted into a choreography based on sign languages, which de Senna explores in his essay.

I want to focus on de Senna's use of "doubleness" and replace it with the idea of dialogism, which links directly to how Svich uses verse and its heteroglossia to reinforce the play's preoccupation with displacement and, as she says, to rebel against "Western canonical forms" ("Email"). Svich's verse seems relatively free, with lines varied from one syllable "in/the/country" (*Carthage* 119) to much longer such as the 18-syllable "And in that time think about when there wasn't a murmur on this planet" (126). The different lengths of the lines link with the weight attached to the words. For example the following lines come towards the end of Canto Five which explores the precarious spaces of forced displacement:

> a border station, a waiting post, holding pen, detention center . . . we could have been in Srebrenica, Dresden, Damscus, or Falujah; Auschwitz or Abu Graib; in a Holocaust train, in the back of the truck, or in the bowels of a slave-ship.
>
> (de Senna 91)

> We're far away now. We're almost
> in
> the
> country.
>
> (*Carthage* 119)

The short lines announce the (almost) end of the journey and the unknow-
ness of the country, emphasizing the precarity and vulnerability attached
to forced displacement. They also emphasize the unique spatial status of
the space and the experience that Serena Parekh describes as being "simul-
taneously within the state and outside of it" (29–30). This does not differ
from how verse operates in several other dramaturgies in this book. Svich's
experimentation is in how the meta struggle of verse mirrors the experi-
ence of displacement. In doing so, on the one hand, she presents her text as
landscape (de Senna 84); on the other hand, she refuses for it to become an
enclosed territory, linking her dramaturgy to contemporary nomadic prac-
tices (Nibbelink 4).

Svich achieves such a nomadic formal effect through rare, but notable
appearances of more formal elements which are carefully (de)placed. Through
that, she creates an impression that the form not only moves the words – Derek
Attridge talks how verse rhythm "makes a physical medium (the body, the
sounds of speech, or music) seem to move with deliberateness through time"
(3–4) – but also that the form itself is in constant movement, speaking to the
broader themes of the play and to Svich's search for new forms. For example
six lines in Canto One end with either "yes", "says", or "mess", which clearly
rhyme. The first appear in the opening prayer (*Carthage* 101) that – as de
Senna argues – is brought by the "inadequacy of language" (87). But the next
"rhyming" line does not happen for 90 lines (it is "mess" on p. 104); after-
wards, the proximity between the rhymes decreases to, respectively 17 and 16
lines, and finally takes the more recognizable form of abcbdeb:

> speak
> it s*ays b*
> pray,
> it s*ays b*
> love
> *No puedo*
> Before y*es b*

(105)

The intensification of the rhymes emphasizes here a tension between the
mastery of language that verse form and rhymes suggest and the "No
puedo" (in Spanish "I cannot") undermines. The tension – facilitated by
heteroglossia – highlights text's different temporal frames and stages of
language acquisition, which links with how the proximities between the
rhymed lines make it into an echo of a rhyme or a distant memory, rather
than a full formal feature. As the proximities decrease in the lines quoted
previously, the memory reveals itself, crossing the temporal borders, and

supporting the temporal structures in *Carthage* that de Senna describes as divided between the present and before, which echoes the experience of displacement and trauma (90–94). The "now" and "before" are also brought together by the intensified formal pattern of rhymes, iambs, and trochees in Canto Five (which evokes spaces of forced displacement). The formal elements appear in memories of home in the Nana's song, revealing larger transtemporal references and tensions between the safety of belonging, the precarity of displacement, and migration as an integral part of human development (Goldin et al.):

They went south to find the rain	x X X x X x X
They went north to stave off pain	x X X x X x X
They never ever did complain	x Xx Xx X xX
Of being lost. (113)	x X X

These examples illustrate how Svich's verse form is constantly in the process of redefining itself. Almost losing itself, it becomes prose, only to reinvent itself in the final prayer that repeats the opening prayer, this time, as noted by de Senna, as "a prayer for transformation":

I want to learn	x X x X
A new language	x X Xx
To return	X x X
The one	x X
I lost. (131–32)	x X.

The "Beckettian" image (also see de Senna 89–90) of a figure trying and failing to speak precedes the previous lines (as per the didascalies, 131) and suggests the transformative power of the text which the final prayer evokes (de Senna 87). However, the gradual shortening of the verse lines reveals that the language is disappearing again, and the wrenching continues.

While Svich's engagement with heteroglossia and hybrid form serves her exploration of displacement, in Bożena Keff's *Utwór o Matce i Ojczyźnie* (*A Piece About Mother and Fatherland*), "wrenching with the form" links with a search for one's own narrative in the context of bonding and binding connections. For both, destabilized identity is central and connected to formal experimentation. Keff's text deals with an oppressive relationship between mother and daughter, between an individual and their motherland, and it raises the issue of the Holocaust as an inextricable bond between Polish and Jewish in the context of Polish anti-Semitism (Janion and Filipiak 96).

Central to all these contexts in *Utwór* is trauma. Mother–Meter (from the mythological Demeter) – in Keff's text is a Holocaust survivor, who identifies herself through the personal and national suffering and her daughter through the lack thereof. *Utwór* – partly inspired by Art Spiegelman's comic *Maus* – puts, as pointed out by Maria Janion and Izabela Filipiak, the spotlight not on a Holocaust survivor but on her adult child: the daughter Usia (from Korusia, a diminutive of Kora). Usia – as they continue – is deprived of identity through her mother's constant bearing witness to and narratives of suffering and self-sacrifice (82–83). These narratives are also integral to the type of Polishness rooted – as Janion described on another occasion – in "the culture of the fallen, epigone Romanticism – the canon of jingoistic, sanctimonious stereotypes" ("List").

Janion and Filipiak explain how Usia attempts to define herself by looking into various cultural myths (86), which include Greek myths, the Bible, Polish Romanticism, *Tomb Raider*, and J.R.R. Tolkien's *The Lord of the Rings*. Usia's struggles are also performed through Keff's wrenching with the form. *Utwór* is primarily a notation of Usia and Meter's conversations; however, Keff does not present them in conventional dialogue form. Instead, she creates a book of poems (or songs) in prose and verse, divided into eight parts with a prologue and epilogue. This arrangement speaks to the lack of actual dialogue between mother and daughter but also allows Keff to play with genres. *Utwór* uses a chorus, evoking the Greek drama but also music genres. And some parts in *Utwór* are described through references to vocal qualities like "mother's soprano" (17) or as arias (56), bringing opera and oratorio (through biblical themes) to mind. Janion and Filipiak describe it as "a part poem" (82), which also speaks to the polyphony of Polish-Jewish history (Dobrowolski 160). Similar ideas – but more formalized – will be echoed in the latter part of this chapter that looks at Marta Górnicka's work. The point is that the flux-ness of the genre in *Utwór* matches Usia's attempts to define herself, as does the flux-ness of the language mode. Keff skips between prose and free, unrhymed verse; sometimes it is not clear when one begins and the other ends, as in "Piekielna infekcja" ("Hellish Infection"):

a co ty wiesz jak mnie boli, gdzie mnie boli, czy wiesz, co mnie boli, a może to trzustka,	what do you know about my pain, where it is, do you know what is painful, maybe it is a pancreas,
zaczyna się jakaś infekcja piekielna, trzeba zrobić badanie.	some hellish infection starts, check-up is a must.
Ale co takie badanie pokaże? Tylko śmierć, zresztą trudno je przeżyć.	But what will such a check-up show? Only death, and anyway it is hard to survive it.

Czy ty to w ogóle rozumiesz? Ty	Do you understand it at all? You think
myślisz, że życie jest proste,	that life is easy,
Co Tobie w ogóle się zdaje –	What do you even think –
A co ja myślę! Ja nic nie myślę!	What do I think! I don't think!
Mnie się trzęsą ręcę, ja się cała trzęsę	My hands are shaking I am shaking
i mówię:	and I say:
kurwa, człowieku, kurwa! (53)	for fuck sake, man, for fuck sake!

At the same time, sporadic rhymes emphasize the form, especially when they take a crude shape such as "Korusia-srusia" (shitty) (25), disturbing the gentle tone of the diminutive "Korusia" and the high tone of biblical and ancient references and the mother's recollections of the Holocaust. The flux-ness paradoxically highlights the heightened form, providing a much-needed aesthetic distance from a text that portrays a victim of the Holocaust and a mother as an oppressor to the extent to which her daughter utters the "unthinkable" thought "zabić cię, myśli Usia, jak cię nie zabili Niemcy" (how can I kill you if Germans failed) (57).

The flux-ness of form and its links with Usia's identity are at the core of Jan Klata's dramaturgical strategy in his 2011 staging at the Polski Theatre in Wrocław. In Klata's version, the chorus of females and one dressed-as-a-female-man (Wojciech Ziemiański) takes on the roles of mother and daughter, playing with different qualities of a speech sound: meloreciting, singing canon, speaking, and chanting. They are wearing black dresses denoting mourning and dreadlocks wigs that connote both the European traditions of Rococo and African tribes; their make-up also references African masks. The visual and aural effect is well exemplified by a long blonde plait (the Romantic symbol of Polish femininity) interwoven with dreadlocks and oppressively connecting mother (Halina Rasiakówna) and daughter (Paulina Chapko) as Chapko tries to separate herself.

The highlighted form in Keff's text also brings to the fore the tension between writing and orality. The latter both magnify and are magnified by the connections between Usia and Keff. Usia is the Narrator, and Keff admitted autobiographical inspirations for *Utwór* (Bielas). The writing-orality tension is the element on which Marcin Liber based his dramaturgy in the 2010 premiere of *Utwór* (Teatr Współczesny, Szczecin). Beata Zygarlicka as Usia is always onstage (even before the audience arrives), sitting with an open laptop through which she controls the projections on a screen behind her. Throughout the show, she also delivers lines from Keff's interviews. As observed by Ewa Guderian-Czaplińska, this adds a meta level to the therapeutic bearing witness ("Próby utworu"), both linking and contrasting mother and daughter. Irena Junn as Meter relives her suffering through oral

recollections – in the text Usia refers to it as "Pismo Oralne" (Oral Scripture) (15) – that her daughter presents in writing. This is emphasized by the verse form, and by the heightened style of Junn's performance, implying that Usia's writing summons Meter's orality.

Wrenching with verse takes a very different form in the solo *How to Keep Time: A Drum Solo for Dementia*, by British performer and poet Antosh Wojcik, and dramaturged by Yaël Shavit. Heteroglossia here is created by the relationship between the text and heightened rhythm, but the source of the beat is a Roland TD-4KP electric drumkit and, in a different sense, biomedical science. Wojcik delivers verse-poetry to the beat that he creates live onstage as he tells the story of his Polish grandfather's dementia. As the show and his grandfather's sickness develop, the beat of the drums begins distorting the speech. For example Wojcik's slow drumbeat makes his speech slow down to the extent that it is difficult to connect single syllables into words, representing degenerating speech as well as the loss of neural connections that causes it (Miller 182). The heightened form and autobiography also emphasize the presence of Wojcik onstage, which adds another context to the ways in which *How to Keep Time* explores the loss of speech, memory, and connectiveness. Wojcik's position as a third-generation Pole is powerfully symbolized by the spelling of his name as Antosh Wojcik rather than Antoś Wójcik or even Antoni Wójcik. In this sense, the "disappearing" speech also symbolizes Wojcik's inability to speak Polish and to communicate with his grandfather and father in Polish.

Wojcik's *How to Keep Time* links with the previous chapters' discussions on verse in autobiography, on dramaturgies concerned with precarity, and those exploring the connection between music and verse challenging Western traditions of "jealousies and rivalries" between the two genres (Black 10). This is, of course, not a new phenomenon. The singing and dancing choruses of Attic tragedy (to which this chapter returns), the theatre of W. B. Yeats or, inspired by Yeats, the theatre of Ted Hughes (Leeming 197–98) are probably the most prominent examples. However, the new verse works interact with music through multiple and diverse cultural references that they play on, juxtapose, and confront; *Hamilton* or *The Canary and the Crow* are both examples. This chapter wants to highlight the productions in which collaboration between music and verse pushes the formal boundaries between theatre and other arts.

Gig theatre – as "a hybrid of theatre and music gig" (Kendrick 48) – is the most obvious example. *How to Keep Time* – and also *The Canary and the Crow*, Kae Tempest's *Hopelessly Devoted*, or Omar Musa's *Since Ali Died* – would fit under its umbrella. However, using merely a "gig theatre" in this chapter would undermine the formal and cultural complexities of the works presented later that underlie their new aural and oral aesthetics.

First, *gig theatre* is a term particularly popular in the UK, and it brings to the fore the precarity of the theatre industry (Kendrick 48–49). And while this strengthens my earlier points about the suitability of verse-based dramaturgies for productions that perform and restructure precarious contexts, here I want to emphasize formal experimentation and ambiguity. Therefore, it is worth thinking about the music-verse hybrid in broader cultural terms. In Poland – for example – the works described as gig theatre could be classified as a form called "an actor's song", which is related to the European traditions of chanson, as well as to the modern French chanson (like that of Jacques Brel), and Bertolt Brecht's songs.

Such a multifocal lens emphasizes how the artists – as in *Ancient Rain* and *AURIC (Songs from a Golden Age)* – seek to submerge their audiences in transcultural and transtemporal aural experiences. *Ancient Rain* is a 2016 collaboration between the Australian artist Paul Kelly and the Irish singer-actress Camille O'Sullivan. It mixes rhythms of Irish poetry in verse (from W. B. Yeats and Seamus Heaney to Enda Wyley), with their Irish and Australian accents, and music to perform multiple characters and search for new forms. *AURIC* (2019) features verses from the Spanish Golden Age (including Lope de Vega and Pedro Calderón de la Barca) spoken and sung in Spanish and English by Paula Rodríguez (from Teatro Inverso) to the music written and performed by the French Arthur Astier.

A ja, Hanna (*And What About Me, Hanna*) is another example in which a hybrid of verse and music re-imagines a classical text. However, the aim here is to rediscover its source's affective powers. The Polish director Tomasz Hynek employs rock music to dialogue with Polish Renaissance poetry: Jan Kochanowski's *Treny* (*Laments*), written after the early death of his daughter Urszula. Hynek's show focuses on Hanna, Kochanowski's daughter, who died after Urszula, but for whom he did not write a series of laments. Kochanowski's verse, performed by Grażyna Rogowska to rock music, becomes a layered "act of indictment towards a father delivered through his own words", which, in return, highlights the core of Kochanowski's texts: the lament for lost loved ones (Rossa). The performance won a Grand Prix of Opolskie Konfrontacje Teatralne "Klasyka Polska 2011" (Theatrical Confrontation "Polish Classics" in Opole), an annual festival that brings together the most accomplished productions of classics in Poland.

The verse-music hybrid can also be politically driven as in *Unknown, I live with you*, by The Airport Society (2018). This mix-media installation, directed by Krystian Lada, uses projections, opera, and poems in verse by Afghan female writers. Through this, it creates a formal dialogic tension between elements associated with high-art and pleasure in Western culture and the global Englishes of the poems and the oppressive reality they expose, which is further emphasized by the scenic space connoting a

morgue (Araszkiewicz 2019; Lech 2020). These tensions dismantle, as Lisa Fitzpatrick puts it, "a set of culturally embedded beliefs about women, men, and sexuality", shifting our understanding of oppression against women (Fitzpatrick 253).

A multifocal perspective on contemporary verse-music experiments also allows us to see their historical roots. The artists discussed in this book and this chapter in particular do not create in vacuum but build on a, largely feminist, tradition of verse-derived experiments sustained in the second half of the twentieth century by artists such as Dorothy Hewett, Ntozake Shange, and Elfriede Jelinek (to whom Keff makes a reference in *Utwór* 49). Shange's choreopoems – "a theatrical expression that combines poetry, prose, song, dance, and music – those elements that, according to Shange, outline a distinctly African American" (Lester 3; Shange 197) – deserve a special mention here as pre-echoing many of this book's concerns. Shange's larger aim was to deform the language and its traditional modes of representation and through that create a platform for voices from "outside" (qtd in Gavin 195) and for the inter-generational community of women (Hamilton 80, 94–95). The point of departure for "choreopoems" was breath as a base for both movement and language (Shange, "Ntozake" 201); in verse-speaking breath is also the moment of the end of the line, so the integral element of verse structure and heteroglossia it facilitates.

The topic of verse, music, and the past brings me to the classical chorus, a device which several artists discussed thus far have used. Choruses, like rhythm, were disregarded by Aristotle, who prioritized plot, thought, and character (Aristotle 11–12; Lehmann *Tragedy* 21–22). Taking further into account that, as argued by Edith Hall, Aristotle called for a "divorce of tragedy from the Athenian democratic *polis*" (305), the final example in this book is radically anti-Aristotelian. It is *HYMN D ✿ M † Ł♡ ŚCI na orkiestrę, chór pluszaków i innych* (*HYMN TO LOVE for Orchestra, Stuffed-Animal Choir, and Others*), a Polish-German co-production by the CHORUS OF WOMEN Foundation, Polski Theatre in Poznań, Ringlokschuppen Ruhr in Mülheim, and the Maxim Gorki Theater in Berlin.

Verse as the purest form of anti-Aristotelian theatre: Marta Górnicka's *HYMN D ✿ M † Ł♡ ŚCI*

In the most basic terms, *HYMN* is a libretto (another anti-Aristotelian form; Bogucki 2–3) performed by a chorus of professional and amateur actors of different races, seniors, children, and adults with Down syndrome, directed and conducted in a live performance by Marta Górnicka. The focus of the upcoming discussion is its innovative and verse-derived form that Marta Górnicka together with dramaturg Agata Adamiecka create and which

structures their ontological exploration of a nation and theatre. The theatre and hybrid form act as epistemological methods that interrogate both the concept of nation and each other. The dramaturgy of form in *HYMN* reveals a nation as materialized through the theatrical and transhistorical processes of "intrainanimation". Rebecca Schneider defines this concept as "the ways the dead play across the bodies of the living, and the living replay the dead" (Schneider and Ruprecht). In *HYMN*, "intrainanimation" of nation aligns it with theatre and re-enactment since it is their integral quality (*Slough Media* 71–74; Schneider and Ruprecht). Because Górnicka's form creates a multidimensional and self-multiplying heteroglossic effect, it extends to the processes of intrainanimation, emphasizing tensions and contradictions within them.

In my discussion, I particularly focus on how the verse-derived form gives Górnicka's libretto a dialogic form, how it both supports and deconstructs the collectivity of the chorus, and how it facilitates the "undecidable space between registers of what is live and what is passed", which is how Schneider defines cross-temporal liveness ("It seems" 155). Through these, dramaturgy of the form in *HYMN* realizes a dialogical approach to the politics of memory as a "communicative paradigm" and the interactive and transtemporal processes by which collective memories are "produced, influence, draw on" and come into "conflict with other narratives that are present within society at large" (Verovšek 535). This connects with the tension within the performativity of Polish collective memory or, as Norman Davies puts it, remembering "what people would have liked to happen" rather than the actual occurrences (401).

HYMN's exploration of relations between nation and community, between collective and individual, and interrogation of collective memories – understood here as "the relationship that a society constructs with its past" (Rusu 261–62) – and their power has also a metatheatrical dimension. The production dialogues with a broader theatre tradition and discourses around Górnicka's work. Its anti-Aristotelian quality arises from how this dramaturgically and rhythmically consistent form, contrasted by its scattered notation, offers a radical rethinking of the relationship between theatre and representation, text and its performance, theatre and its politics, and theatre and time.

HYMN's commitment to multivocality is already visible in its title, foreshadowing how the language form will operate in the performance. The title – *HYMN D✿ M✝ Ł♡ ŚCI na orkiestrę, chór pluszaków i innych* (*HYMN TO LOVE for Orchestra, Stuffed-Animal Choir, and Others*) – refers to the idea of nation and community creation, connoting love, tradition, and a sense of profoundness.[1] At the same time, the title conveys naivety, shallowness, and exclusion. This is through its emoji-aesthetics, reference

to stuffed animals, and the final word "others" that through its appearance suggests inclusion but through its form and connotation reveals exclusion. Furthermore, the visual references to Christianity and Judaism in the Polish-German co-production connote a long and complicated history and a memory thereof. In the performances, these tensions are expanded and multiplied through a verse-derived hybrid form.

The libretto is internally dialogized, highlighting the inhomogeneous quality of collective memory and collective itself. The script features both verse and prose texts, many coming from traditional songs and poems and religious rituals as well as nationalistic and fascist watchwords and lines from extremist leaders, all containing the community-creating (and destroying) rituals. Texts and references include "Warszawianka" ("The Warsaw Song") (known as a Polish patriotic poem and song but actually written as "La Varsovienne de 1831" by the French Casimir François Delavigne), Władysław Bełza's female version of "Katechizm Małego Polaka" ("The Catechism of a Little Pole", a well-known rhyme for children), church liturgy, and the Gospel of John, but also the Holocaust, Anders Breivik's *2083 – A European Declaration of Independence*, Internet hate speech (see Figure 4.1), and speeches by Abu Bakr al-Baghdadi and Osama bin Laden.

In the performance, they are often delivered simultaneously, a libretto-derived technique (Bogucki 3), but in a way that they seem to be in dialogue.

Figure 4.1 The Chorus performs Internet hate speech in *HYMN D✿ M✝Ł♡ ŚCI* (*HYMN TO LOVE*). Directed by Marta Górnicka. The CHORUS OF WOMEN Foundation, Polski Theatre, Poznań, Poland, Ringlokschuppen Ruhr, Mülheim, Maxim Gorki Theater, Berlin, Germany, 2017.

Credit: Magda Hueckel/The CHORUS OF WOMEN Foundation.

Górnicka and Adamiecka adapt the mode of language in *HYMN*, so it remains close to the ontological realm of verse. I mean here the patternized use of a line – and within it, formal structure-enhancing principles – and the relationship between rhythmical and lexical layers and its dialogical consequences. However, the heteroglossic effect of the language mode that Górnicka creates is multidimensional, self-multiplying, and materialized. This is because the repetition happens here not only to the line but also to the individual elements within the line, and the structure-enhancing principles are written not only into the text but also into other aural and visual elements of the mise-en-scène, especially the bodies of the performers. Consequently, the heteroglossic effect in *HYMN* is extended across several sign systems and media, and "chorusized" – not only because it is performed by the Chorus (often divided into micro-choruses), but primarily because it is created by several individual elements that are united in the choric form but belong to different realms (aural, visual, bodily but also temporal and political) and retain their individuality.

For example the performance begins with the opening line from the oldest version of the Polish national anthem, "Mazurek Dąbrowskiego" ("The Dąbrowski Mazurka"), by Józef Wybicki: "Jeszcze Polska nie umarła" (literally "Not yet Poland has died", meaning "Poland is not yet lost"). Ewa Szumska is positioned downstage with the performers arranged in a shape reminiscent of eagle wings, connoting the White Eagle emblem of Poland. The choristers rhythmically repeat "Jeszcze" ("Not yet"), dividing it into syllables: "Je-szcze". Some of the chorus members begin short-pulsating (moving up and down). Both "jeszcze" and one pulsation have the same count of two. Another group begins saying "Polska" with the first syllable prolonged to the count of three and the second delivered to the count of one. The prolonged syllable is additionally sounded through an audible breathing out. Finally, the last group emerges shouting "nie umarła" (not died), so it seems that this three-syllable phrase has only two counts. The line is then repeated, and elements of the anthem's subsequent lines are introduced and juxtaposed with some "pearls" of wisdom such as "don't expect anything for free" or invocations to God taken from the patriotic song "Marsz, Marsz Polonia" ("March, March Polonia"). As this happens, the chorus changes positions. It begins marching in a soldier-like manner mirroring the anthem's lines "Marsz, marsz Dąbrowski" (March, march Dąbrowski") but also connoting Nazi parades. Paradoxically, it is the prolonged call "March" that stops the Chorus; but the pattern is still there, now created by the rhythmicized and unified sound of heavy breathing.

In the opening sequence – approximately two minutes long – the heteroglossic form both facilitates and deconstructs the patterns of performing a nation. The visible presence of the rhythmic structures – on the one hand

unifying and on the other creating contradictions – highlights the homog-
enizing mechanisms involved in "imagining" a nation as a unified commu-
nity (Anderson; Kosiński 216–44). By extension, the form of the language
also reveals a nation as a meeting point for diverse and often contradicting
and dead ideas and rituals that produce and destroy the community. Gór-
nicka's Chorus is presented as a collective – as the classical tradition had it
(Gould 223) – but the collectiveness of its identity is deconstructed through
the form of language and the diversity of choristers; it is also suggested
already in the second part of the title "for orchestra, stuffed-animal choir,
and others". This, in turn, as argued by Jan-Tage Kühling, makes it "impos-
sible to encapsulate the choristers within one 'signifier'" (5). In short, the
form of the language performs an act of creating a nation while both posing
and making it impossible to answer a question about who the "we" that the
Chorus claims to be speaking for – when they repeatedly say "we, Poles"
or, less often, "we, Europeans" – are.

This methodology of dialogizing text continues throughout the perfor-
mance, sometimes enhanced by bilingual utterances. The Chorus answers
its own "wszystkim zbędnym narodom powiemy: bye / wrzucimy ich do
pieca, damy im popalić" ("to all unnecessary nations, we will say: bye / we
will throw them to a stove/gas chamber,[2] give them a burny ride") (7) with
"nie mamy z tym nic wspólnego / nie ta wspólnota wartości / no platform"
("we have nothing to do with this / it's not the same community of values /
no platform") (8). The latter is delivered at the same time as a smiley assur-
ance of all-encompassing Christian community. The form of language per-
forms here tensions between these individual claims of unity, superiority,
and homogeneity. And the English-language interjections (and references
to global movements like No Platform) further enhance these tensions, also
revealing the selectiveness, internal paradoxes, and imaginary quality of
the claims (also see Anderson 5–7). At the same time, the references to
Auschwitz mark the crimes and suffering inflicted in the name of national
unity, superiority, and homogeneity.

Heteroglossia in *HYMN* also highlights the destructive potential of the
community through a moment of silence, and through its disappearance in
rare and carefully placed moments of complete choral unison. The former
happens, for example, when the Chorus joyfully dances Stanisław Moni-
uszko's mazurka (the Polish national dance as well as the title of the anthem)
and through a song celebrates their unity despite the costs. Spectators see
Ewa Szumska's "mute scream" (Helena-Weigel-style) – referencing *Mother
Courage* but also lamenting these costs. An example of the latter is when the
Chorus unites in an admission that "My, Polacy, jesteśmy ludźmi. / Jesteśmy
zwyczajnymi, normalnymi ludźmi" ("We, the Poles, are people / We are
regular, normal people") (8) repeated several times with growing conviction

as the group moves closer and closer together, and, finally, turns into a pack of aggressively baying hounds.

Highlighting the communal and (self-)destructive aspects of nation as intertwined is part of *HYMN*'s broader strategy to present a nation not as natural but as produced through "intrainanimation", as "cross-temporal reenactments" that allow the "dead play [to] across the bodies of the living, and the living [to] replay the dead". And through that, following Schneider, to "allow the live and the no-longer-live to cohabitate, cross-interrogate, and pose old questions anew, or new questions of old" (*Slough Media* 72; Schneider and Ruprecht), inviting critical engagement from the audience with a nation, Polishness, and its history. Emancipation of an individual spectator is a larger objective that underlies Górnicka's work (Burzyńska). The key element of this aim in *HYMN* is its complex temporal structures – transhistorical connections and cross-temporal liveness in particular – that heteroglossia creates.

The already mentioned examples showcase how Górnicka, echoing Brecht, encourages the audience to make transhistorical connections. Another moment is when Breivik's manifesto is followed by the overlapping quotes from Adolf Hitler, Abu Bakr al-Baghdadi, Osama bin Laden, and liturgy (*HYMN* 8–10). It begins thus:

My name is: Anders Breivik	My name is: Anders Breivik
Jestem pomnikiem Europejskich narodów	I am the monument of European nations.
Męskim mitem heroicznego męczeństwa	Masculine myth of heroic martyrdom
Barankiem paschalnym	The paschal lamb
Zajebistą marką (8)	Fucking brilliant brand

The rhythmic delivery is accompanied by physical gestures such as the Nazi salute and aggressive punching (associated earlier in *HYMN* with contemporary nationalist movements and hate speech).

The transhistorical references link with how the heteroglossia in *HYMN* is "livenessed" and how it facilitates "cross-temporal liveness", problematizing dichotomies of past and present, liveness and pastness, and prompting questions about agency. These operate in relation to the materializing of the nation and on the metatheatrical level. On the one hand, the formal structure that underlies the performance – Anna Burzyńska compares the Chorus to a bee swarm (Burzyńska) – reveals the rehearsal process, speaking to Richard Schechner's idea of performance as "a restored behaviour" that presents "action that people train for and rehearse" (28) and to Schneider's point that "the body performing live" is "a matter of record"

(*Performing* 92). This also relates to the content, as many of the texts, movements, or rituals that the Chorus performs – for example the national anthem or the Mazurka dance – are well known and associated with or rooted in the past.

On the other hand, Górnicka conducts the Chorus, and her presence is made visible to the audience. In other words, the patterns that facilitate heteroglossia in *HYMN* are not only rooted in the text and the bodies but also seem to be "created" live by Górnicka's animation of the Chorus. At the same time, the heteroglossic form performed by the bodies of the choristers is the main carrier of meaning – the production uses no material properties – highlighting the live labour of the choristers who create *HYMN* "out of nothing materially present" (Schneider, "It seems" 154–55). Górnicka points to that speaking about the published version of *HYMN* that fails to fully express the senses expressed by the choristers in the performances, as the elements such as pulsations, staccato deliveries, simultaneity (facilitating rhythmical structure) exist in her head and, partly, in her own notes, which include musical notes and which she does not publish (Górnicka in Jaworska).

This radicalized tension between writing and orality and the emphasized scattering of performance notations speak to the long debate in theatre studies about the impossibility of theatrical score (Raszewski 279–82) and to Peggy Phelan's suggestion of documentability as a possible antonym of liveness (Phelan 31). However, even more so, the emphasized cross-temporal-liveness, the tensions described here between "liveness" and "pastness" of heteroglossia and between writing and orality, ask what it is that makes the Chorus act, which is also a question of agency. The question links with the classical theatre traditions and dual status of the classical chorus that both is and represents the Chorus, which allows the Chorus to be both powerless and to connote otherness (in the diegetic context; Gould 220–24) and – in the context of socio-political aspects of the theatre and the Dionysia – to speak with the full authority of the collective, bringing about "the tension between individual and collective", integral to both tragedy and "democratic theory and practice" (Goldhill 248–53).

As a result, *HYMN* presents the memory – particularly mythologized memory – and control thereof as political power, echoing concerns of the memory politics. As argued by Herbert Hirsch and Peter Verovšek, by manipulating memory, one manipulates symbols that a society values and identifies with (Hirsch 23; Verovšek 529, 533). This, in turn, following Katharine Hodgkin and Susannah Radstone's arguments (1), changes one's view of the present and the future. In *HYMN* these ideas are materialized and emphasized by Górnicka's live conducting and the animal puppets (animated by choristers) who call for protection of Europe.

And the idea of a collective having agency to change history – as the discourse about the past (Rusu 262) – gets the point in the finale as the Chorus turns its back to the audience, and to Górnicka, and moves casually, bringing instruments to the stage. They position themselves in an inward-facing circle, with a small gap inviting one to join in. Their position references the poster of *HYMN* with a death camp orchestra. They play and sing *St Matthew Passion* in German, connoting Polish historical traumas but also, through peaceful singing, offering a different quality of engagement. This anticlimactic finale may suggest that emancipation from the past does not mean forgetting it but taking control and responsibility of its position towards it. But, at the same time, it conveys the impossibility of freeing oneself from the past: the end of one performance or recollection is at the same time the beginning of another.

HYMN's engagement with collective memory also builds on and dialogues with the classical chorus conventions, Polish theatre traditions, and the discourses about Górnicka's own work, showing how the hybrid form in Górnicka's work facilitates multiple layers and tensions connoting the multiple contexts in which it operates. These contexts allow Górnicka to ask how theatre in general, including Polish theatre and her theatre, shapes the relationship between society and its past, and how it performs its relations with its history. This, in turn, highlights the political potential and response-ability of theatre as, Kühling argues, a space in which the idea of nation as a construct and the mechanisms creating it can be explored and exposed because "theatre as an institution generates the political in that very sense and, in doing so, enables the political (as well as aesthetic) laws of discourse to be reconfigured" (2). This is even more so in Górnicka's *HYMN*, as her focus is on Polishness, which, Dariusz Kosiński argues, is highly theatrical and built on spectacle (21) and has played an instrumental role in shaping Polish identity.

And *HYMN*'s use and deconstruction of well-known dramatic structures, tropes, and conventions to re-examine one's relationship with memory echoes how in Beckett's *Endgame* "(e)xposition, complication, plot, peripetia and catastrophe return in decomposed form as participants in an examination of the dramaturgical corpse" (Adorno, "Trying" 260). The link between the two is even more visible through their questions about an individual agency and constant dialogue with memory – including references to Auschwitz – and a refusal to offer any solution or "painkillers" from the past (Adorno, "Trying" 260). But where *Endgame*'s interrogative power is rooted in its construction built on "the technique of reversal" (Adorno 274), *HYMN*'s verse-derived form facilitates an infinite multiplication of and self-interrogations of reversals and contradictions. This, in turn, underlies its radical offer in terms of theatre aesthetics and politics.

In relation to Górnicka's own work, the questions of agency that the dramaturgical operation of form in *HYMN* prompts relate also to the criticism she received for her earlier works not doing enough to change the ecology of Polish theatre as "a director's theatre" and functioning as a display of a violent director-performer relationship (Adamiecka-Sitek 10–12). The metatheatrical level also relates to Górnicka's work in relation to the past. The discussion so far has highlighted how the formal elements underscore Brechtian references, and engagement with Polish theatre traditions. In relation to the latter, Agata Łuksza compared Górnicka's presence on a stage to Tadeusz Kantor's work, saying that "Kantor directed the Theatre of Death while Górnicka conducts a chorus of life. . . . Kantor's theatre turned to the past, Górnicka's Chorus looks to the future" (14). In *HYMN*, the way the content and the form in a dialogical relationship bring and complexify temporal structures allows the Chorus to look to both the past and the future and to operate as the Chorus of dead and alive.

Finally, the way that verse-derived form brings together multiple pasts to the present in order to theatricalize the relationship between them echoes how the unity of time in Aristotelian drama theatricalized the past (Ubersfeld), as discussed in my first case study: Seamus Heaney's *The Burial at Thebes*. However, while the theatricalization of the past in the classical theatre presented history as something that cannot be changed but which changes the present (Ubersfeld 128–30), in *HYMN* history – as the discourse about the past (Rusu 262) – can be changed and, through that, following Hodgkin and Radstone's arguments (1), can change the present and the future. In short, Górnicka and Adamiecka present the purest form of anti-Aristotelian theatre.

Conclusion: verse structure and re-dramaturging theatre

Górnicka's work is a fitting closure to this book, which explored my theory of heteroglossic verse as a base for diverse dramaturgical endeavours, from the start had anti-Aristotelian underpinnings, and used *Antigone* as its first case study. If, as Lehmann argues, Antigone questions the idea of the polis as a base for community and "conjures up a final point of uncertainty in the law" of the polis (*Tragedy* 182), then Górnicka, to paraphrase Lehmann, conjures up the groundlessness of a nation. Although *Antigone* and *HYMN* come from very different worlds, they both relate to socio-political crises while questioning the paradigms of their respective civilizations. In this sense, their relationship speaks to the major dramaturgies surrounding this book. These chapters were structured to allow their case studies to reflect on verse in relation to changing socio-political contexts and broader fields

of cultural production (in Pierre Bourdieu's sense). Through that, this book showed how verse has supported theatre artists in redefining theatre aesthetics structures, and relationships between themselves, their audiences, and the spaces in which they create.

Verse facilitated these leadership and dramaturgical tasks (Stroich) because dramatic verse not only is a dialogue but is eternally in-a-dialogue. Through that, verse has a unique ability to simultaneously stage, investigate, and redefine existing relationships and structures, so that they correspond with diverse socio-political contexts and ecologies of theatre-making. Verse also supports the artists' claims to their agencies over these ecologies. The discussion also showed how verse shifts and complicates power dynamics in theatre. While the heteroglossia of verse empowered its various dramaturgical operations presented in this book, it also revealed the vulnerability of dramaturgy and its traditional authors – playwrights, directors, and dramaturgs – and their reliance on actors. It is the actor who delivers verse in the performance, and the quality of this delivery can empower or damage the heteroglossic quality of verse and its dramaturgy. If the actor does not pause at the end of each verse line, for example, it is very difficult for the verse pattern (and the dialogic qualities it empowers) to reveal itself in the performance. Therefore, while empowering the actor in one way, verse also requires the actor to adapt their performance to it. And so, this book ends with a call to verse-speaking and voice coaches to prepare actors to actively and consciously engage with verse and its potential for the twenty-first-century theatre.

Notes

1 Polish "hymn" denotes both a "hymn" and an "anthem", also connoting "Hymn o miłości" ("Hymn about Love"), commonly used in Poland as a title for the biblical "Song of Songs".
2 The Polish "piec" denotes both a stove and a gas chamber.

Bibliography

Adamiecka-Sitek, Agata. "How Far Can You Go in an Institution? On a Feminist Turn That Wasn't: Agata Adamiecka-Sitek Talks with Milena Gauer and Weronika Szczawińska." *Polish Theatre Journal*, vol. 1, no. 1, 2015.

Adamowska, Monika. "Niepełnosprawni: Miasto Bez Barier?" *Gazeta Wyborcza*, 15 Mar. 2012.

Adams, Carol. *The Sexual Politics of Meat*. Methuen, 2000.

Adorno, Theodor W. *Aesthetic Theory*, translated by Robert Hullot-Kentor, U of Minnesota P, 1998.

———. "Trying to Understand *Endgame*." *Notes to Literature*, by Theodor W. Adorno, edited by Rolf Tiedemann, translated by Shierry Weber Nicholsen, Columbia UP, 1991, vol. 1, pp. 241–75.

Ainsworth, Thomas. "Form vs. Matter." *The Stanford Encyclopedia of Philosophy*. Summer 2020 ed., edited by Edward N. Zalta, The Metaphysics Research Lab Center for the Study of Language and Information, Stanford U.

Ambrosi, Paola. "Verse Translation for the Theatre: A Spanish Example." *Theatre Translation in Performance*, edited by Silvia Bigliazzi et al., Routledge, 2013, pp. 61–76.

Anannikova, Ludmiła. "Mówią: Nie chcemy ich, niech lepiej zginą." *Gazeta Wyborcza*, 12 Dec. 2016.

Anderson, Benedict. *Imagined Communities: Reflections on the Origin and Spread of Nationalism*. Rev. ed., Verso, 2006.

Araszkiewicz, Agata. "Sex, Oppression, and Singing." *The Airport Society*, 15 May 2019.

Arendt, Hannah. *The Human Condition*. U of Chicago P, 1998.

Aristotle. *The Poetics of Aristotle*. U of North Carolina P, 1942.

Aston, Elaine and George Savona. *Theatre as Sign-System*. Routledge, 2005.

Athanasiou, Athena. "Reflections on the Politics of Mourning: Feminist Ethics and Politics in the Age of Empire." *Historein: A Review of the Past and Other Stories*, vol. 5, 2005, pp. 40–57.

Attridge, Derek. *Poetic Rhythm: An Introduction*. Cambridge UP, 1995.

Auslander, Philip. *Liveness: Performance in a Mediatized Culture*. 2nd ed., Routledge, 2008.

Austin, John Langshaw. *How to Do Things with Words*. 2nd ed., Oxford UP, 1975.

Bakare, Lanre. "Drama Schools Accused of Hypocrisy Over Anti-Racism Statements." *Guardian*, 9 June 2020.

Bakhtin, Mikhail M. "Discourse in the Novel." *The Dialogic Imagination: Four Essays*, edited by Michael Holquist, U of Texas P, 1981, pp. 259–422.

———. *Speech Genres and Other Late Essays*. U of Texas P, 1986.

Banks, Daniel. "Introduction: Hip Hop's Ethic of Inclusion." *Say Word! Voices from Hip Hop Theater*, edited by Daniel Banks, U of Michigan P, 2011, pp. 1–20.

Barnette, Jane. *Adapturgy: The Dramaturg's Art and Theatrical Adaptation*. Southern Illinois UP, 2018.

Barry, Peter. *Contemporary British Poetry and the City*. Manchester UP, 2000.

Bass, Laura. *The Drama of the Portrait: Theater and Visual Culture in Early Modern Spain*. Pennsylvania State UP, 2008.

Bassnett, Susan. *Translation*. Routledge, 2013.

Bauman, Zygmunt. *Wasted Lives: Modernity and Its Outcasts*. Wiley, 2003.

Bennett, Susan. *Theatre Audiences*. 2nd ed., Routledge, 2003.

Bergson, Henri. *Henri Bergson: Key Writings*. A&C Black, 2002.

Berry, Cicely. *The Actor and the Text*. Virgin Books, 1993.

Bhabha, Homi K. *The Location of Culture*. Routledge, 1994.

Bielas, Katarzyna. "Nielegalny Plik." *Gazeta Wyborcza*, 27 May 2008.

Bigliazzi, Sylvia et al. "Introduction." *Theatre Translation in Performance*, edited by Silvia Bigliazzi et al., Routledge, 2013, pp. 1–26.

Black, Michael. *Poetic Drama as Mirror of the Will*. Vision Press, 1977.

Błażewicz, Andrzej. *Polskie rymowanki albo ceremonie*. 2019. Theatre Script. Private collection.

Boenish, Peter M. "Acts of Spectating: The Dramaturgy of the Audience's Experience in Contemporary Theatre." *New Dramaturgy: International Perspectives on Theory and Practice*, edited by Katalin Trencsényi and Bernadette Cochrane, Methuen, 2014, pp. 225–41.

Bogucki, Marcin. "Najczystsza postać niearystotelesowskiej poetyki." *Dialog*, vol. 735, no. 2, 2018, pp. 47–57.

Boland, Eavan. "Anorexic." *New Collected Poems*, Carcanet, 2005, pp. 75–76.

Bourke, Angela. "The Irish Traditional Lament and the Grieving Process." *Women's Studies International Forum*, vol. 11, no. 4, 1988, pp. 287–91.

———. "More in Anger than in Sorrow: Irish Women's Lament Poetry." *Feminist Messages: Coding in Women's Folk Culture*, edited by Joan Newlon Radner, U of Illinois P, 1993, pp. 160–82.

Boyle, Michael Shane et al. "Introduction: Form and Postdramatic Theatre." *Postdramatic Theatre and Form*, edited by Michael Shane Boyle et al., Methuen, 2019.

Boy-Żeleński, Tadeusz. "Plotka o *Weselu* Wyspiańskiego." *Wolnelektury.pl*, Fundacja Nowoczesna Polska, https://wolnelektury.pl/media/book/pdf/plotka-o-weselu-wyspianskiego.pdf.

Bradford, Richard. *Stylistics*. Routledge, 1997.

Bradley, Regina N. "Barbz and Kings: Exploration of Gender and Sexuality in Hip-Hop." *The Cambridge Companion to Hip-Hop*, edited by Justin A. Williams, Cambridge UP, 2015, pp. 181–91.

Braidotti, Rosi. "Nomadic European Identity." *No Culture, No Europe: On the Foundations of Politics*, edited by Pascal Gielen, Valiz, 2015, pp. 97–113.

Brogan, T.V.F. "Verse and Prose." *The New Princeton Encyclopedia of Poetry and Poetics*, edited by Alex Preminger et al., Princeton UP, 1993, pp. 1346–51.

Brook, Barbara. *Feminist Perspectives on the Body*. Routledge, 2014.

Buffery, Helena. "Negotiating the Translation Zone: Invisible Borders and Other Landscapes on the Contemporary 'Heteroglossic' Stage." *Translation Studies*, vol. 6, no. 2, 2013, pp. 150–65.

The Burial at Thebes. Play Guide. The Guthrie Theater, 2011.

Burnett, Jon. "Racial Violence and the Brexit State." *Race & Class*, vol. 58, no. 4, 2017, pp. 85–97.

Burzyńska, Anna R. "W poszukiwaniu nowego podmiotu." *Dialog*, vol. 735, no. 2, 2018.

Butler, Judith et al. "Introduction." *Vulnerability in Resistance*, edited by Judith Butler, Zeynep Gambetti, and Leticia Sabsay, Duke UP, 2016.

———. *Precarious Life: The Powers of Mourning and Violence*. Verso, 2004.

Calderón de la Barca, Pedro. *La primera versión de La vida es sueño*, edited by José M. Ruano de la Haza, Liverpool UP, 1992.

———. *La vida es sueño*, edited by Albert E. Sloman, Manchester UP, 1961.

———. *Life Is a Dream*, translated by Gregary J. Racz, Penguin, 2006.

Canagarajah, Suresh. *Translingual Practice: Global Englishes and Cosmopolitan Relations*. Routledge, 2013.

Caplan, Debra. "European Dramaturgy in the Twenty-First Century: A Constant Movement." *The Routledge Companion to Dramaturgy*, edited by Magda Romanska, Routledge, 2014, pp. 141–44.

Carlson, Marvin. "Semiotics and Its Heritage." *Critical Theory and Performance*, edited by Janelle G. Reinelt and Joseph R. Roach, U of Michigan P, 2007, pp 13–25.

———. *Speaking in Tongues*. U of Michigan P, 2006.

Carpenter, Andrew. *Verse in English from Eighteenth-Century Ireland*. Cork UP, 1998.

Churchill, Caryl. *Cloud 9*. Nick Hern Books, 1989.

Cieślak, Robert. *Teatr Anny Augustynowicz*. Wydawnictwo Naukowe, 2011.

Colum, Padraic. "Introduction." *Anthology of Irish Verse*, Boni and Liveright, 1922, pp. 3–22.

Costello, Brigid. *Rhythm, Play and Interaction Design*. Palgrave, 2018.

Cronin, Michael. *Translation and Globalization*. Routledge, 2003.

Csató, Edward. "Funkcje mowy scenicznej." *Problemy Teorii Dramatu i Teatru*. 2nd ed., edited by Janusz Degler, 2 vols., Wydawnictwo Uniwersytetu Wrocławskiego, 2003, pp. 121–40. The article was originally printed in 1962.

Cullen, L. M. "The Contemporary and Later Politics of *Caoineadh Airt Uí Laoire*." *Eighteenth-Century Ireland*, vol. 8, 1993, pp. 7–38.

Daddario, Will et al. "What Is Refugee?" *Performance Philosophy*, vol. 4, no. 1, 2018, pp. 206–33.

Danan, Joseph. "Dramaturgy in 'Postdramatic' Times." *New Dramaturgy: International Perspectives on Theory and Practice*, edited by Katalin Trencsényi and Bernadette Cochrane, Methuen, 2014, pp. 3–17.

Davies, Norman. *God's Playground: A History of Poland, Volume I: The Origins to 1795*. Rev. ed. Oxford UP, 2005.

Dean, Jodi. "Whatever Blogging." *Digital Labor: The Internet as Playground and Factory*, edited by Trebor Scholz, Routledge, 2012, pp. 127–46.

Delabastita, Dirk. "Fictional Representations." *Routledge Encyclopedia of Translation Studies*. 2nd ed., edited by Mona Baker and Gabriela Saldanha, Routledge, 2009, pp. 109–12.

de la Rey, Cheryl. "Reconciliation in Divided Societies." *Peace, Conflict, and Violence: Peace Psychology for the 21st Century*, edited by Daniel J. Christie and others, Prentice-Hall, 2001, pp. 251–61.

Diamond, Elin. *Unmaking Mimesis: Essays on Feminism and Theatre*. Routledge, 1997.

Dłuska, Maria. *Odmiany i dzieje wiersza polskiego*. Universitas, 2001.

———. *Próba teorii wiersza polskiego*. Universitas, 2001.

Dobrowolski, Piotr. *Teatr i polityka. Dyskursy polityczne w polskiej dramaturgii współczesnej*. Poznańskie Studia Polonistyczne, 2019.

Eckersall, Peter et al. "Dramaturgy as Ecology: A Report from the Dramaturgies Project." *New Dramaturgy: International Perspectives on Theory and Practice*, edited by Katalin Trencsényi and Bernadette Cochrane, Methuen, 2014, pp. 18–35.

Ellams, Inua. *The 14th Tale*. Oberon, 2015.

———. *The Half God of Rainfall*. 4th Estate, 2019.

———. "Postshow Dicussion." 4 Oct. 2012, Project Arts Centre, Dublin.

Fabiszak, Jacek. "'Ugly' Tempests: The Aesthetics of Turpism in Derek Jarman's Film and Krzysztof Warlikowski's Stage Production." *Eyes to Wonder, Tongue to Praise: Volume in Honour of Professor Marta Gibińska*, edited by Agnieszka Pokojska and Agnieszka Romanowska, Jagiellonian UP, 2012.

Fischer-Lichte, Erika. *The Show and the Gaze of Theatre: A European Perspective*. U of Iowa P, 1997.

Fitzpatrick, Lisa. *Rape on the Contemporary Stage*. Palgrave, 2018.

Flannery, James W. *W.B. Yeats and the Idea of a Theatre*. Yale UP, 1976.

Fragkou, Marissia. *Ecologies of Precarity in Twenty-First Century Theatre: Politics, Affect, Responsibility*. Methuen, 2018.

Fuchs, Elinor. *The Death of Character: Perspectives on Theater after Modernism*. Indiana UP, 1996.

Gallagher, Michael. *Political Parties in the Republic of Ireland*. Manchester UP, 1985.

Garner, Steve. "Empirical Research into White Racialized Identities in Britain." *Sociology Compass*, vol. 3, no. 5, 2009, pp. 789–802.

Garratt, Robert F. *Modern Irish Poetry: Tradition and Continuity from Yeats to Heaney*. U of California P, 1986.

Gavin, Christy. *African American Women Playwrights: A Research Guide*. Routledge, 1999.

Gentzler, Edwin. *Translation and Rewriting in the Age of Post-Translation Studies.* Routledge, 2016.

Gieracka, Aleksandra. "Szczecin nieprzyjazny dla niepełnosprawnych." *Interia Fakty*, 18 Oct. 2018.

Gillespie, Gordon. *The A to Z of the Northern Ireland Conflict.* Scarecrow Press, 2008.

Glenda Leeming. *Poetic Drama.* Palgrave, 1989.

Goddard, Lynette. "(Black) Masculinity, Race and Nation in Roy Williams' Sports Plays." *Modern and Contemporary Black British Drama*, edited by Mary Brewer et al., Palgrave, 2014, pp. 112–27.

Goldhill, Simon. "Collectivity and Otherness – The Authority of the Tragic Chorus." *Tragedy and the Tragic: Greek Theatre and Beyond*, edited by M. S. Silk, Clarendon Press, 1996, pp. 244–56.

Goldin, Ian, Geoffrey Cameron and Meera Balarajan. *Exceptional People: How Migration Shaped Our World and Will Define Our Future.* Princeton UP, 2012.

Górnicka, Marta. "Hymn do miłości." *Dialog*, vol. 735, no. 2, 2018, pp. 5–12.

Gould, John. "Tragedy and Collective Experience." *Tragedy and the Tragic: Greek Theatre and Beyond*, edited by M. S. Silk, Clarendon Press, 1996, pp. 217–43.

Green, Martin. "Emilia Lanier IS the Dark Lady of the Sonnets." *English Studies*, vol. 87, no. 5, 2006, pp. 544–76.

Griffith, Mark. "Commentary." *Antigone*, by Sophocles, edited by Mark Griffith, Cambridge UP, 1999, pp. 119–355.

Gross, Andrea. "Costumes." *The Burial at Thebes: Play Guide*, The Guthrie Theater, 2011, pp. 27–28.

Gross, Harvey. "Introduction to 'The Metrical Frame'." *The Structure of Verse*, edited by Harvey Gross, Ecco Press, 1979, pp. 77–78.

———. *Sound and Form in Modern Poetry.* U of Michigan P, 1964.

Grzegorzewska, Antonina. *Migrena.* 2010. Theatre Script. Współczesny Theatre's collection.

Guderian-Czaplińska, Ewa. "Próby utworu." *Didaskalia Gazeta Teatralna*, no. 2, 2011.

Hall, Edith. "Is There a Polis in Aristotle's Poetics?" *Tragedy and the Tragic: Greek Theatre and Beyond*, edited by M. S. Silk, Clarendon Press, 1996, pp. 295–309.

Hamilton, Pamela. "Child's Play: Ntozake Shange's Audience of *Colored Girls.*" *Reading Contemporary African American Drama: Fragments of History*, edited by Trudier Harris, Peter Lang, 2007, pp. 79–97.

Handke, Peter. "Theater-in-the-Street and Theatre-in-Theaters" (1969). *Radical Street Performance: An International Anthology*, edited by Jan Cohen-Cruz, Routledge, 2013, pp. 7–10.

Hansen, Mogens Herman. *The Athenian Democracy in the Age of Demosthenes: Structure, Principles, and Ideology*, translated by J. A. Crook, Blackwell, 1991.

Hardwick, Lorna. "'Murmurs in the Cathedral' . . ." *Yearbook of English Studies*, vol. 36, 2006, pp. 204–15.

———. *Translating Words, Translating Cultures.* Duckworth, 2000.

Haughton, Miriam. *Staging Trauma: Bodies in Shadow.* Palgrave, 2018.

Heaney, Seamus. *Beowulf: A New Verse Translation.* W. W. Norton, 2001.

———. *The Burial at Thebes: Sophocles'Antigone.* Faber & Faber, 2004.

———. "Crediting Poetry." *Nobel Lectures, Including Presentation Speeches and Laureates'Biographies*, edited by Sture Allén, World Scientific, 1997, pp. 85–113.

———. "*The Cure at Troy:* Production Notes in No Particular Order." *Amid Our Troubles: Irish Versions of Greek Tragedy*, edited by Marianne McDonald and J. Michael Walton, Methuen, 2002, pp. 171–80.

———. *The Cure at Troy: A Version of Sophocles'Philoctetes.* Faber & Faber, 1990.

———. "Growing into Poetry." *Stepping Stones. Interviews with Seamus Heaney*, by Dennis O'Driscoll, Faber & Faber, 2008, pp. 34–58.

———. "The Jayne Lecture: Title Deeds: Translating a Classic." *Proceedings of the American Philosophical Society*, vol. 148, no. 4, 2004, pp. 411–26.

———. "'Me' as in 'Metre': On Translating Antigone." *Rebel Women: Staging Ancient Greek Drama Today*, edited by John Dillon and Steve E. Wilmer, Methuen, 2005, pp. 169–73.

———. "A Note by Seamus Heaney." *The Burial at Thebes. Theatre Programme*, The Abbey Theatre, 2004.

———. "Ocean's Love to Ireland." *North*, Faber & Faber, 2001, pp. 40–41.

———. "On His Work in the English Tongue." *Electric Light*, by Seamus Heaney, Faber & Faber, 2001, pp. 61–63.

Heddon, Deirdre. *Autobiography and Performance: Performing Selves.* Palgrave, 2007.

Hejmej, Andrzej. *Muzyczność dzieła literackiego.* Wydawnictwo Uniwersytetu Wrocławskiego, 2002.

Hermans, Theo. *The Conference of the Tongues.* Routledge, 2014.

Hirsch, Herbert. *Genocide and the Politics of Memory: Studying Death to Preserve Life.* U of North Carolina P, 1995.

Hodgkin, Katharine and Susannah Radstone. *Contested Pasts: The Politics of Memory.* Routledge, 2003.

Holquist, Michael. "Heteroglossia," by M. M. Bakhtin. *The Dialogic Imagination: Four Essays*, edited by Michael Holquist, U of Texas P, 1981, p. 427.

hooks, bell. *Talking Back: Thinking Feminist, Thinking Black.* South End Press, 1989.

Houseman, Barbara. *Tackling Text.* Nick Hern Books, 2008.

How Do They Do That at Guthrie Theater, Minneapolis, 22 Oct. 2011.

Hudson, John. *Shakespeare's Dark Lady: Amelia Bassano Lanier the Woman Behind Shakespeare's Plays?* Amberley, 2014.

Hughes, Jenny. *Performance in a Time of Terror: Critical Mimesis and the Age of Uncertainty.* Manchester UP, 2011.

Ibsen, Henrik. *The Correspondence of Henrik Ibsen.* Haskell House, 1905.

Ingarden, Roman. "Functions of Language in the Theatre." 1957. *The Literary Work of Art*, edited by James M. Edie, Northwestern UP, 1973, pp. 377–96.

Jackson, Zakiyyah Iman. *Becoming Human: Matter and Meaning in an Antiblack World.* New York UP, 2020.

Jakobson, Roman. "On Linguistic Aspects of Translation." *The Translation Studies Reader.* 2nd ed., edited by Lawrence Venuti, Routledge, 2000.

Janion, Maria. "List Marii Janion." *Gazeta Wyborcza*, 10 Oct. 2016.

———. "Polacy i ich wampiry." *Twórczość*, vol. 12, 1984, pp. 59–68.

Janion, Maria and Izabela Filipiak. "Zmagania z Matką i Ojczyzną." *Utwór o Matce i Ojczyźnie*, by Bożena Keff, Ha Art, 2008, pp. 81–98.

Jaworska, Justyna. "Sensy w Gardłach, w Ciałach. Rozmowa z Martą Górnicką." *Dialog*, vol. 735, no. 2, 2018.

Jefferess, David. *Postcolonial Resistance: Culture, Liberation, and Transformation.* U of Toronto P, 2008.

Karpinski, Eva C. "Can Multilingualism Be a Radical Force in Contemporary Canadian Theatre? Exploring the Option of Non-Translation." *Theatre Research in Canada/Recherches théâtrales au Canada*, vol. 38, no. 2, 2015, pp. 153–67.

Kaynar, Gad. "Postdramatic Dramaturgy." *The Routledge Companion to Dramaturgy*, edited by Magda Romanska, Routledge, 2014, pp. 391–96.

Keff, Bożena. *Utwór o Matce i Ojczyźnie*. Ha Art, 2008.

Kelly, Fiach. "Mary McAleese Calls for Yes Vote." *Irish Times*, 13 Apr. 2015.

Kendrick, Lynne. *Theatre Aurality*. Palgrave, 2017.

Kerkhoven van, Marianne. "On Dramaturgy." *Theaterschrift*, vol. 5–6, 1994.

———. "The Theatre Is in the City and the City Is in the World and Its Walls Are of Skin." *State of the Union Speech, 1994 Theaterfestival, Brussels*. Available in English translation at http://sarma.be/docs/3229 (accessed 31 Aug. 2020).

Kershaw, Baz. *The Radical in Performance: Between Brecht and Baudrillard*. Routledge, 2013.

Klarer, Mario. "Orality and Literacy as Gender-Supporting Structures in Margaret Atwood's *The Handmaid's Tale*." *Mosaic: An Interdisciplinary Critical Journal*, vol. 28, no. 4, 1995, pp. 129–42.

Kosiński, Dariusz. *Teatra polskie. Historie*. Wydawnictwo Naukowe PWN, 2010.

Kucer, Stephen B. *Dimensions of Literacy: A Conceptual Base for Teaching Reading and Writing in School Settings*. Routledge, 2014.

Kühling, Jan-Tage. "On the Common Good: The Institution of the Chorus and Images of a Nation in Marta Górnicka's Theatre." *Polish Theatre Journal*, vol. 4, no. 1–2, 2017.

Kwaśniewska, Monika. "Świadectwa czy/i spektakle?" *Dialog*, vol. 759, no. 2, 2020.

Laera, Margherita. "Performing Heteroglossia: The Translating Theatre Project in London." *Modern Drama. Special Issue: Migration and Multilingualism*, edited by Yana Meerzon et al., vol. 61, no. 3, 2018, pp. 380–410.

———. *Theatre & Translation*. Palgrave, 2019.

Lakoff, Robin. "Language and Woman's Place." *Language in Society*, vol. 2, no. 1, 1973, pp. 45–48.

LaRubia-Prado, Francisco. "Calderón's *Life Is a Dream*: Mapping a Culture of Contingency for the Twenty-First Century." *Bulletin of the Comediantes*, vol. 54, no. 2, 2002, pp. 373–405.

Lech, Kasia. "Claiming Their Voice: Foreign Memories on the Post-Brexit Stage." *Migration and Stereotypes in Performance and Culture*, edited by Yana Meerzon et al., Palgrave, 2020, pp. 215–34.

———. "Metatheatre and the Importance of Estrella in Calderón's *La vida es sueño* and Its Contemporary Productions." *Bulletin of the Comediantes*, vol. 66, no. 2, 2014, pp. 175–93.

———. "Pain, Rain, and Rhyme: The Role of Rhythm in Stefanie Preissner's Work." *Radical Contemporary Theatre Practices by Women in Ireland*, edited by Miriam in Haughton and Maria Kurdi, Carysfort Press, pp. 151–66.

———. "'Roughening Up of the Utterance' or 'It's Not All Mountains and Sheep and Emily Dickinson': How Contemporary Practitioners Test Boundaries of Verse Drama?" *Coup de Théâtre*, Special issue on verse drama, 2020.

———. "Verse in Contemporary Irish Theatre." *The Palgrave Handbook of Contemporary Irish Theatre*, edited by Eamonn Jordan and Eric Weitz, Palgrave, 2018, pp. 599–613.

Leeming, Glenda. *Poetic Drama*. Palgrave Macmillan, 1989.

Lehmann, Hans-Thies. *Postdramatic Theatre*. Routledge, 2006.

———. *Tragedy and Dramatic Theatre*. Routledge, 2016.

Lester, Neal A. *Ntozake Shange: A Critical Study of the Plays*. Garland, 1995.

Limon, Jerzy. *Piąty Wymiar Teatru*. słowo/obraz terytoria, 2006.

———. "Waltzing in *Arcadia*: A Theatrical Dance in Five Dimensions." *New Theatre Quarterly*, vol. 24, no. 3, 2008, pp. 222–28.

Linklater, Kristin. *Freeing Shakespeare's Voice*. Theatre Communication Group, 1992.

Lorca, Marcela. "Personal Interview." 21 Oct. 2011.

Łuksza, Agata. "'Wołam do ciebie': O teatrze chórowym Marty Górnickiej." *Polish Theatre Journal*, vol. 1, no. 1, 2015.

MacCarthy, Anne. *Identities in Irish Literature*. Netbiblo, 2004.

Maksymowicz, Krystyna. "Personal Interview." 24 Mar. 2017.

Malcolm, Morgan Lloyd. *Emilia*. Oberon, 2018.

———. "Introduction to the Poems." *Emilia*, by Morgan Lloyd Malcolm, Oberon, 2018, pp. 76–78.

———. "A Note on the Text." *Emilia*, by Morgan Lloyd Malcolm, Oberon, 2018, p. vii.

Marinetti, Cristina. "Theatre as a 'Translation Zone': Multilingualism, Identity and the Performing Body in the Work of Teatro delle Albe." *The Translator*, 2018, pp. 128–46.

Marlowe, Christopher. *The Tragical History of Doctor Faustus*. Aldine House, 1897.

Matthews, Brander. "Notes." *The New Art of Writing Plays*, by Lope de Vega, translated by William T. Brewster, Dramatic Museum of Columbia University, 1914, pp. 41–57.

McNeice, Katie. "'In Awe of All Mná' – IFTA 2017 Best Short Film Goes to Viral *Heartbreak*." *IFTN*, 10 Apr. 2017.

Meerzon, Yana and Katharina Pewny. "Dramaturgies of Self: Language, Authorship, Migration." *Dramaturgy of Migration: Staging Multicultural Encounters in Contemporary Theatre*, edited by Yana Meerzon and Katharina Pewny, Routledge, 2019, pp. 1–5.

Meerzon, Yana et al. "Introduction: Migration and Multilingualism." *Modern Drama. Special Issue: Migration and Multilingualism*, edited by Yana Meerzon et al., vol. 61, no. 3, 2018, pp. 257–70.

Menkman, Rosa. *The Glitch Moment(um)*. Institute of Network Cultures, 2011.

———. "Glitch Studies Manifesto." *Amodern, Department of English, Concordia University*, 2016, https://amodern.net/wp-content/uploads/2016/05/2010_Original_Rosa-Menkman-Glitch-Studies-Manifesto.pdf.

Michałowska, Danuta. *Mówić wierszem*. Wydawnictwo PWST Kraków, 1999.

Mickiewicz, Adam. "Dziady: część trzecia." *Wirtualna Biblioteka Literatury Polskiej*, edited by Marek Adamiec, Uniwersytet Gdański, 2003, https://literat.ug.edu.pl/dziadypo/index.htm.

———. "Forefathers' Eve", translated by Dorothea Prall Radin and George Rapall Noyes, 2 parts, *The Slavonic Review*, vol. 3, 1925, Part 1, pp. 499–523.

———. "The Invocation," translated by Jarek Zawadzki. *print(new_line);: /* original poems and translations */*, by Jarek Zawadzki, CreateSpace, 2016.

———. *Pan Tadeusz, czyli ostatni zajazd na Litwie*. *Wirtualna Biblioteka Literatury Polskiej*, edited by Marek Adamiec, Uniwersytet Gdański, 2003.

Miller, L. Stephen. "Neuroimaging an Aging Population: Potential Tools in Cognition, Everyday Functioning, and Exercise Research." *Active Living, Cognitive Functioning, and Aging*, edited by Leonard W. Poon et al., Human Kinetics, 2006.

Miranda, Lin-Manuel. *Hamilton. Original Broadway Cast Recording*. Atlantic, 2015.

Mirocha, Łukasz. "Communication Models, Aesthetics and Ontology of the Computational Age Revealed." *Postdigital Aesthetics: Art, Computation and Design*, edited by David M. Berry and Michael Dieter, Palgrave, 2015, pp. 58–71.

Misztal, Barbara. *Theories of Social Remembering*. Open UP, 2003.

Morra, Irene. *Verse Drama in England, 1900–2015*. Methuen, 2016.

Murphy, Colin. "Interview with Seamus Heaney." *Sunday Tribune*, 8 Apr. 2008.

Myskja, Kjetil. "Foreignisation and Resistance: Lawrence Venuti and His Critics." *Nordic Journal of English Studies*, vol. 12, 2013, pp. 1–23.

Nibbelink, Liesbeth Groot. *Nomadic Theatre: Mobilizing Theory and Practice on the European Stage*. Methuen, 2019.

Ní Chonaill, Eibhlín Dubh. "Caoineadh Airt Uí Laoghaire." *Irish Poetry: An Interpretive Anthology from Before Swift to Yeats and After*, edited by W. J. McCormack, New York UP, 2002, pp. 65–75.

———. "The Lament for Art O'Leary," translated by Frank O'Connor. *Irish Poetry: An Interpretive Anthology from Before Swift to Yeats and After*, edited by W. J. McCormack, New York UP, 2002, pp. 76–83.

Nightingale, Andrea. "Mimesis: Ancient Greek Literary Theory." *Literary Theory and Criticism: An Oxford Guide*, edited by Patricia Waugh, Oxford UP, 2006, pp. 37–47.

Nowakowski, Jan. "Wstęp." *Wesele*, by Stanisław Wyspiański, edited by Jan Nowakowski, 4th ed., Ossolineum, 1984, pp. iii–xcvi.

Nwegaard, Siri and Stephano Arduini. "Translation: A New Paradigm." *Translation*, inaugural issue, 2011, pp. 8–17.

O'Brien, Carl. "Sex Education in Irish Schools." *Irish Times*, 29 Apr. 2019.

O'Brien, Cormac. "New Century Theatre Companies: From Dramatist to Collective." *The Palgrave Handbook of Contemporary Irish Theatre*, edited by Eamonn Jordan and Eric Weitz, Palgrave, pp. 255–68.

Ong, Walter J. *Orality and Literacy*. Routledge, 1988.

O'Toole, Emer et al. "Introduction: Othering Sameness." *Ethical Exchanges in Translation, Adaptation and Dramaturgy*, edited by Emer O'Toole et al., BRILL, 2017, pp. 1–20.

Pamuła, Natalia et al. "Nic o nas bez nas." *Studia de Cultura*, vol. 10, no. 1, 2018, pp. 4–12.

Parekh, Serena. *Refugees and the Ethics of Forced Displacement*. Routledge, 2016.

Paul, Joanna. "Homer and Cinema: Translation and Adaptation in Le Mépris." *Translation & The Classic: Identity as Change in the History of Culture*, edited by Alexandra Lianeri and Vanda Zajko, Oxford UP, 2008, pp. 148–65.

Paulson, Michael and Charo Henríquez. "Lin-Manuel Miranda Brings *Hamilton* to a Troubled But Appreciative Puerto Rico." *New York Times*, 12 Jan. 2019.

Pechey, Graham. "Not the Novel: Bakh-tin, Poetry, Truth, God." *Bakhtin and Cultural Theory*, 2nd ed., edited by Ken Hirschkop and David Shepherd, Manchester UP, 2001, pp. 62–84.

Pennycook, Alistair. "English in the World/The World in English." *Analysing English in a Global Context: A Reader*, edited by Anne Burns and Caroline Coffin, Routledge, 2001, pp. 78–89.

Pewny, Katharina. *Das Drama des Prekären: Über die Wiederkehr der Ethik in Theater und Performance*. Transcript, 2011.

Phelan, Peggy. *Unmarked: The Politics of Performance*. Routledge, 1993.

Polezzi, Loredana. "Translation and Migration." *Translation Studies*, vol. 5, no. 3, 2012, pp. 345–56.

Pratt, Mary Louise. *Toward a Speech Act Theory of Literary Discourse*. Indiana UP, 1977.

Preissner, Stefanie. "An Interview by Kasia Lech." *Radical Contemporary Theatre Practices by Women in Ireland*, edited by Miriam Haughton and Maria Kurdi, Carysfort Press, pp. 162–65.

———. *Our Father*, 2011a. Theatre Script. Author's Private collection.

———. *Solpadeine Is My Boyfriend*, 2012a. Theatre Script. Author's Private collection.

Prussak, Maria. *Wyspiański w labiryncie teatru*. Instytut Badań Literackich PAN, 2005.

Quayson, Ato. *Aesthetic Nervousness: Disability and the Crisis of Representation*. Columbia UP, 2007.

Radosavljević, Duška. "The Place of a Dramaturg in Twenty-First Century England." *The Routledge Companion to Dramaturgy*, edited by Magda Romanska, Routledge, 2014, pp. 40–44.

Ransome, Niall. *FCUK'D*, 2017. Theatre Script. Author's Private collection.

———. "Personal Interview." 28 Nov. 2019.

Raszewski, Zbigniew. "Partytura Teatralna." *Problemy Teorii Dramatu i Teatru*, edited by Janusz Degler. 2nd ed., vol. 1, Wydawnictwo Uniwersytetu Wrocławskiego, 2003, pp. 256–86.

Rehm, Rush. *Greek Tragic Theatre*. Routledge, 1994.

Richards, Ivor Armstrong. "Rhythm and Metre." *The Structure of Verse*, edited by Harvey Gross, Ecco Press, 1979, pp. 68–76. The article was originally published in *Principles of Literary Criticism*, by I. A. Richards, in 1925.

———. "Science and Poetry." *Poetry in Theory: An Anthology 1900–2000*, edited by Jon Cook, Blackwell, 2004, pp. 152–59.

Rodenburg, Patsy. *The Need for Words*. Methuen Drama, 2005.

Rodríguez, Paula. "Personal Interview." 25 May 2018.

Rodríguez, Paula and Sandra Arpa. *Rosaura*. Theatre Script. Authors' Private collection.

Romanska, Magda. "Drametrics: What Dramaturgs Should Learn from Mathematicians." *The Routledge Companion to Dramaturgy*, edited by Magda Romanska, Routledge, 2014, pp. 438–47.

———. "Introduction." *The Routledge Companion to Dramaturgy*, edited by Magda Romanska, Routledge, 2014, pp. 1–15.

Ross, David. *Aristotle*. Routledge, 1995.

Rossa, Mateusz. "Tańcząc w ciemnościach." *TEKTURA OPOLSKA*, 13 Apr. 2011.

Rudakoff, Judith. "Transcultural Dramaturgy Methods." *The Routledge Companion to Dramaturgy*, edited by Magda Romanska, Routledge, 2014, pp. 151–57.

Rusu, Mihai. "History and Collective Memory: The Succeeding Incarnations of an Evolving Relationship." *Philobiblon*, vol. 18, 2013, pp. 260–82.

Rychcik, Radosław. "Personal Interview." 28 June 2018.

Sadeghian, Peyvand. "Personal Email." 10 Mar. 2020.

Sadler, Victoria. "Theatre Review: Emilia." *Victoria Sadler*, 31 Aug. 2018.

Schechner, Richard. *Performance Studies: An Introduction*. 3rd ed. Routledge, 2013.

Schneider, Rebecca and Lucia Ruprecht. "In Our Hands: An Ethics of Gestural Response-ability. Rebecca Schneider in Conversation with Lucia Ruprecht." *Performance Philosophy Journal*, vol. 3, no. 1, 2017.

———. "It Seems as If . . . I Am Dead: Zombie Capitalism and Theatrical Labor." *TDR: The Drama Review*, vol. 56, no. 4, 2012, pp. 150–62.

———. *Performing Remains: Art and War in Times of Theatrical Reenactment*. Routledge 2011.

———. "Slough Media." *Remain*, by Ioana B. Jucan et al., U of Minnesota P, 2019, pp. 49–107.

Schulman, Michael. "More Broadway Recommendations." *New Yorker*, 21 Nov. 2016.

Sedgman, Kirsty. *The Reasonable Audience: Theatre Etiquette, Behaviour Policing, and the Live Performance Experience*. Palgrave, 2018.

Senna de, Pedro. "Laying Siege to *Carthage*." *JARMAN (All This Maddening Beauty) and Other Plays*, edited by Caridad Svich, Intellect Books, 2016, pp. 81–98.

Sex Workers' Education Network. "Sex Workers' Manifesto." Nov. 1997.

Shakespeare, William. *Burza*, translated by Stanisław Barańczak. Theatre Script.

———. *A Midsummer Night's Dream. The Norton Shakespeare*. 2nd ed., Norton, 2008, pp. 849–96.

———. *The Tempest. The Norton Shakespeare*. 2nd ed., Norton, 2008, pp. 3064–115.

Shalghin, Akram. "Time, Waiting, and Entrapment in Samuel Beckett." *International Journal of Humanities and Social Science*, vol. 4, no. 9, 2014, pp. 101–17.

Shalson, Lara. *Theatre & Protest*. Palgrave, 2017.

Shange, Ntozake. "Ntozake Shange." *The Playwright's Voice: American Dramatists on Memory, Writing and the Politics of Culture*, edited by David Savran, Theatre Communications Group, 1999.

Shilyaeva, Olga. *28 Days. The Tragedy of a Menstrual Cycle*, translated by Katherine Soloviev, 2020. Theatre Script. Translator's Private collection.

———. *28 дней. Трагедия менструального цикла*, 2018. Theatre Script.

Sikorska-Miszczuk, Małgorzata, *YEMAYA – Królowa Mórz*. 2016, Unpublished Script.

Skórczewski, Dariusz. *Polish Literature and National Identity: A Postcolonial Landscape*, translated by Agnieszka Polakowska, Rochester UP, 2020.

Sloman, Albert E. "Introduction." *La vida es sueño*, by Pedro Calderón de la Barca, edited by Albert E. Sloman, Manchester UP, 1961, pp. ix–xxxviii.

———. "The Structure of Calderón's *La vida es sueño*." *Critical Essays on the Theatre of Calderón*, edited by Bruce W. Wardropper. New York UP, 1965, pp. 90–100.

Solga, Kim. *Theatre & Feminism*. Palgrave, 2015.

Sophocles. *Antigone*. Cambridge UP, 1999.

Sostek, Brian. "Personal Interview." 23 Oct. 2011.

Stallybrass, Peter and Allon White. *The Politics and Poetics of Transgressions*. Cornell UP, 1986.

Stanislavski, Constantin. *Building a Character*. Methuen, 1983.

States, Bert O. *Great Reckonings in Little Rooms*. U of California P, 1985.

Stock, Robert. "Celebrity Translators in the Theatre – Marketing Tools or Cultural Facilitators?" *Translation into Theatre and the Social Sciences Conference*, 16–17 June 2017, Oxford University.

Stříbrný, Zdeněk. *The Whirligig of Time: Essays on Shakespeare and Czechoslovakia*. U of Delaware P, 2010.

Stroich, Vicki. "On Dramaturgy and Leadership." *The Routledge Companion to Dramaturgy*, edited by Magda Romanska, Routledge, 2014, pp. 236–40.

Styrt, Philip Goldfarb. "Toward a Historicism of Setting: *Hamilton* and American History." *Modern Drama*, vol. 61, no. 1, 2018, pp. 1–19.

Svich, Caridad. "*Carthage/Cartagena*." *JARMAN (All This Maddening Beauty) and Other Plays*, edited by Caridad Svich, Intellect Books, 2016, pp. 33–79.

———. "Personal Email." 26 Apr. 2018.

———. "Visions of Migration: Internal Diasporas." *Performance Research*, vol. 6, 2001, pp. 12–23.

Szatkowski, Janek. *A Theory of Dramaturgy*. Routledge, 2019.

Szmeja, Maria. "Silesian Identity: Social and Political Problems." *Journal of Borderlands Studies*, vol. 22, no. 1, 2007, pp. 99–115.

Szondi, Peter and Michael Hays. "Theory of the Modern Drama, Parts I-II." *Boundary 2*, vol. 11, no. 3, 1983, pp. 191–230.

Taylor, Paul. "Emilia, Shakespeare's Globe, London." *Independent*, 16 Aug. 2018.

Telega, Michał. "The Actresses, or Sorry for Touching You," translated by Dorota Pilas-Wiśniewska. *Polish Theatre Journal*, vol. 7–8, no. 1–2, 2019.

———. "Aktorki, czyli przepraszam, że dotykam." *Polish Theatre Journal*, vol. 7–8, no. 1–2, 2019.

Trencsényi, Katalin. *Dramaturgy in the Making: A User's Guide for Theatre Practitioners*. Methuen, 2015.

Trencsényi, Katalin and Bernadette Cochrane. "New Dramaturgy: A Post-mimetic, Intercultural, Process-Conscious Paradigm." *New Dramaturgy: International Perspectives on Theory and Practice*, edited by Katalin Trencsényi and Bernadette Cochrane, Methuen, 2014, pp. xi–xx.

Turner, Cathy and Synne K. Behrndt. "Editorial." *Contemporary Theatre Review*, vol. 20, no. 2, 2010, pp. 145–48.

Ubersfeld, Anne. *Reading Theatre*. U of Toronto P, 1999.

van Dijck, José. 2004. "Mediated Memories: Personal Cultural Memory as Object of Cultural Analysis." *Continuum*, vol. 18, no. 2, 2004, pp. 261–77.

Venuti, Lawrence. *The Scandals of Translation: Towards an Ethics of Difference*. Routledge, 1998.

———. *The Translator's Invisibility: A History of Translation*. Routledge, 2008.

Verovšek, Peter J. "Collective Memory, Politics, and the Influence of the Past: The Politics of Memory as a Research Paradigm." *Politics, Groups, and Identities*, vol. 4, no. 3, 2016, pp. 529–43.

"Verse." *OED Online*, Oxford UP, 2018.

Walsh, Tony. "This Is the Place." *Albert Square*, Manchester, 24 May 2017.

Walton, J. Michael. *Found in Translation: Greek Drama in English*. Cambridge UP, 2006.

Watkins, Neil. "The Year of Magical Wanking." *The Oberon Anthology of Contemporary Irish Plays*, edited by Thomas Conway, Oberon Books, 2012, pp. 291–326.

Wegerif, Rupert. *Dialogic: Education for the Internet Age*. Routledge, 2013.

"*Wesele*. Program." Theatre Programme. *Teatr Śląski*, 2016.

Wiles, David. *Greek Theatre Performance: An Introduction*. Cambridge UP, 2000.

———. *Theatre and Time*. Palgrave, 2014.

Wilmer, Stephen. "Finding a Post-colonial Voice for *Antigone:* Seamus Heaney's *Burial at Thebes*." *Classics in Post-Colonial Worlds*, edited by Lorna Hardwick and Carol Gillespie, Oxford UP, 2007, pp. 228–42.

———. *Performing Statelessness in Europe*. Palgrave Macmillan, 2018.

Wilson, Peter. "Music." *A Companion to Greek Tragedy*, edited by Justina Gregory, Blackwell Publishing, 2005, pp. 183–93.

Wilson, Timothy. *Frontiers of Violence Conflict and Identity in Ulster and Upper Silesia 1918–1922*. Oxford UP, 2010.

Wintour, Patrick, and Vikram Dodd. "Blair Blames Spate of Murders on Black Culture." *Guardian*, 12 Apr. 2007.

Wolf, Stacy. "*Hamilton's* Women." *Studies in Musical Theatre*, vol. 12, no. 2, 2018, pp. 167–80.

Wolfe, Andrea Power. "Mammy." *Encyclopedia of Motherhood*, edited by Andrea O'Reilly, 3 vols., vol. 2, Sage, 2010, pp. 683–85.

Woźniak-Łabieniec, Marzena. *Klasyk i Metafizyka*. Wydawnictwo Arcana, 2002.

Wright, George T. *Shakespeare's Metrical Art*. U of California P, 1988.

Wyspiański, Stanisław. *The Wedding*, translated by Noel Clark, Oberon Books, 1998.

———. *Wesele*, edited by Jan Nowakowski, 4th ed., Ossolineum, 1984.

———. *Wyzwolenie*. *Wirtualna Biblioteka Literatury Polskiej*, edited by Marek Adamiec, Uniwersytet Gdański, 2003, literat.ug.edu.pl/wyzwol/index.htm.

Yeats, W. B. "On Baile's Strand." *Selected Plays*, by W. B. Yeats, Penguin Books, 1997.

———. "The Tragic Theatre." *Essays and Explorations*, by W. B. Yeats. Palgrave, 1961, pp. 238–45.

Index

Printed in the United States
by Baker & Taylor Publisher Services